KRUG

BY KRUG LOVERS

Endpapers: Illustrations © Alice d'Orglandes

© 2014 Assouline Publishing
601 West 26th Street, 18th floor
New York, NY 10001, USA
Tel.: 212-989-6769 Fax: 212-647-0005
www.assouline.com
ISBN: 9781614282884

Foreword translated from the French by Denise Raab Jacobs.

KRUG

BY KRUG LOVERS

ASSOULINE

CONTENTS

FOREWORD *By Olivier Krug* 6

CHARISMATIC KRUG *By Serena Sutcliffe, M.W.* 12

KRUG LOVERS 22

CHRONOLOGY 186

ACKNOWLEDGEMENTS & CREDITS 192

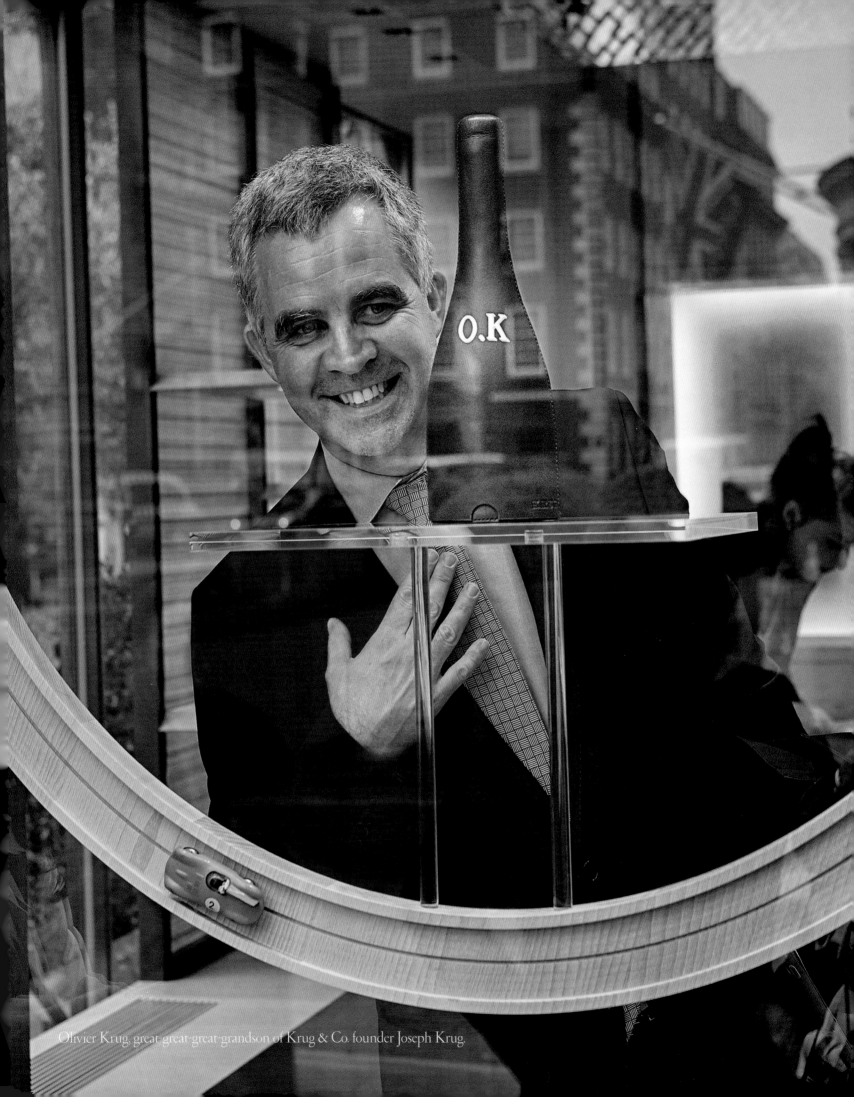

Olivier Krug, great-great-great-grandson of Krug & Co. founder Joseph Krug.

FOREWORD
Olivier Krug

My Very Dear Krug Lovers,

For the first time in over 170 years, the Maison Krug has asked its devoted admirers to tell our tale through their own stories. Many were intrigued by the idea and passionate to share what they consider an intimate relationship.

We are proud to invite our readers on this rich cultural journey of genuine emotion. Not a day has passed, since the very first bottle was created, without Krug Lovers wanting to share their personal experiences of Krug. If my ancestor Joseph Krug—who had the wild dream to found this House—were to walk among us today, he would fully expect these testimonies, and be touched by their true spontaneity.

For me, these tales of adventure, discovery and memories never to be forgotten are quite simply the bedtime yarns of my childhood—it was how I was brought up.

Never did the importance of our Krug Lovers resonate more than the day my father, Henri Krug, asked me if I would join the House to be a part of the Krug team. As he instilled in me the foundations upon which the House of Krug is built, fundamental to this was the relationship Krug has with its Krug Lovers.

In keeping with our family tradition, I learned a lot from these impassioned and deeply personal stories.

Of course, all devoted Krug Lovers have one significant advantage over me: they can recall and describe in minute detail the first time they ever tasted

Krug Champagne, while my first taste was long before I was even forming memories... well, almost. The experience has gone down as something of a family legend, how a drop of Krug was placed on my lips the day I was born. More than a legend, this has become an actual family tradition, one that I have carried on with my four children.

I therefore owe a great part of my apprenticeship to the Krug Lovers. While it would be impossible to include them all in this acknowledgement, I must say so many of them—from the wildly famous to the devotedly discreet, traditional growers or international jet-setters, socialite hedonists or studious Champagne Lovers—deeply influenced me and have enriched my life ever since I was a young child.

As a boy, I looked at my grandparent's visitors to the Maison as intriguing personalities and they always left a lasting, if mysterious, impression on me. I always felt at ease in their company and loved listening to their anecdotes about faraway places. If I behaved well during those evenings (which, admittedly, did not happen very often) I would be allowed *une goutte de "Champagne"* (my grandfather never said "Krug" at home), always served in a silver goblet. A rarefied privilege, I knew it even then.

Later, when I visited the vineyards with my father, I learnt to love the land through the warm passion of the growers and their families. If there is one person who particularly stands out in my mind, it would have to be Monsieur Simon, who left us this past winter. It is to him that I pay homage for teaching me everything I have come to love about this region, its nature and climate.

Later, as a young man, I went to work in Japan, a journey that has wedged this country into my heart forever. Here I developed a full sense of what Krug Lovers seek: from the craftsmanship of the finest artisans—an essential requirement of

the top professionals in any given field—to a natural sense of discretion matched by spontaneous generosity and everlasting loyalty, as well as a true appreciation of the magic that occurs when you pop the cork of a bottle of Krug.

Leafing through these pages, readers will recognise their own memories or encounter previously unknown facets all connected to the experience of sharing a bottle of Krug Champagne. They are powerful, singular narratives that together make a complete whole, which I love and I am grateful for.

These messages punctuate the journey of my own "Monsieur Krug" life, as part of an ever growing, dynamic and passionate Krug team around the world. Joseph created Krug Champagne by listening to fine Champagne enthusiasts who dreamt of a House that could propose the ultimate experience in Champagne year after year.

I have been given the great honour of carrying on this extraordinary tradition alongside everyone I am privileged to call my colleagues at the Maison Krug. And every single day we are all filled with joy and pride that it is enjoyed by people across the world, regardless of boundaries or cultures, from morning till night, from festive occasions to simple moments made spectacular by the essentially simple feat of sharing a bottle made with love, passion and dedication.

This book was created as an homage to you: our Krug Lovers the world over. You share an eternal moment of complicity with our founder, Joseph. This book is a tribute to you, from all the generations of dedicated people who followed him in creating his dream at the Maison since 1843..

I hope this book provides you with as much enjoyment as we experienced preparing it.

And so, I raise my glass to you, Krug Lovers, and thank you for the inspiration you bring us day after day.

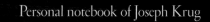

" Whoever drinks Krug, whatever the time of day, is helping to enhance the friendship between people: for it is impossible to feel bitterness or jealousy once you have savoured such nectar. "

SERENA SUTCLIFFE, M.W., *A Celebration of Champagne*

CHARISMATIC KRUG
Serena Sutcliffe, M.W.

To drink Krug is a privilege; to appreciate it is a duty. We Krug lovers hone our skills with all the application of the truly passionate, combining homework and studies "sur place" as often as we can. It is the ultimate sensual/intellectual experience, when we can be both subjective and objective until we resolve everything by finishing the bottle. We love Krug, but we also honour it, which is a finely balanced exercise tinged with respect.

In the beginning, and this may have a somewhat biblical ring to it, I was slightly in awe of Krug. One saw at once that this was not a frothy matter. Whenever our paths crossed, I approached the glass with a degree of reverence, rather like first meeting Paul Krug. I was young and on a learning curve, coming face-to-face with tradition and gold-standard reputation that had stood the test of time. What could one do other than to bury one's nose in the Champagne itself and take a deep breath, before taking an equally deep gulp? It turns out that this is the best way to learn about Krug.

I have always felt that Krug is constructed, not made, certainly not "crafted," but built on solid roots that form the base of a vinous monument. It starts outside in the fresh air, on the Montagne de Reims, the Côte des Blancs, and the Marne Valley, with Krug's own superb vineyards and their long-standing contracts with growers who have worked with Krug for generations. Then the action moves inside, to Krug's cellars in Reims, presided over by Eric Lebel, Chef de Caves, a man of sharp intelligence and formidable memory. You have to be hardwired for excellence to work at Krug, or maybe

Serena Sutcliffe, M.W.,
head of Sotheby's
international wine
department.

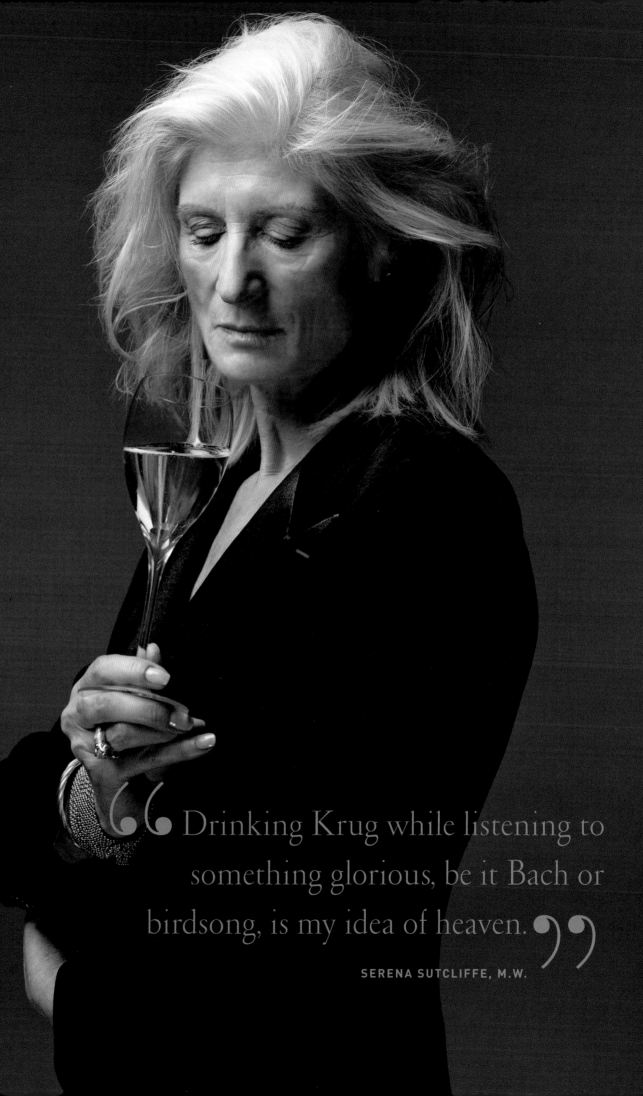

"Drinking Krug while listening to something glorious, be it Bach or birdsong, is my idea of heaven."

SERENA SUTCLIFFE, M.W.

I should say work *for* Krug as, ultimately, the House is the master. At harvest time, Eric Lebel conducts his orchestra, with oenologist Julie Cavil going to Le Mesnil-sur-Oger, while Laurent Halbin is in charge in Reims and Ambonnay. The link between vineyard and cellar is vital, the connection between the raw material and the transformation into liquid being at the centre of quality. And, incidentally, while many consider Krug to be the most "masculine" of all Champagnes, in all its winey majesty, there are females key to making it, and there is a woman at the top of the tree! There is precedent for this—Krug 1915 was made by a woman.

One of the most atmospheric sights for a Krug lover, as the harvest nears, is to see the forest of *fûts* covering the entire courtyard in Reims, the small 205-liter barrels being moistened with water in preparation for the first, parcel-by-parcel fermentation. This is a Krug signature (and sometimes Krug refer to its *fûts* as its "casseroles"), but only a part of the complex dance that now begins to see the still wine through to the turbo-charged Champagne that will emerge. At the core of the process, there is the tasting and the intricate blending of the year's wines from 250 plots, as well as 150 reserve wines from previous vintages. This is a formidable operation, involving both the technical team, with Eric Lebel and his handwritten "Bible" that never leaves his side and the Krug family itself with their link to their ancestors and their vision of what Krug Champagne should be. I often sense that the spirit of Joseph Krug, the founder of the House, hovers over all, with his determination and his clear view of what Champagne should represent. For him, the blend was pivotal, the culmination of the art, consistent and true to itself. His leather notebook from the 1840s

insisted upon wines from good sites, wines with real character. The flagship Champagne was to be a multidimensional blend of crus, vintages, and reserve wines, aiming for real depth and complexity, with all the elements sparking off each other to produce the ultimate in vinous excitement. This was, and is, at the heart of Krug, now exemplified by Krug Grande Cuvée.

The second creation came into being when a year was judged to have the personality to stand on its own, illustrating the particular character of that vintage. It had to be able to express itself with aplomb—then it could join the ranks of the great. Thus we have Krug Vintage, which gives us the frisson of anticipation—is this a year when vintage will be made, did it make the grade? This is all part of being a Krug lover —it could be called an obsession, but perhaps we need not apologize for this, since Joseph Krug must have been something of an obsessive himself to set and adhere to such standards.

In life, there are loves one leaves—and those one keeps. Krug is a keeper, in all senses of the word. All love has to be rekindled and, for me, renewed passion has come in the form of watching (and tasting) the evolution of Krug Grande Cuvée. It has been a revelation, spearheaded by Krug's CEO, Maggie Henriquez, with her inquiring mind and Latin fire, a magic blend if ever there were one. Krug Grande Cuvée is a conversation between the component parts of the blend that amplifies and opens out in bottle. The reserve wines that are its route to greatness are the history of the House, its living memory. They are also its secret. The blends for Krug Grande Cuvée today are even more numerous and precise than in the past, a mosaic of scents and flavours conjured up to bewitch us.

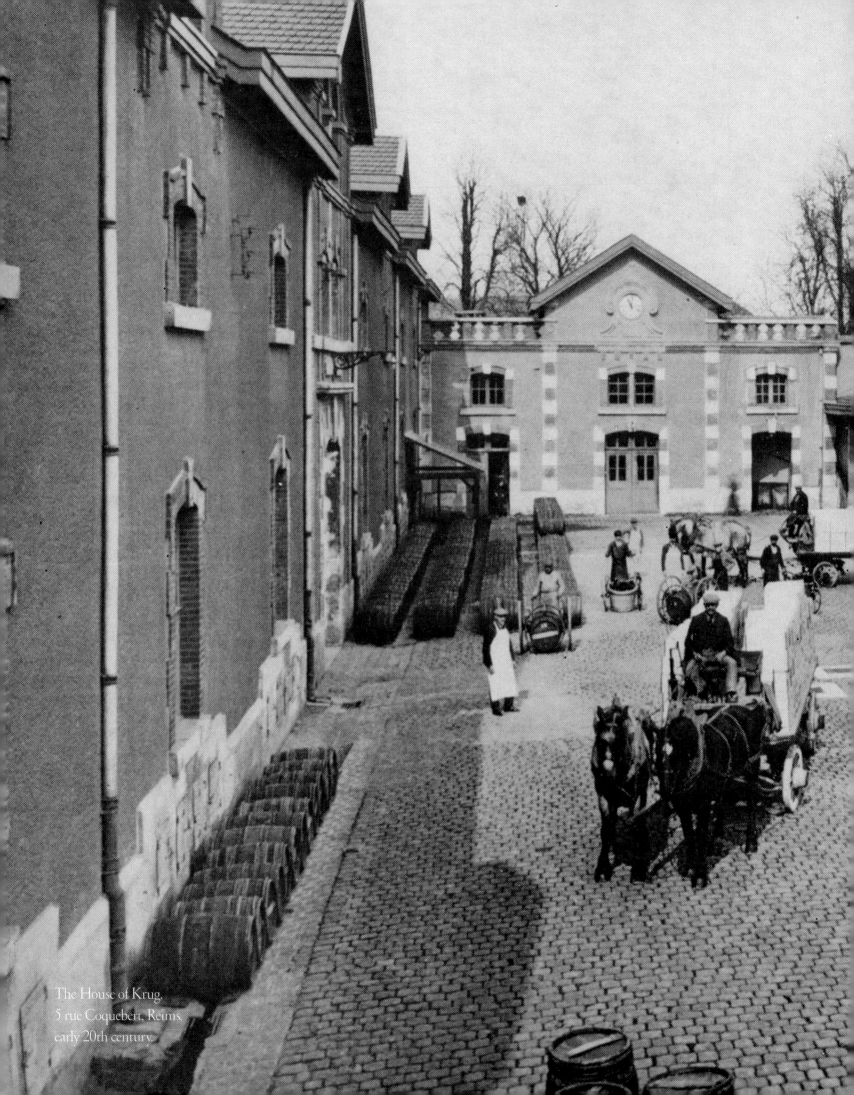

The House of Krug,
5 rue Coquebert, Reims,
early 20th century.

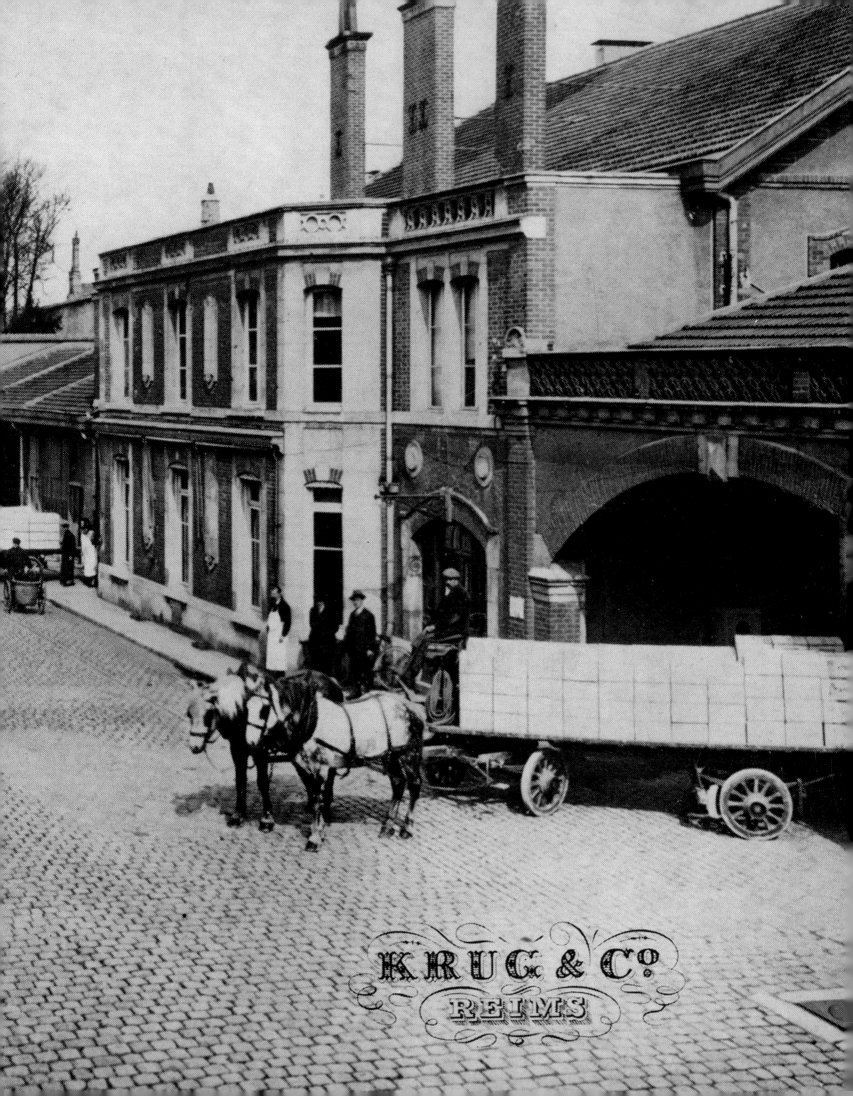

KRUG & C?
REIMS

When aged stocks of Krug Grande Cuvée were unearthed in their cellars, each blend was identified and tasted with mounting expectation. Of course, quantities were finite, but Sotheby's was permitted to auction some of these gems at a glittering sale in New York in December 2012. And, presale in Reims, I was permitted to see them all, comparing these brilliant blends of up to eleven different years and 120 wines. It was one of the most absorbing and inspiring tastings of my life. It also sprung a huge surprise: As we tasted the blends through the decades, it became crystal clear that Krug Grande Cuvée probably ages better than any other Champagne, including its own impressive Vintages. Over several hours, I juggled terms that seem contradictory but, in fact, complement each other. Generosity and elegance, finesse and power, persistence and freshness, they all live happily together. And the hedonistic vocabulary rivals this, with acacia honey, orange zest, nougatine, biscuits, peanuts, walnuts, and—wait for it—sometimes a riveting "maritime" scent, a certain saline quality that fascinates. Maybe that is why I have often drunk Krug Grande Cuvée by the sea, most memorably on a landmark birthday on the Greek island of Symi, feet in the water and a glass in one hand and a spoonful of caviar in the other.

King Krug can be consumed anywhere and everywhere; it can be drunk by queens and presidents or by commoners at picnics. It has been revealing to see how serious wine collectors, from Europe to the Americas to Asia, embrace Krug as the prelude to their wine dinners, as if its gravitas and vinosity lay the foundation for their comparisons of red wine. These same people have always compared Krug vintages and now, with the Krug ID on the back label of the bottles, this adds a new dimension to their deliberations.

Krug creates memories, and many of mine revolve around the Krug family. In the late 1990s, a rather mysterious summons to Paris from Henri and Rémi brought me to that classic restaurant, Carré des Feuillants. Strangely, the two brothers were looking serious as we met in an alcove—they said they would appreciate my opinion on two glasses of Krug. Concentrating hard, I thought that one was "ready," but that the other needed more time, whereupon smiles broke out all round. Apparently, I had just endorsed their decision to release Krug 1989 before the 1988, thereby, for the first time, breaking the usual chronological rule for vintages. When Olivier was doing his apprenticeship in Japan, we took to the floor together at Hiramatsu in Hiroo, Tokyo, to extol the virtues of Krug Collection 1971 in magnum, not the most difficult of tasks. Then, in 2007, Henri, Rémi, and Olivier Krug were all on hand when a small, and spoiled, group was led into the tiny Clos d'Ambonnay for the presentation of its first vintage, a mere 3,000 bottles of the 1995. We were agog to see this pure Pinot Noir creation and, lo and behold, a tray with glasses was borne through the vines, followed by Henri with a bottle of his latest "baby"—a coup de théâtre that only served to whet the thirst. And, careening through Milan's fabulous food emporium, Peck, with the gastronomic Rémi is a treat in itself—no one knows better how to match Krug with culatello.

Krug lovers like to play with food and their chosen bottle or, better still, magnum. We can all do that. Why not reach for a gingery Krug 1998 to go with Cantonese lobster on noodles, with its fresh ginger and spring onions. The most recently released vintage, the heat-wave 2003, was harvested from 23 August—the last time there was an August harvest at Krug was in 1822.

The Meunier in the blend, together with the Pinot Noir and Chardonnay, provides both vivacity and expression that makes it highly gulpable at 11 in the morning—this is still in its youthful, aperitif phase. The all-Chardonnay Clos du Mesnil, protected by walls since 1698, is dreamy with seared scallops sprinkled with hazelnut oil, a taste that always finds the creamy nuttiness of the Champagne. The last time I essayed the 1996 Krug Clos du Mesnil, I described it as "together, like a top dressage horse," which only shows how far we can go in our appreciation of Krug. Then there is totemic Krug Collection, tantalizingly released later in life to prove Olivier Krug's throwaway line, "Krug Champagne is born in cask and aged in bottle." I can wax lyrical on this too—Krug Collection 1982 reminds me of cinnamon french toast, like breakfast in New Orleans, while the 1985 is all marmalade, figs, and raisins, dangerously addictive. And there is a patina to Krug, a texture one can feel as it rolls over the tongue—try it and see.

Linear dynasties are fascinating to follow, in people as in great wines. They ebb and they flow, they evolve and flower, they innovate and grow. Krug has applied itself to making superlative Champagne since 1843 and we are the beneficiaries. Where else can it go and what lies ahead? History hones Champagne houses to face challenges and turn them to their advantage. Improvements and experiments are part of all endeavours, and viticulture and winemaking are no exception. New markets appear, with different social habits and demands requiring mutual adaptation. Krug has the experience and the motivation to continue making Champagne of the highest quality and we shall continue to light up our lives by drinking Krug. I think that is a fair trade!

Six generations of the Krug family tree.

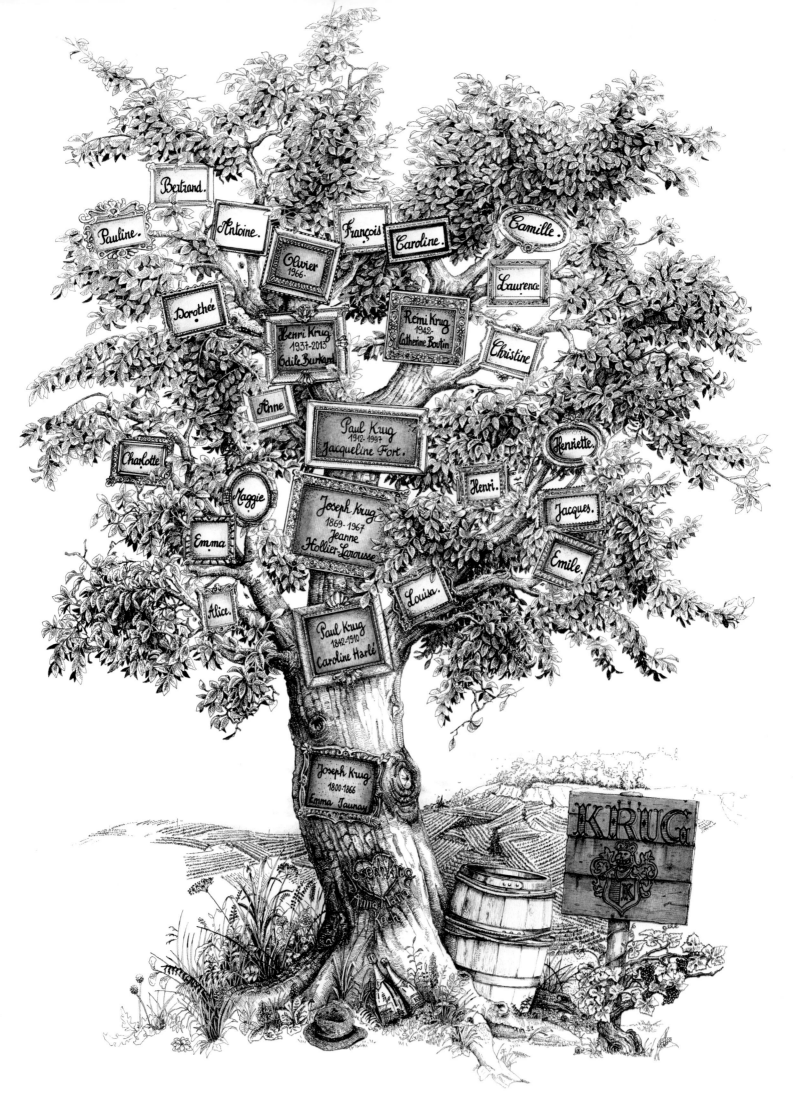

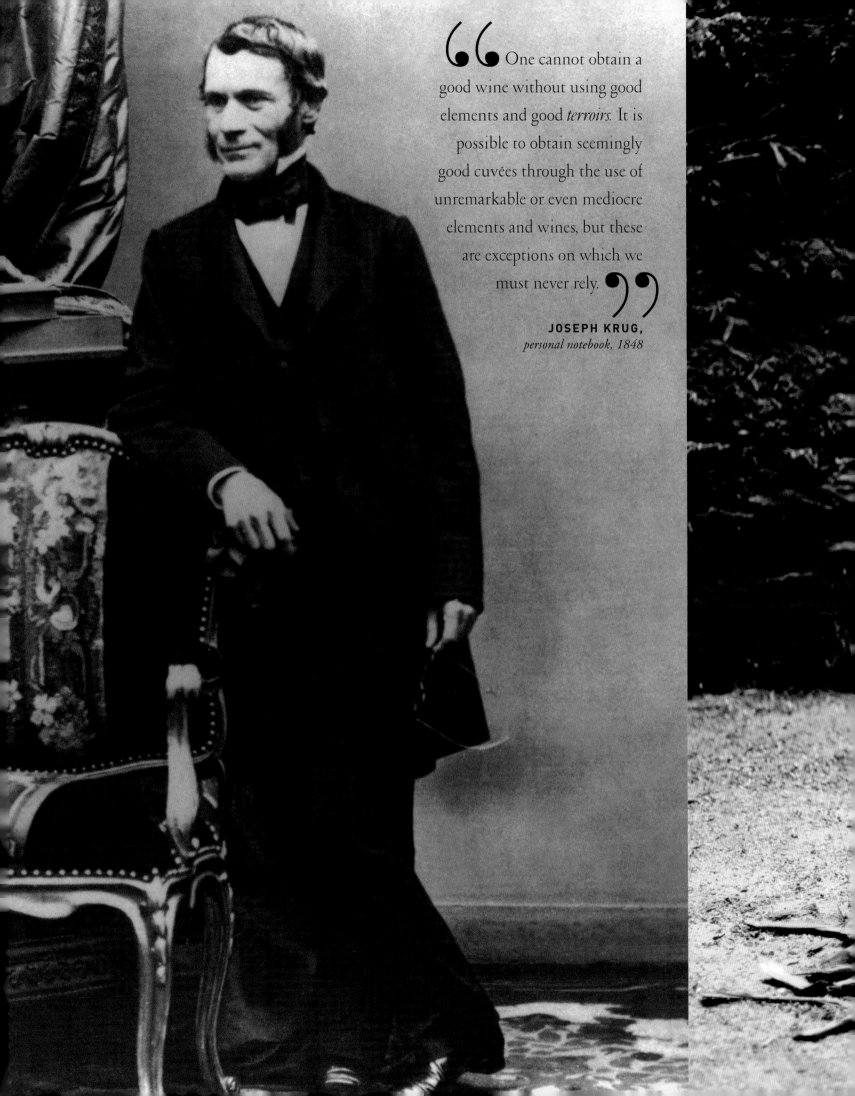

> "One cannot obtain a good wine without using good elements and good *terroirs*. It is possible to obtain seemingly good cuvées through the use of unremarkable or even mediocre elements and wines, but these are exceptions on which we must never rely."
>
> **JOSEPH KRUG,**
> *personal notebook, 1848*

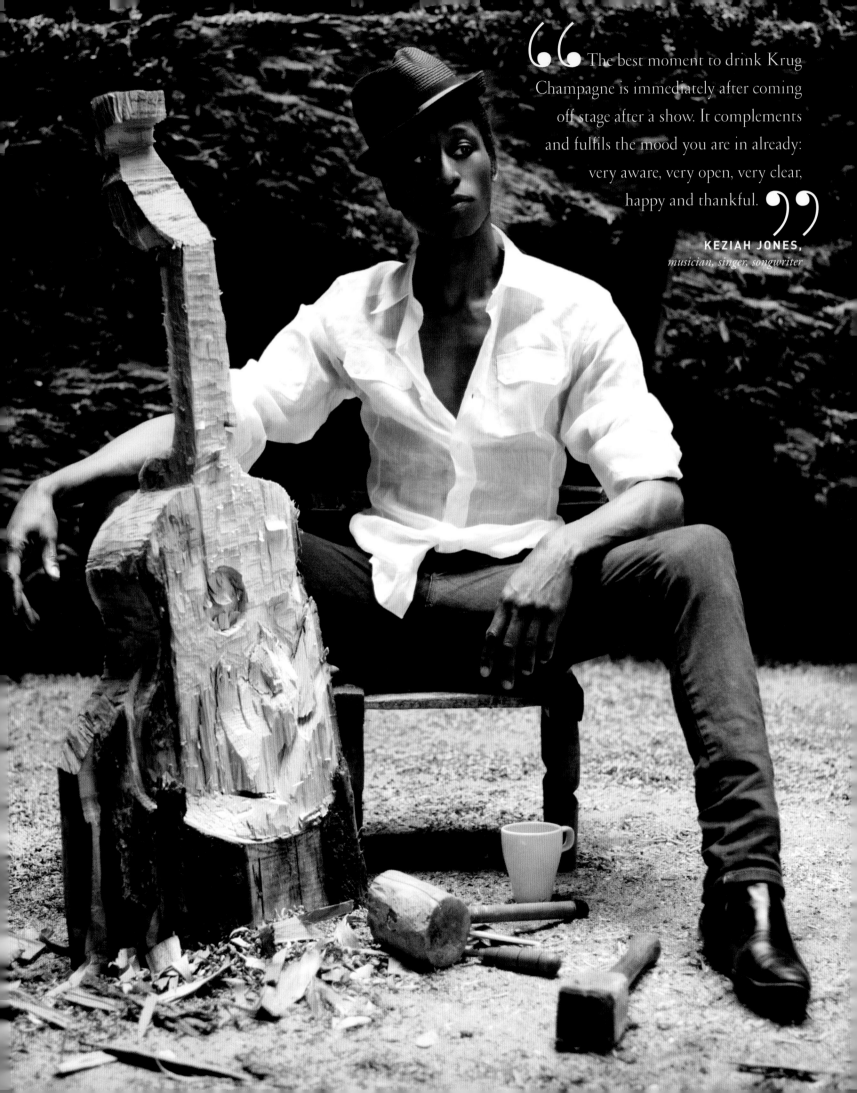

"I have always admired Krug Champagne, and the family tradition that is behind it. It seems synonymous with 'the best.'"

FRANCIS FORD COPPOLA,
screenwriter, director, producer, winemaker

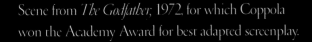
Scene from *The Godfather*, 1972, for which Coppola won the Academy Award for best adapted screenplay.

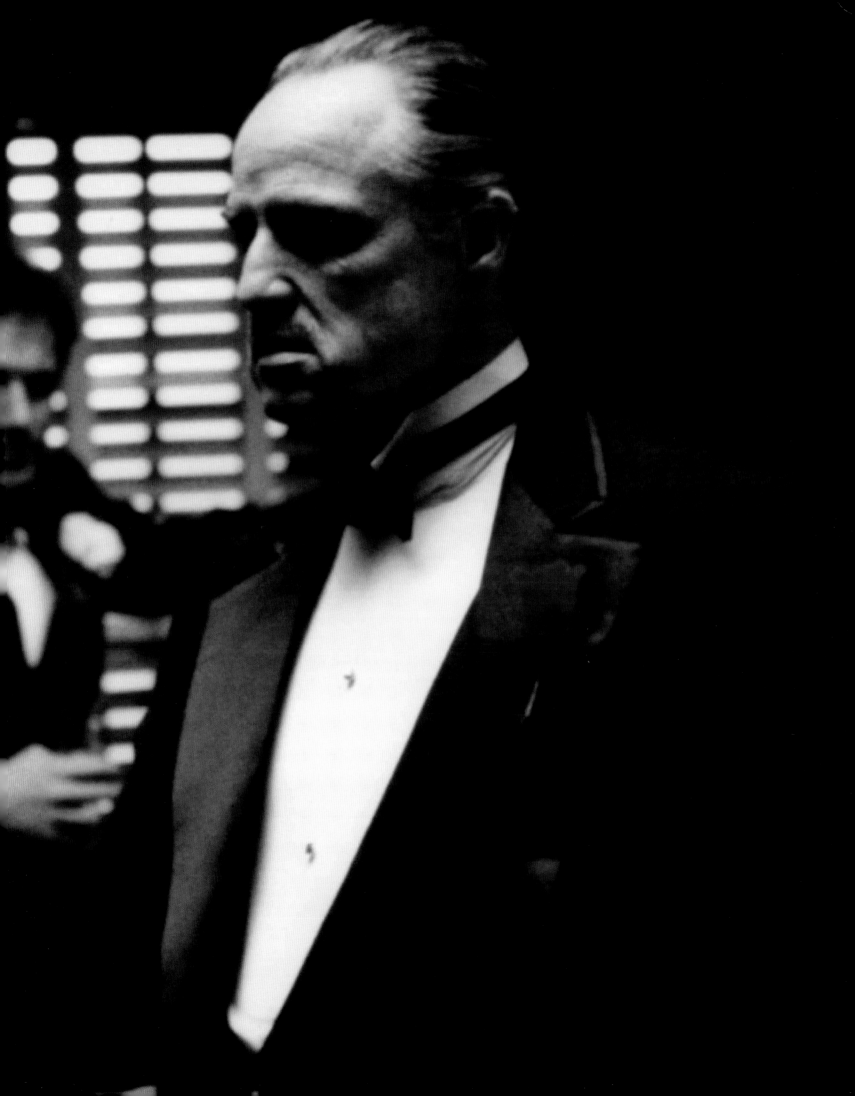

Paris, le 1er Février 1985

SOCIETE KRUG
5, rue Coquebert
51100 REIMS

Dear Mister Krug,

Remerciements quelque peu tardifs mais d'autant plus chaleureux.

Considère toujours votre marque comme la Rolls des champagnes.

Très cordialement à vous.

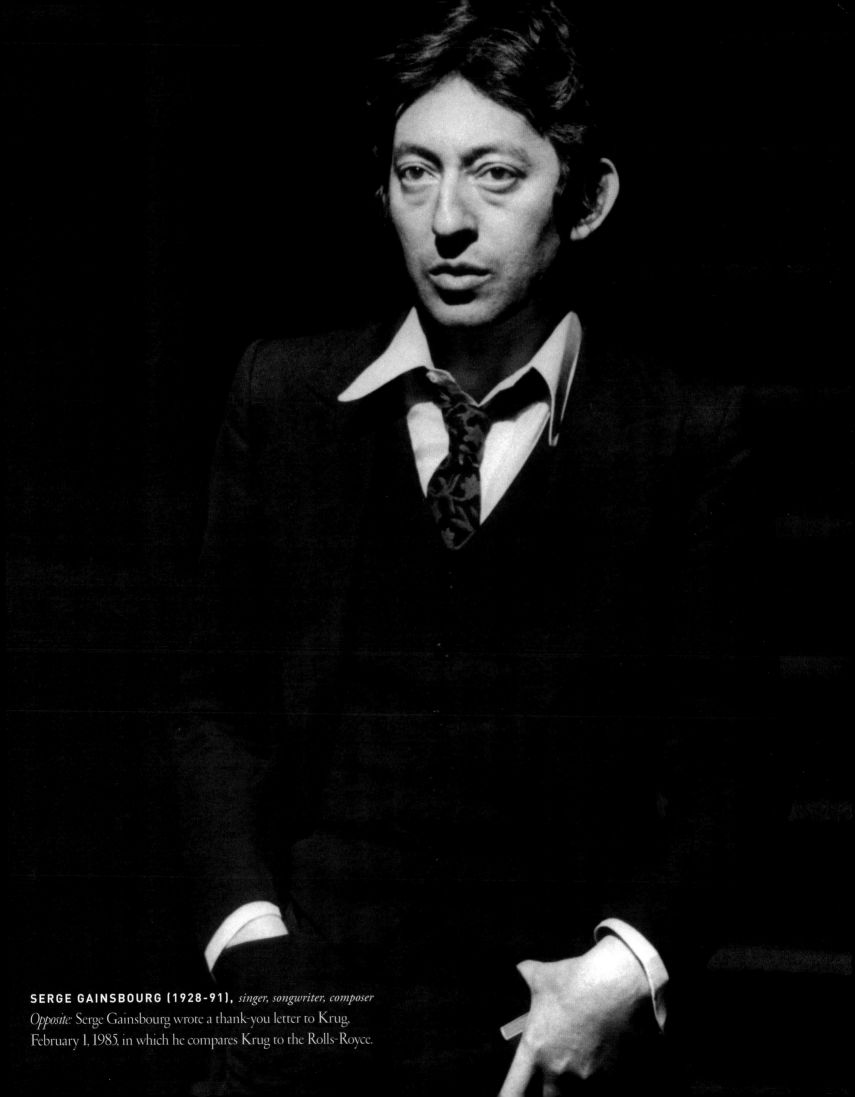

SERGE GAINSBOURG (1928-91), *singer, songwriter, composer*
Opposite: Serge Gainsbourg wrote a thank-you letter to Krug,
February 1, 1985, in which he compares Krug to the Rolls-Royce.

66 Middle age has its own rewards; its own matured and satisfying preferences. A taste for Champagne is one of them. In my twenties I despised it as a vulgar ostentatious drink. In my thirties I patronised it. But most men after forty, if they have not switched to spirits, find that Champagne does something for them that no other wine can do. I was lucky in that my taste for it began to mature at the very moment in the late '30s when Krug 1928 was moving to its majestic peak. I do not expect to see a wine like that again in its depth of color, body and full-blooded fragrance. 99

In Praise of Wine & Certain Noble Spirits, 1959

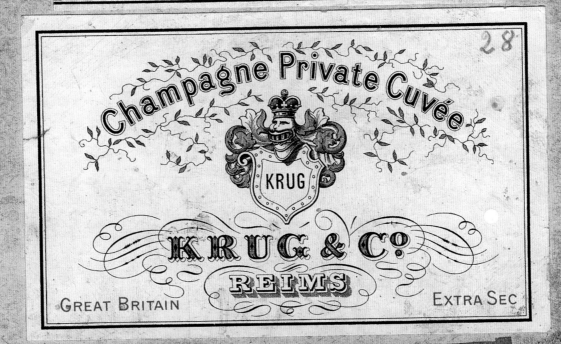

PRODUCED AND BOTTLED BY
KRUG & COMPANY
REIMS, France
NICHOLAS & Co. Inc., Importers
NEW-YORK, N.Y.

NICHOLAS & Co, INCORPORATED
IMPORTERS
NEW-YORK

KRUG
PRODUCE
PRIVATE CUVÉE
EXTRA SEC
1928

KRUG
& Co
REIMS

KRUG
OF FRANCE

CONTENTS 1 PINT 10 FLUID OUNCES
ALCOHOLIC STRENGTH BY VOLUME 12 ½ %

28

Champagne Private Cuvée

KRUG

KRUG & Cº
REIMS

GREAT BRITAIN EXTRA SEC

Champagne

Casing for Champagne to be shipped to Great Britain, 1928.

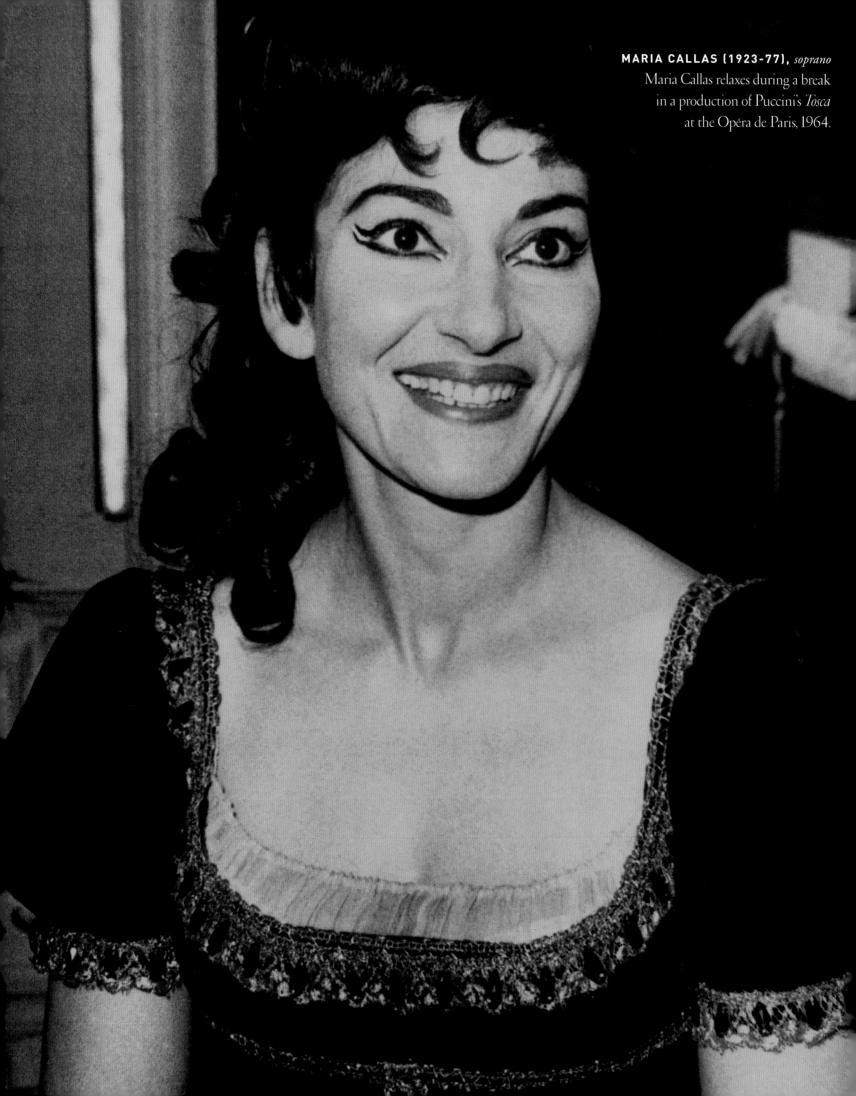

MARIA CALLAS (1923-77), *soprano*
Maria Callas relaxes during a break
in a production of Puccini's *Tosca*
at the Opéra de Paris, 1964.

"Those who are devoted to Krug have as much character as their Champagne of choice. Maria Callas, Gabrielle (Coco) Chanel, Anne de Noailles... all drink Krug because they love it."

Katia D. Kaupp, *Le Nouvel Observateur*

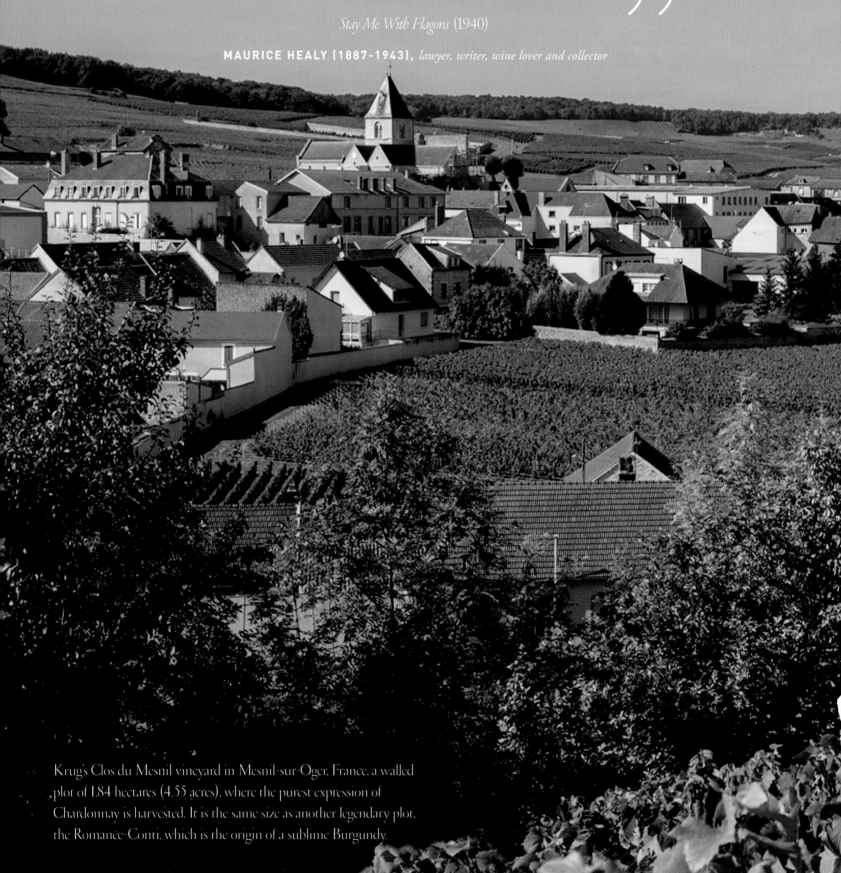

> " Krug holds my allegiance as the king of them all; my recollection does not go beyond the Krug 1919 but that was truly an excellent wine. And Krug 1928 must be the best wine made in the present century. "

Stay Me With Flagons (1940)

MAURICE HEALY (1887-1943), *lawyer, writer, wine lover and collector*

Krug's Clos du Mesnil vineyard in Mesnil-sur-Oger, France, a walled plot of 1.84 hectares (4.55 acres), where the purest expression of Chardonnay is harvested. It is the same size as another legendary plot, the Romanée-Conti, which is the origin of a sublime Burgundy.

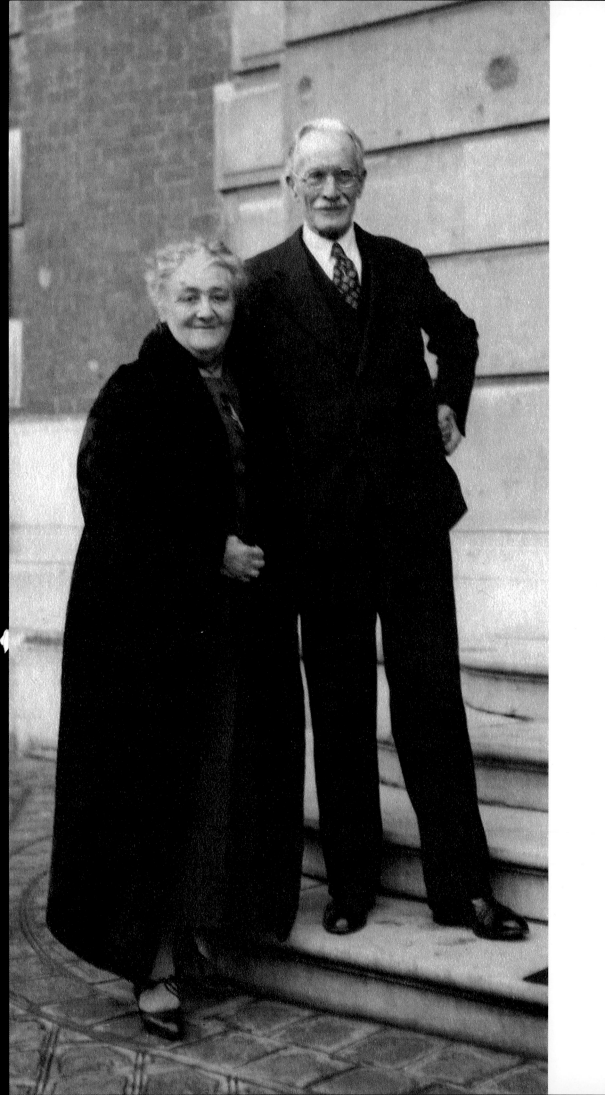

Jeanne and Joseph Krug, circa 1950s.

Opposite: During World War I, Christmas 1915, a celebration was organised in the cellars of the House of Krug. A Christmas tree was put up in the "crypt"; gathered around it were both employees as well as those Reims residents who had taken refuge in the Krug cellars.

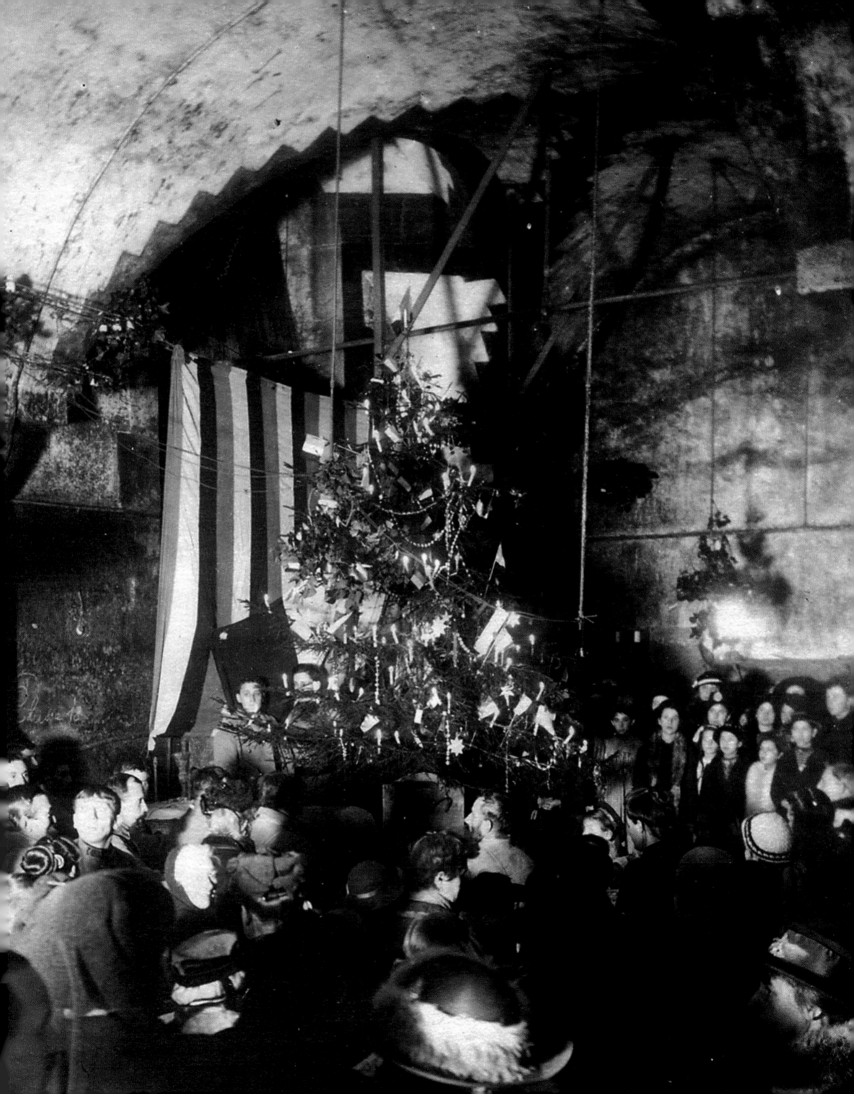

66 One of my earliest introductions to Champagne was Krug. I still remember the shock of that first encounter. I was accustomed to the senses of smell, feel, and look through my work as a designer; I was familiar with handling and selecting the finest leathers, silks, and cashmeres using these senses. But Krug awakened my awareness of sensory centres I never suspected I possessed. It evoked emotions that have lived with me ever since and are forever connected with Krug. Once it has awakened your senses, it continues to sensitise you. Having shown you the way, it continues to open new pathways. 99

RAMESH NAIR, *creative director, Moynat, Paris, France*

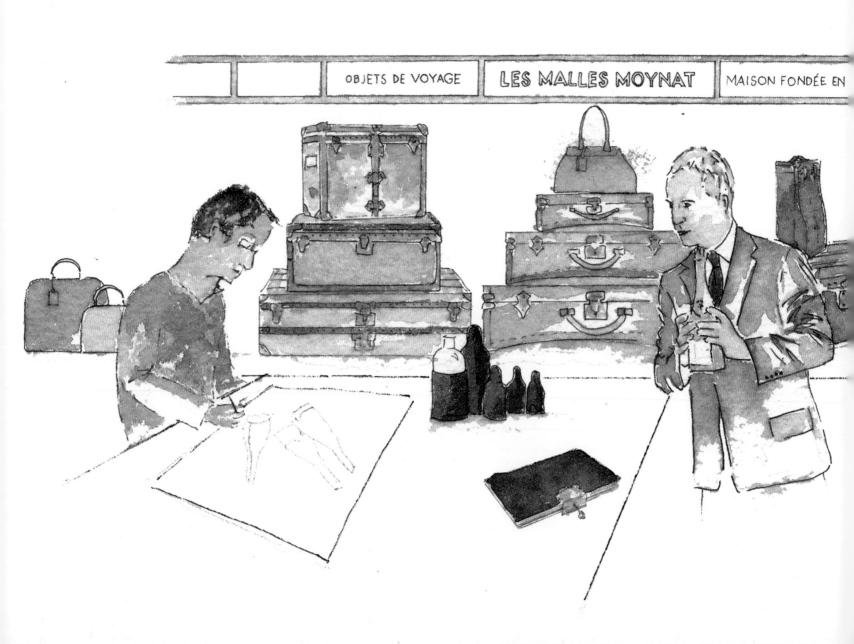

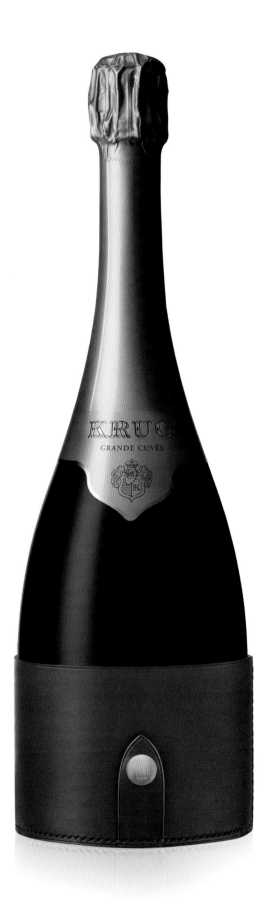

A. d'Orpleander

Eric Beaumard describes Krug 1996:

66 The nose is at first discreet, then asserts hazelnut, lemon, and quince upon aeration. It is both elegant and powerful. The texture of the wine and the bubbles give the impression at first of having a mouthful of praline cream. It is incredibly delicious, complex and light at the same time. The flavour then becomes very concentrated... but very balanced with the body of the wine. The finish, mineral and seductive, lasting more than a minute, spreads across the palate with notes of lemon, date, and dried fruits. This is a unique wine... a class apart, a pure delight. 99

ERIC BEAUMARD, *Meilleur Sommelier du Monde 1998 silver medalist, director of Le Cinq restaurant, 2 Michelin stars, Four Seasons Hôtel Georges V, Paris, France*

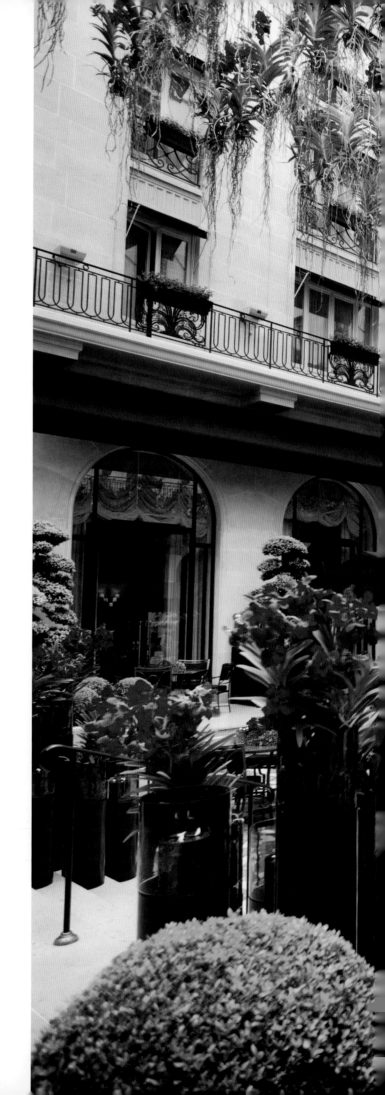

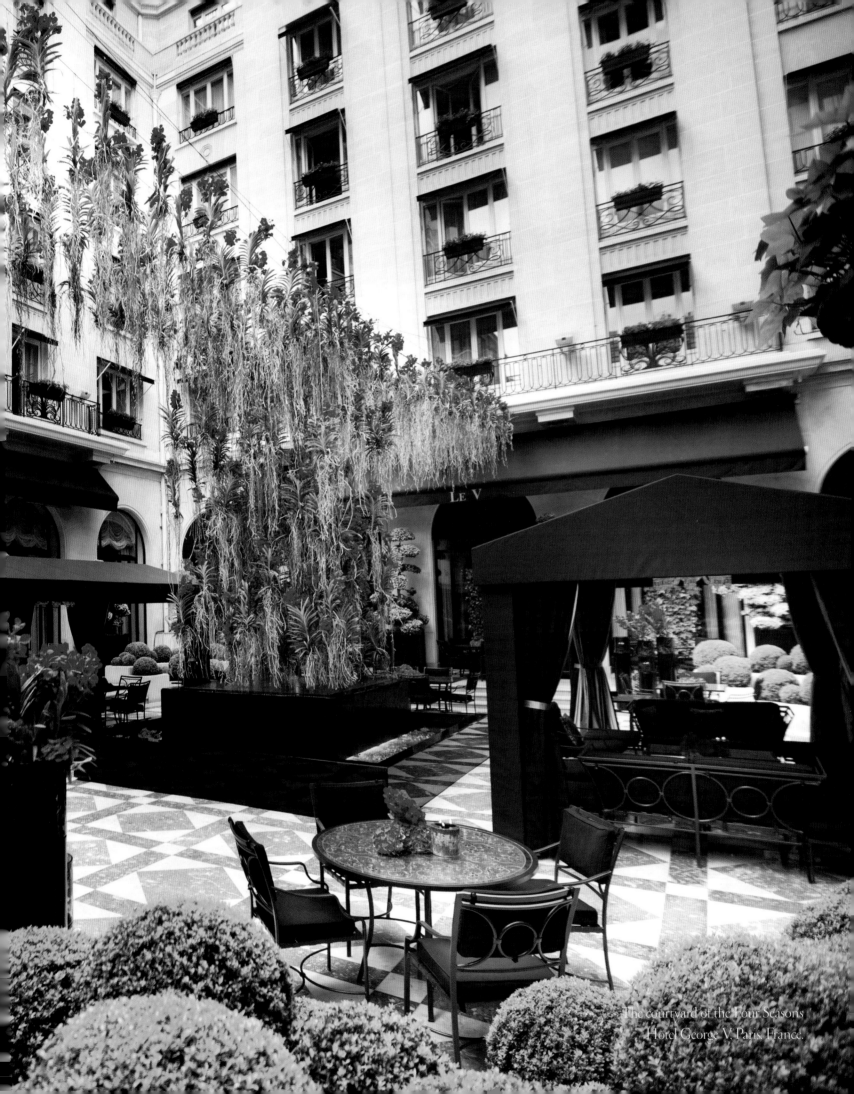

The courtyard of the Four Seasons
Hotel George V, Paris, France.

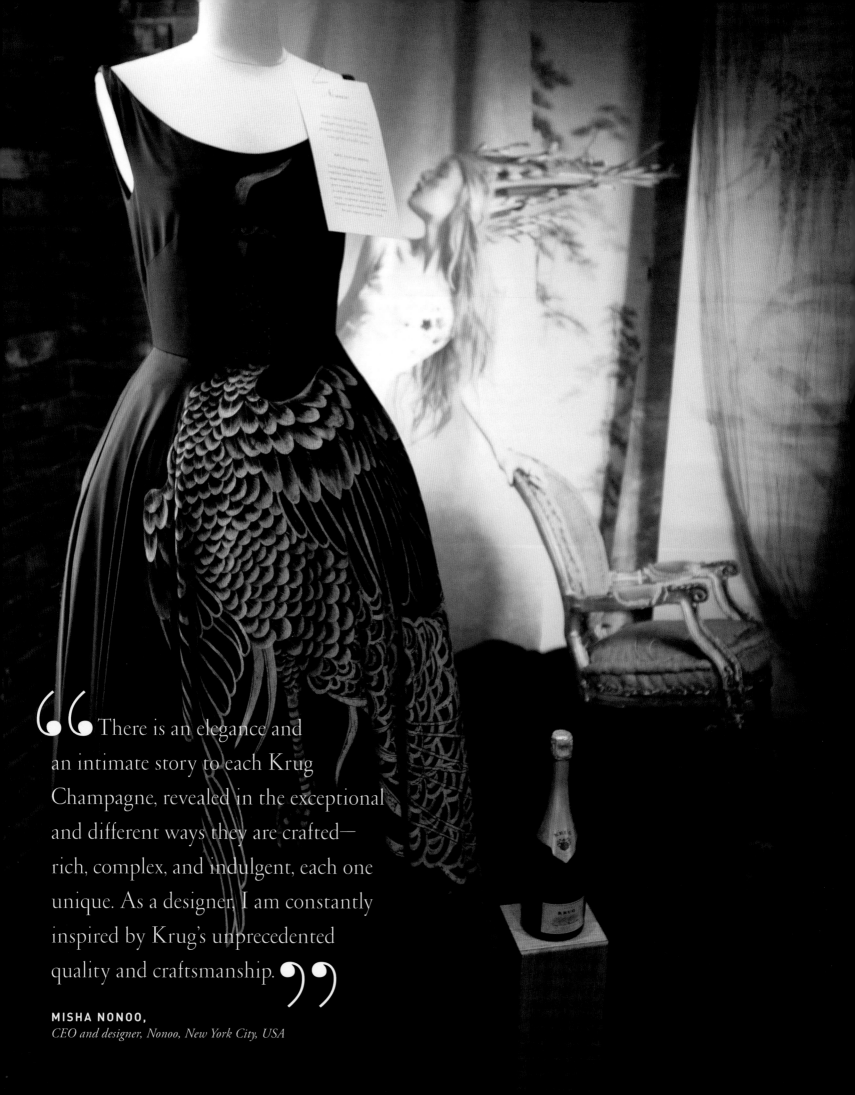

"There is an elegance and an intimate story to each Krug Champagne, revealed in the exceptional and different ways they are crafted— rich, complex, and indulgent, each one unique. As a designer, I am constantly inspired by Krug's unprecedented quality and craftsmanship."

MISHA NONOO,
CEO and designer, Nonoo, New York City, USA

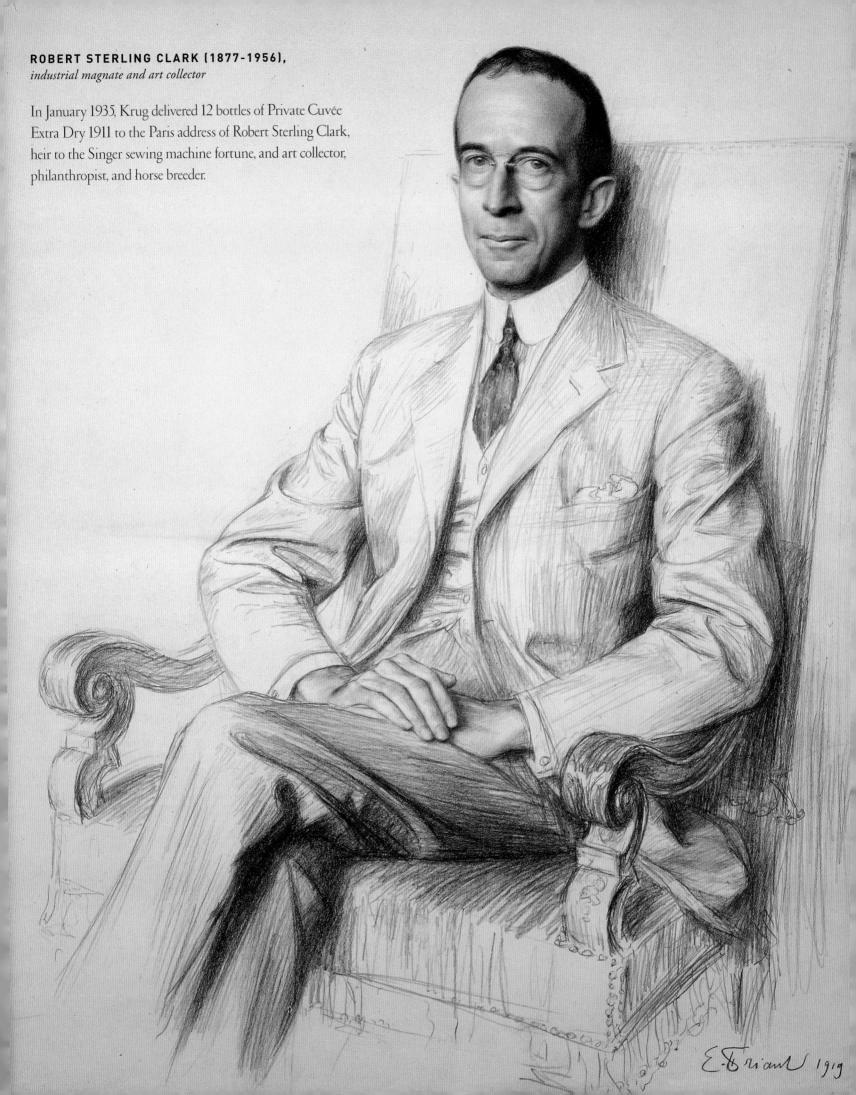

ROBERT STERLING CLARK (1877-1956),
industrial magnate and art collector

In January 1935, Krug delivered 12 bottles of Private Cuvée
Extra Dry 1911 to the Paris address of Robert Sterling Clark,
heir to the Singer sewing machine fortune, and art collector,
philanthropist, and horse breeder.

E. Friant 1919

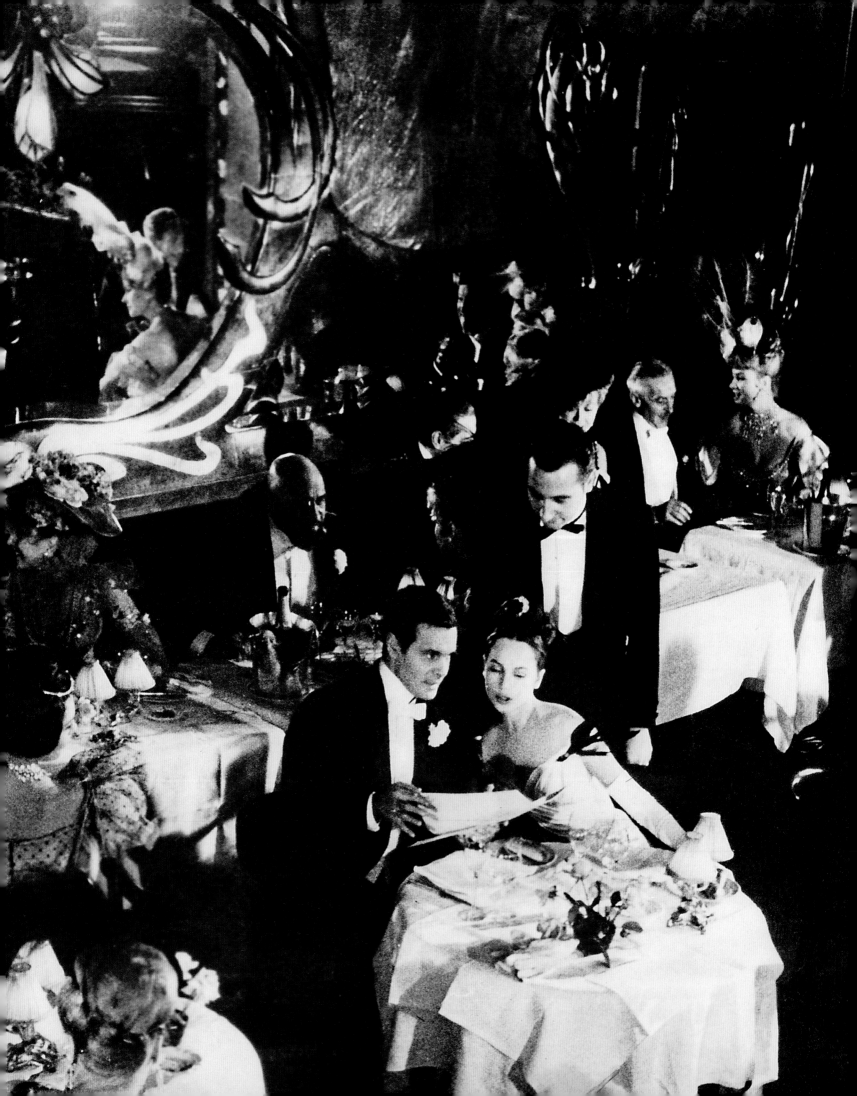

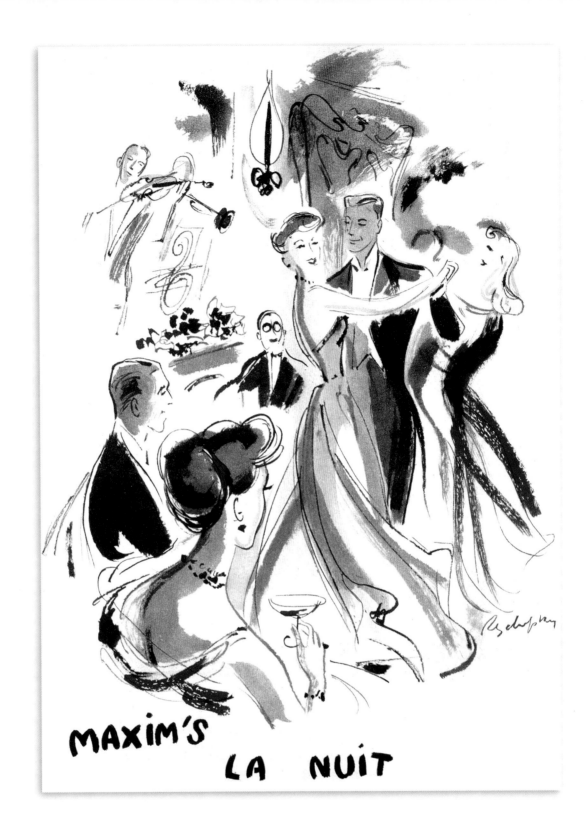

MAXIM'S LA NUIT

Illustration by Jean Reschofsky, 1949, of the legendary Parisian restaurant Maxim's, founded in 1893. The House of Krug makes several annual deliveries of Krug Private Cuvée bottles and magnums to Maxim's. In a letter addressed to the Maison in 1933, brand agent Brossault & Cie noted, "Maxim's is among the houses where the most Champagne is drunk, and here Krug Champagne is given a place of honour."

Opposite: Scene at Maxim's from *Gigi*, 1958, the film adaptation of the novel by Colette.

Janine Gobé's famous Grape Tart

Pastry shell:
200 g (7 oz) flour
100 g (3 1/2 oz) granulated sugar
100 g (3 1/2 oz) butter, diced
50 ml (1 3/4 oz) hot water
pinch of salt
butter and sugar for tart pan

Filling:
500 g (1 lb, 2 oz) Chardonnay grapes
 from Krug's Clos du Mesnil
25 g (1 oz) digestive biscuits, graham crackers,
 or vanilla wafer cookies, crushed
75 g (2 3/4 oz) vanilla sugar

Grease tart pan with butter and sprinkle with sugar, patting
it into the butter, and set pan in freezer for 30 minutes.
Preheat oven to 175°C (350°F). Wash and drain grapes
before drying them with a paper towel. In a medium-size
mixing bowl, sift flour, add sugar plus a pinch of salt and
the cubed butter. Cut butter into the flour-sugar mixture
until it resembles bread crumbs. Slowly pour in the hot
water and knead, forming dough into a ball. Roll out the
pastry to 1/2 cm (1/4 inch) thickness, line the cold tart
pan, and trim the edges. Spread a thin layer of crushed
cookies over the pastry, then spread an even layer of grapes
over the crushed biscuits, and dust the top with vanilla
sugar. Bake for about 25 minutes.

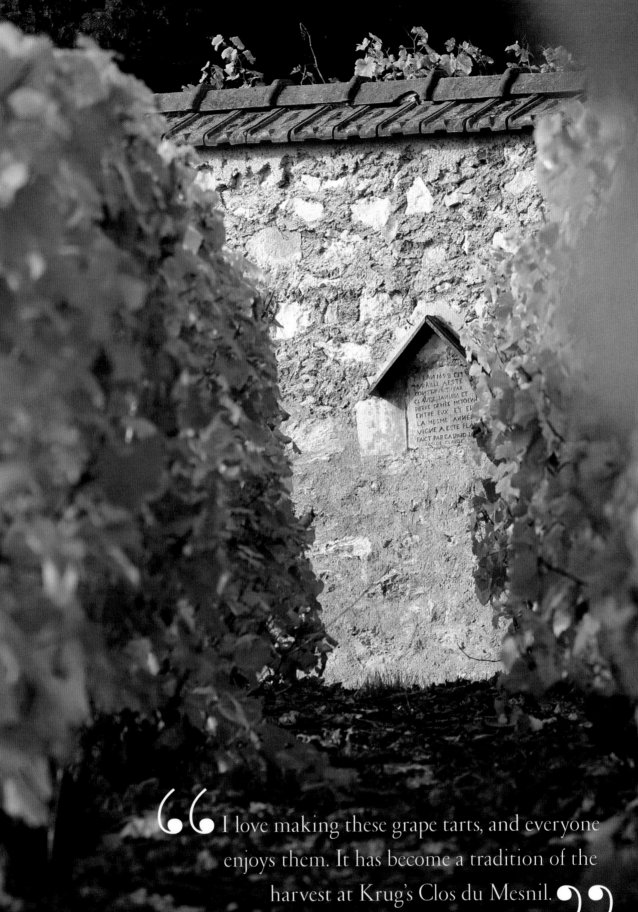

> *"I love making these grape tarts, and everyone enjoys them. It has become a tradition of the harvest at Krug's Clos du Mesnil."*

JANINE GOBÉ, *winegrower at Krug's Clos du Mesnil for 40 years*

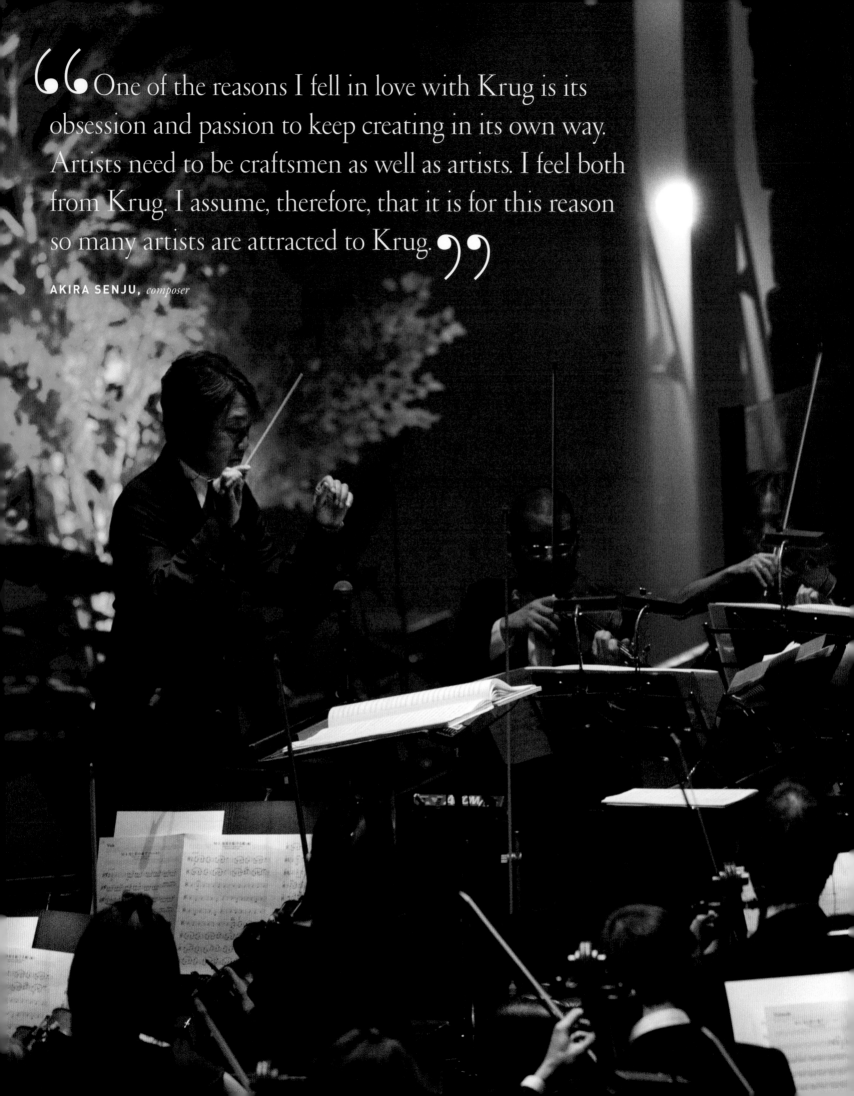

"One of the reasons I fell in love with Krug is its obsession and passion to keep creating in its own way. Artists need to be craftsmen as well as artists. I feel both from Krug. I assume, therefore, that it is for this reason so many artists are attracted to Krug."

AKIRA SENJU, *composer*

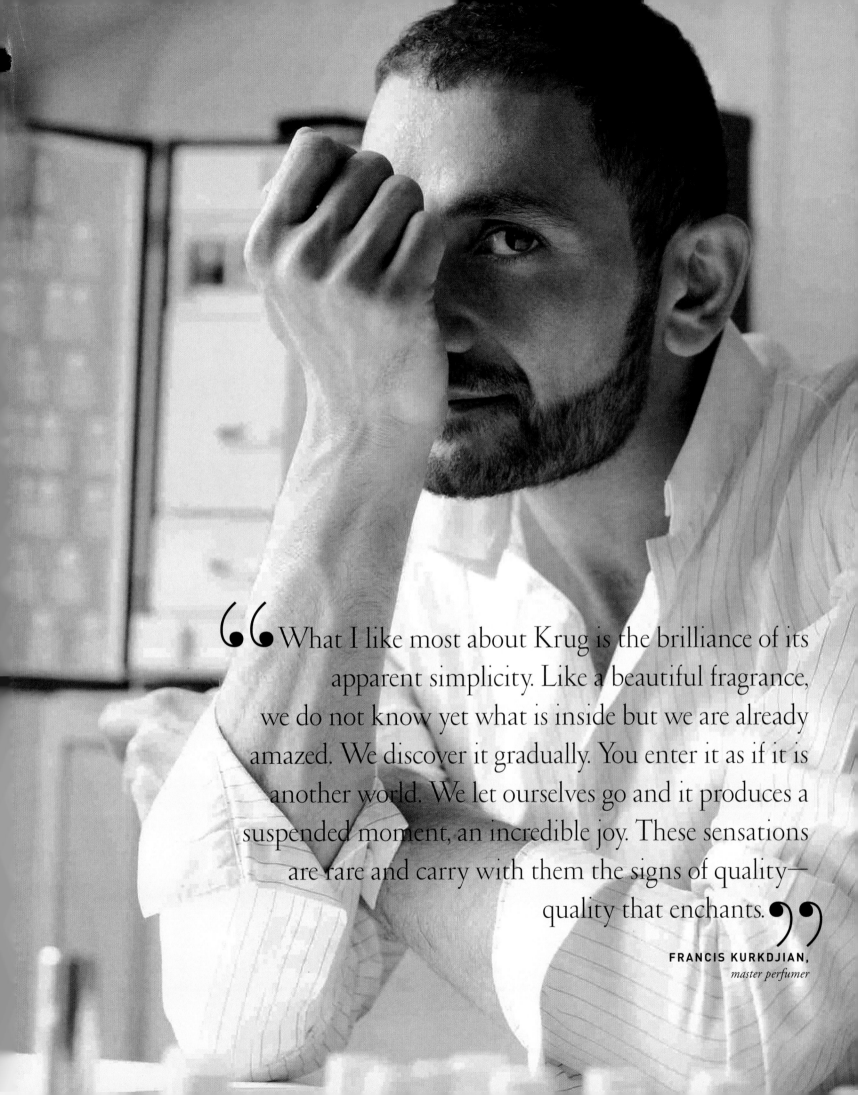

"What I like most about Krug is the brilliance of its apparent simplicity. Like a beautiful fragrance, we do not know yet what is inside but we are already amazed. We discover it gradually. You enter it as if it is another world. We let ourselves go and it produces a suspended moment, an incredible joy. These sensations are rare and carry with them the signs of quality— quality that enchants."

FRANCIS KURKDJIAN,
master perfumer

At Krug, time does not constrain, it strengthens.

66 From the selection of the grapes through to the slow maturation of our Champagnes, patience and a deep appreciation for time is a fundamental guiding force for us. Krug cannot be rushed. Time is our strength. 99

ERIC LEBEL, *House of Krug Chef de Caves*

Above: Krug Blind Experience at
East Pole, New York, September 2013

Above: Forgione dinner, New York, October 2013.
Right: East Pole, New York, September 2013.

Miami Art Walk, 2011.

Above: Celebrating the glory of Krug Champagne
with Rémi Krug.
Right: Krug party at Le Baron, Art Basel Miami, 2010.

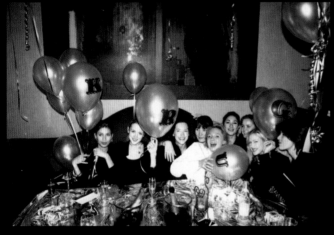

Above: Krug Sous la Pleine Lune,
St. Moritz, 1997.

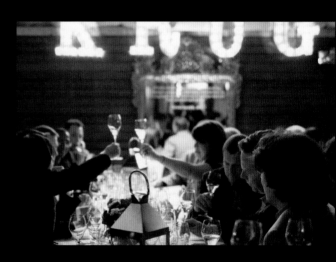

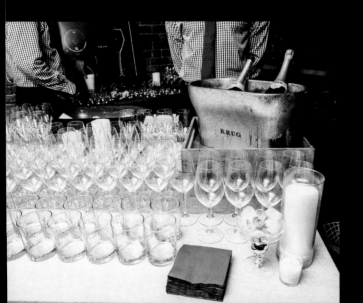

Right: Forgione dinner,
New York, October 2013.
Left: Krug House,
New York, 2013.

Door to the Maison Krug winery.
5 rue Coquebert, Reims, France.

"Krug at its best and most mature is one of the greatest Champagnes, if not the greatest. The finest Champagne I have ever had in my life was Krug '28."

MICHAEL BROADBENT, M.W.,
wine expert, critic, writer, and auctioneer at Christie's, UK,
quoted in Krug: House of Champagne, *by John Arlott, referring to Broadbent's first taste of the 1928 vintage of Krug,*
served by Monsieur Paul Krug at a dinner at his house in Reims

"And, taking well-known brands all round, I do not know that I was more faithful to any than to Krug. I began my fancy for it with a '65, which memory represents as being, though dry, that 'winey wine,' as Thackeray describes it, which Champagne ought to be, but too seldom is. And when, just fifty years after that vintage, I drank farewell to my cellar before giving up housekeeping, it was in a bottle of Krug Private Cuvée 1906."

Notes on a Cellar Book (1920)

GEORGE SAINTSBURY (1845-1933),
writer, literary historian, scholar, critic, and wine collector

"One of my keenest competitors... and the memory of whose friendship I cherish, came up to me in Mark Lane soon after we had offered the Krug 1928 on the market, and said, 'Ian, I have gone about saying your Krug 1926 is the best Champagne ever made and, damn it all, your 1928 is better.'"

Wayward Tendrils of the Vine (1947)

IAN MAXWELL CAMPBELL (1870-1954), *wine shipper and UK agent for Krug, and author of Reminiscences of a Vintner (1950)*

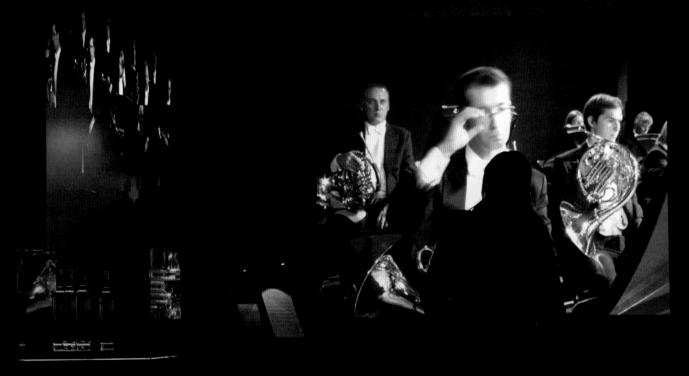

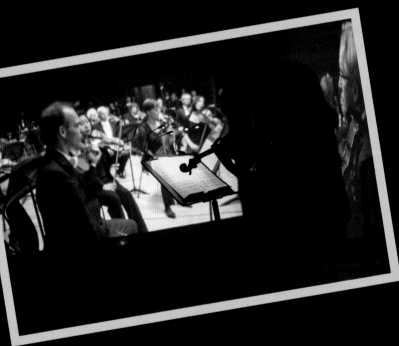

RE-RITE by Krug and the Philharmonia Orchestra, a digital installation featuring Stravinsky's *The Rite of Spring,* in London, April 2014: An ephemeral experience and exhibition to discover the parallel between conducting a symphony and creating Krug Grande Cuvée.

66 Making great live music, like making the perfect Champagne, is a kind of alchemy. As a conductor I have to bring together the right music and the right musicians, but it's also about being in the right place at the right time, and the exciting thing is that every single performance is different; like a master wine-maker, we're always striving for the perfect blend. We're absolutely delighted to be working with Krug to bring this unique marriage of our world and theirs to London in truly immersive form. 99

ESA-PEKKA SALONEN, *principal conductor and artistic advisor, Philharmonia Orchestra*

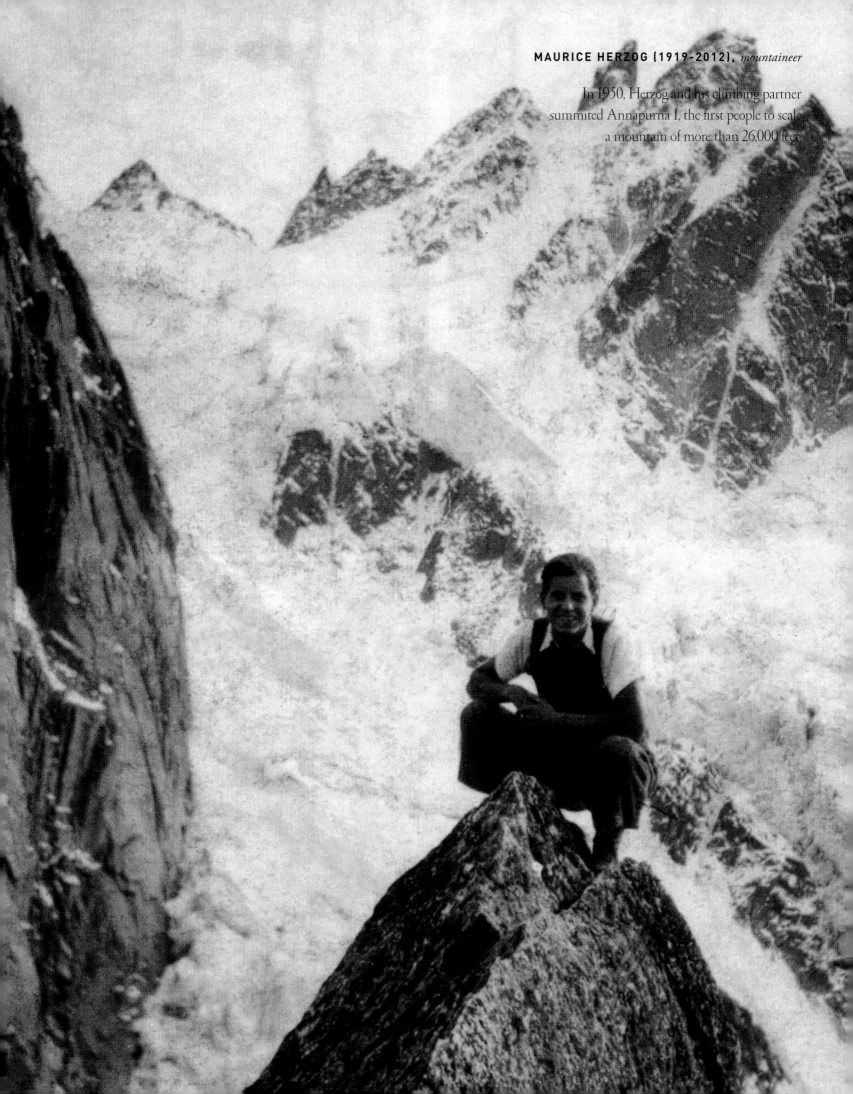

MAURICE HERZOG (1919-2012), *mountaineer*

In 1950, Herzog and his climbing partner
summited Annapurna I, the first people to scale
a mountain of more than 26,000 feet

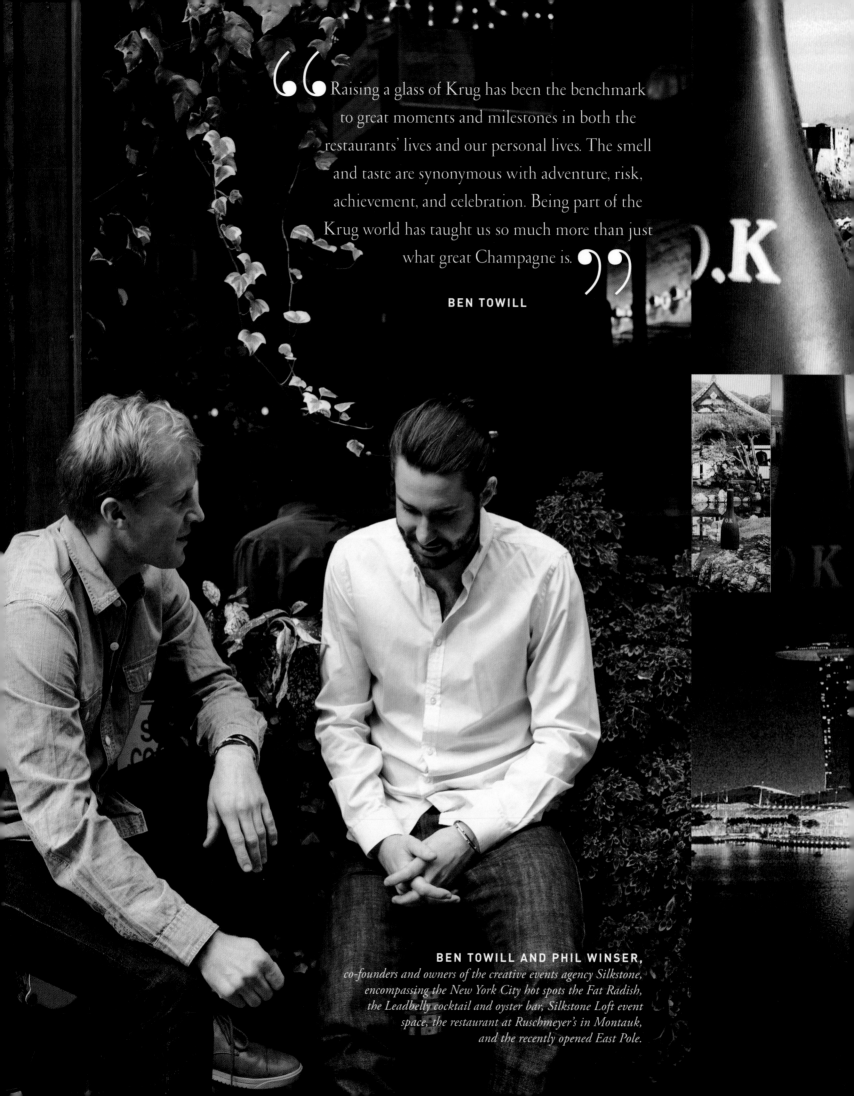

> " Raising a glass of Krug has been the benchmark to great moments and milestones in both the restaurants' lives and our personal lives. The smell and taste are synonymous with adventure, risk, achievement, and celebration. Being part of the Krug world has taught us so much more than just what great Champagne is. "

BEN TOWILL

BEN TOWILL AND PHIL WINSER,
*co-founders and owners of the creative events agency Silkstone,
encompassing the New York City hot spots the Fat Radish,
the Leadbelly cocktail and oyster bar, Silkstone Loft event
space, the restaurant at Ruschmeyer's in Montauk,
and the recently opened East Pole.*

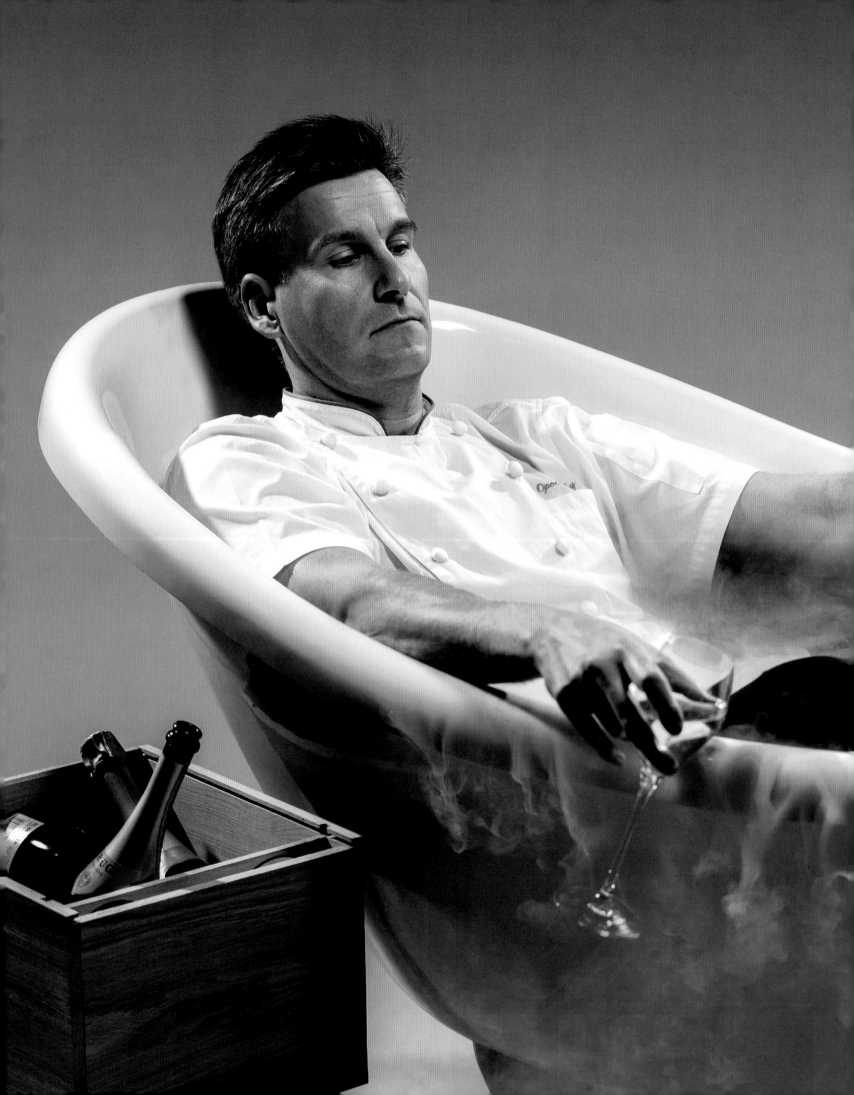

“ Krug Champagnes give me freedom, they give me space. I can really express my cooking, my philosophy. They have no boundaries, they have no restrictions, they are just all about giving. ”

UWE OPOCENSKY, *executive chef, The Krug Room and Mandarin Grill + Bar, 1 Michelin star, Mandarin Oriental, Hong Kong*

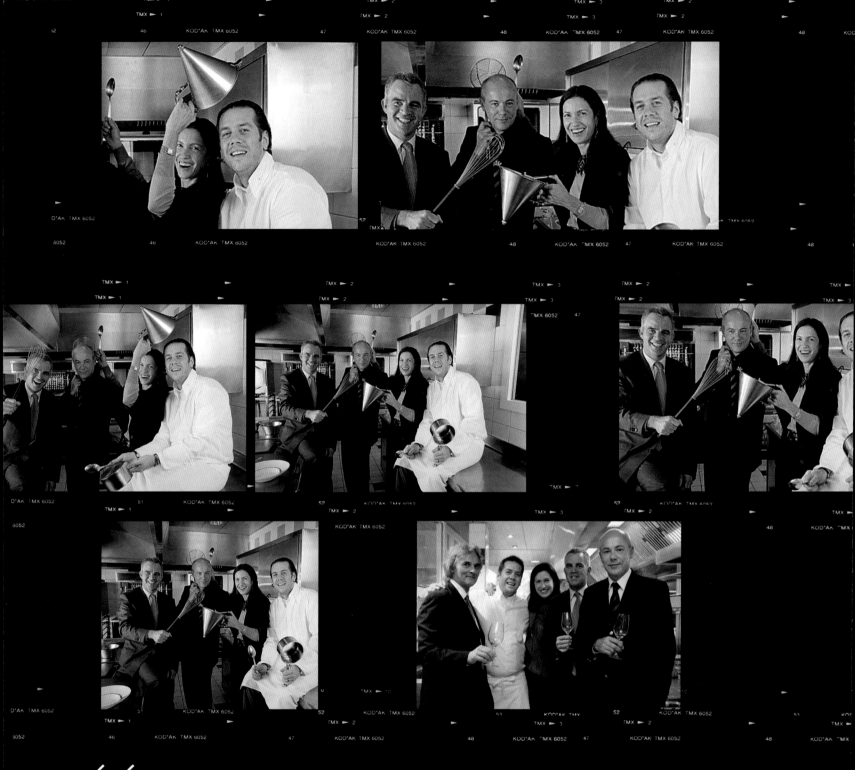

66 Krug, Champagne, gastronomy...
for me it is all about pleasure. And it is not a selfish pleasure, it is
something to be shared. I would most like to share a glass of Krug
with my father, because I lost him too early, and I would want to
share this love for Krug with him. **99**

ARNAUD LALLEMENT,
owner, chef, and manager, l'Assiette Champenoise hotel and restaurant, 3 Michelin stars, Tinqueux, France, near Reims

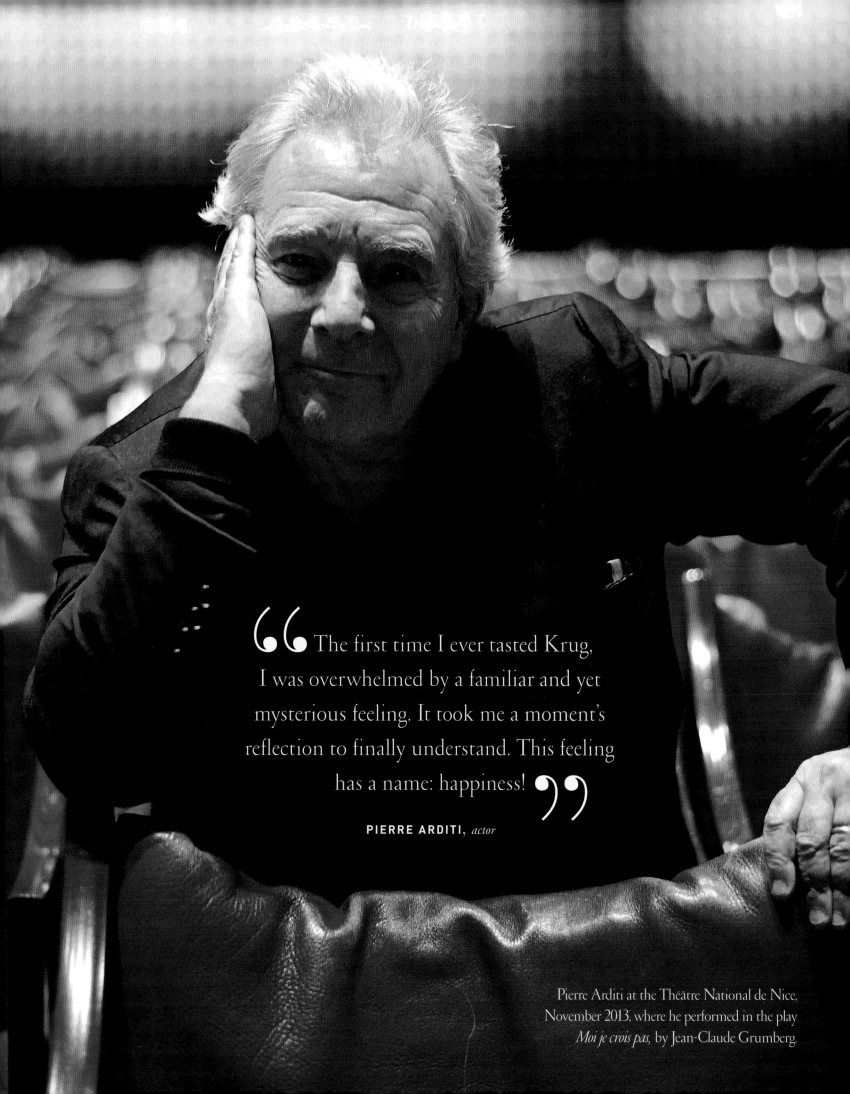

66 The first time I ever tasted Krug,
I was overwhelmed by a familiar and yet
mysterious feeling. It took me a moment's
reflection to finally understand. This feeling
has a name: happiness! 99

PIERRE ARDITI, *actor*

Pierre Arditi at the Théâtre National de Nice,
November 2013, where he performed in the play
Moi je crois pas, by Jean-Claude Grumberg.

66 John le Carré wrote a bottle of Krug into one of his books. Rémi Krug sent him a magnum to say 'thanks,' and le Carré wrote back, saying he had been introduced to Krug by Alec Guinness. So the chain evolves. 99

Jon Ashworth, *The Times of London*, September 30, 1995

SIR ALEC GUINNESS (1914-2000), *actor*

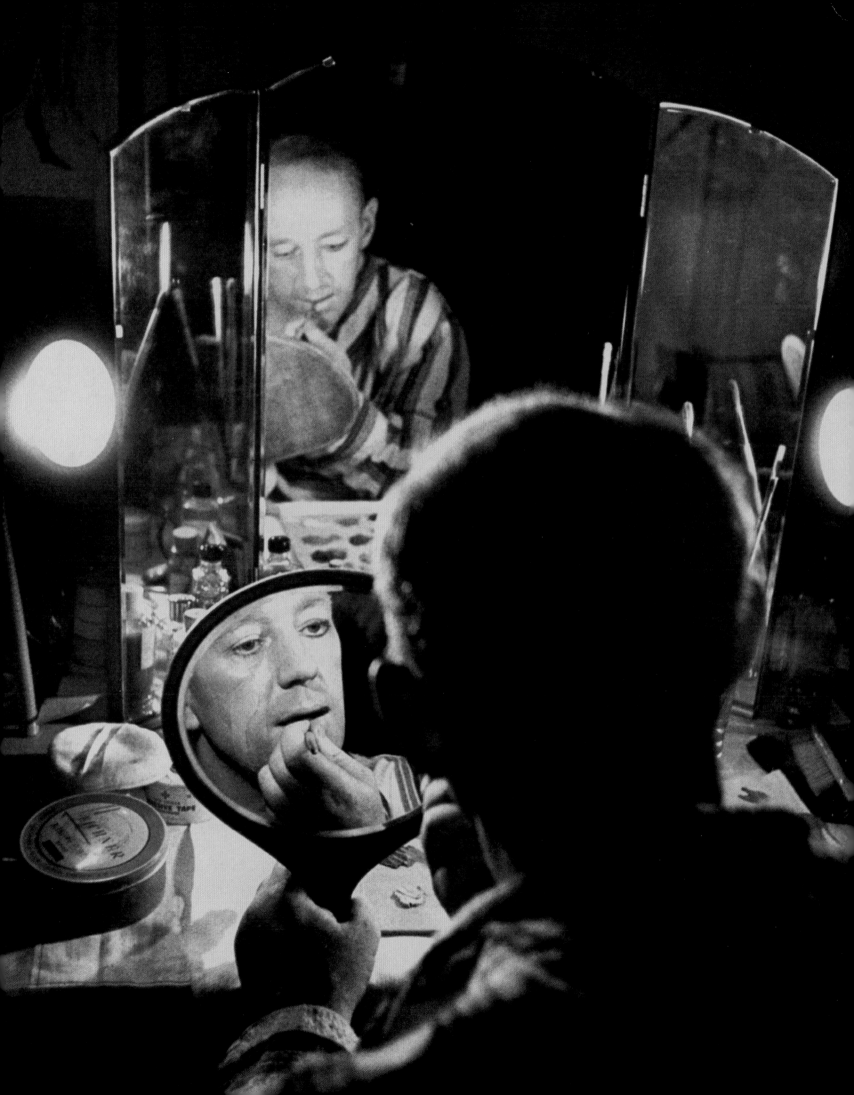

Invitation for a soirée given by
Caca's Club at Castel, Paris.

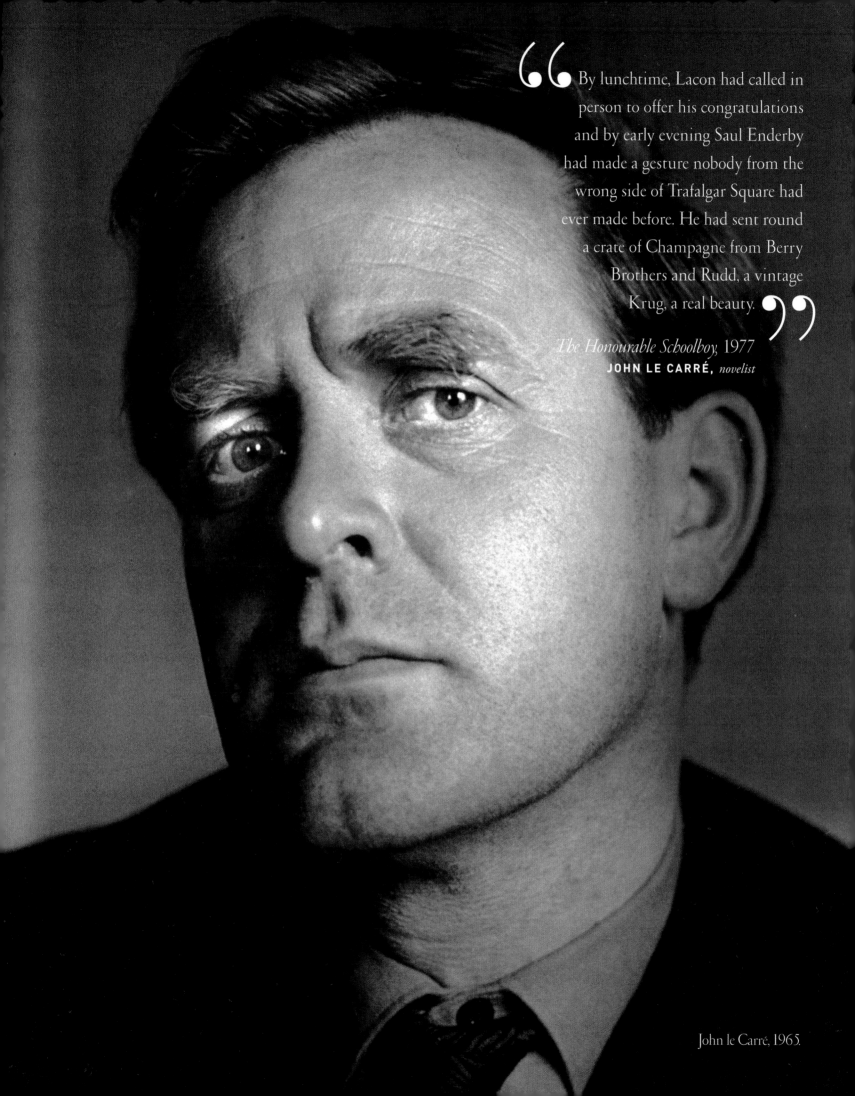

"By lunchtime, Lacon had called in person to offer his congratulations and by early evening Saul Enderby had made a gesture nobody from the wrong side of Trafalgar Square had ever made before. He had sent round a crate of Champagne from Berry Brothers and Rudd, a vintage Krug, a real beauty."

The Honourable Schoolboy, 1977
JOHN LE CARRÉ, *novelist*

John le Carré, 1965.

" Krug's pleasure is a sale without risk. **"**

GÉRARD SIBOURD-BAUDRY, *president of Caves Legrand, Paris, France*

Krug Champagne is served at the Rock Bar at the Ayana Resort and Spa, Bali.

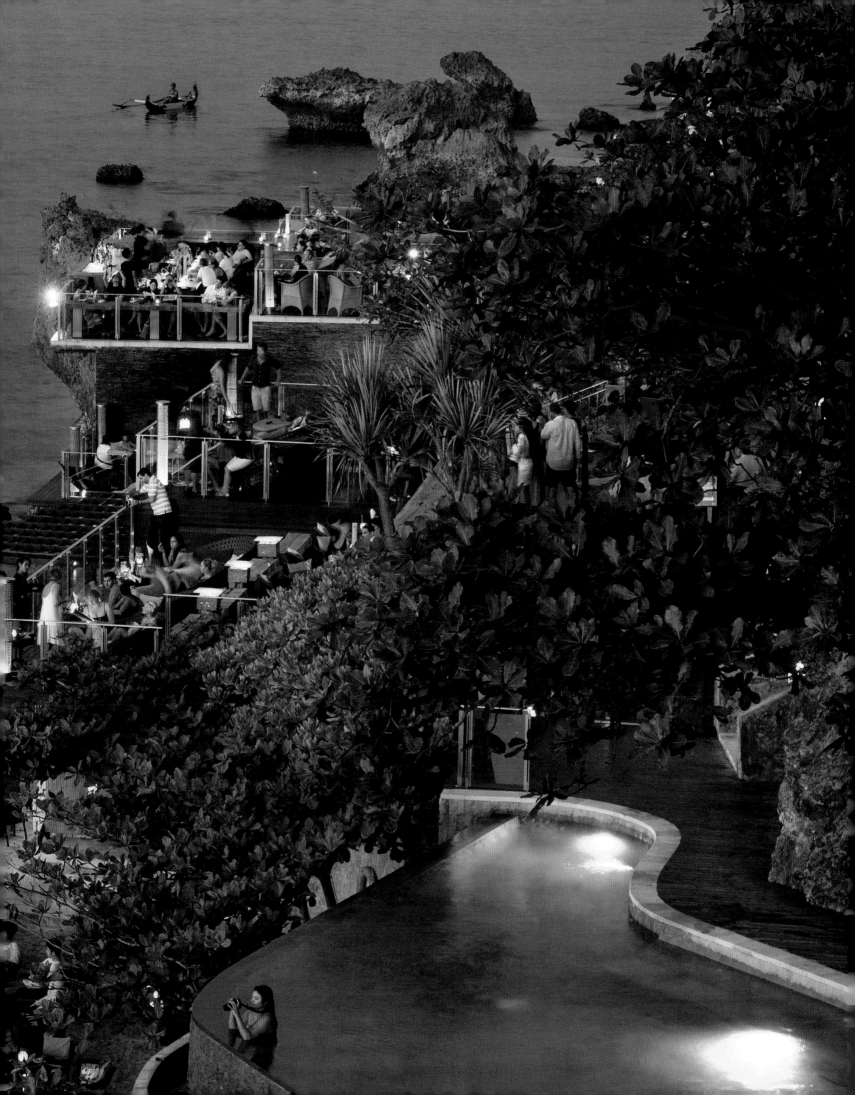

66 This is a wonderful rosé with magnificent body and complexity, approaching a Clos du Mesnil in its structure and extraordinary finesse. By far the standout in this tasting, we award it 6 stars. 99

—*La Revue du Vin de France,* December 2003

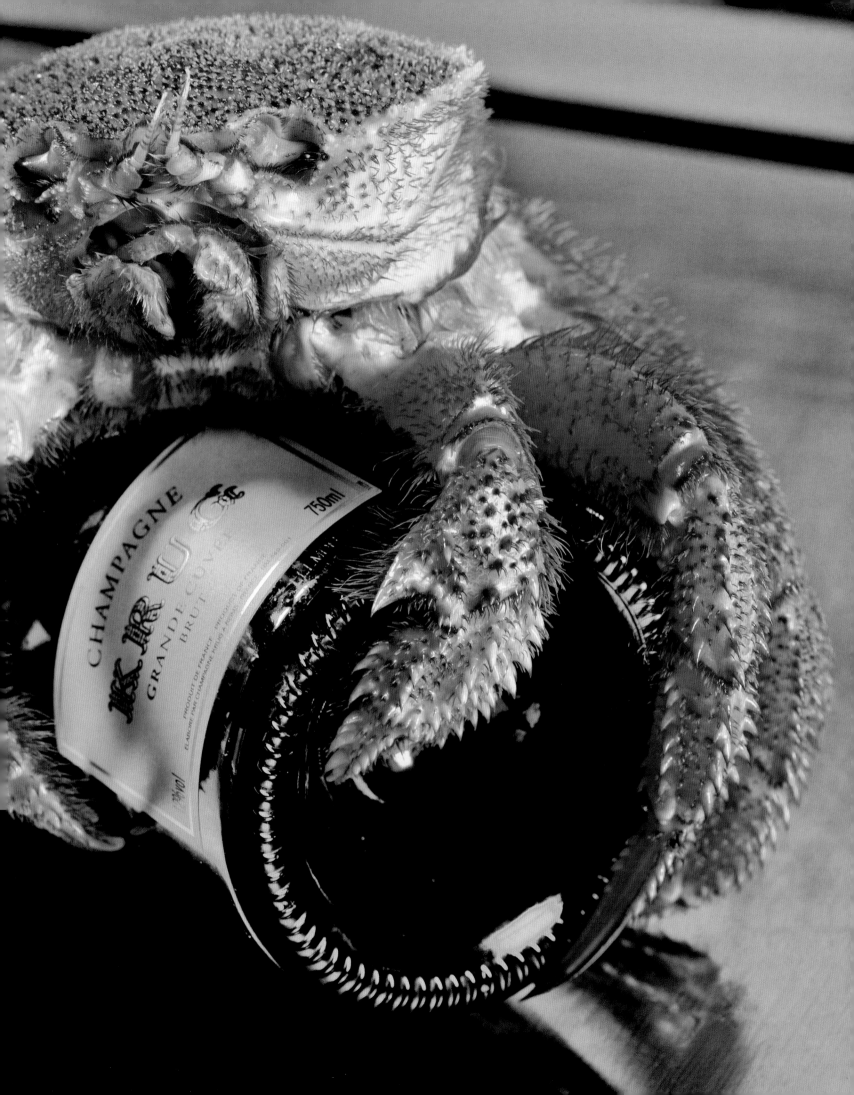

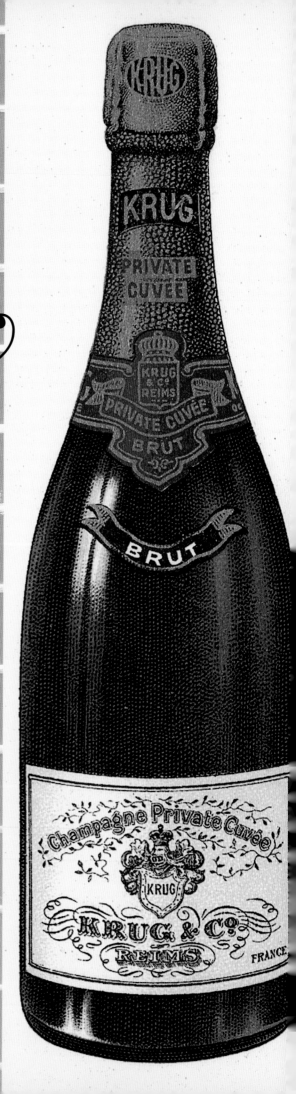

> "I bought my first bottles of Krug—one bottle of vintage 1979 and a 1985—in the backyard of an old house in Berlin in the early 1990s. It was a hand-to-hand cash deal. The price for the two bottles was more than the monthly rent for my apartment. After the first sip I fell in love. Since that day, Krug is part of our life, like the Krug Table in our restaurant, and we are glad to celebrate the special moments in our lives with Krug!"

TIM RAUE, *chef and owner, Restaurant Tim Raue, 2 Michelin stars, Berlin, Germany*

restaurant

TIM RAUE

eingang | entrance

→

AMBASSADE OFFICIELLE

DE LA MAISON

KRUG

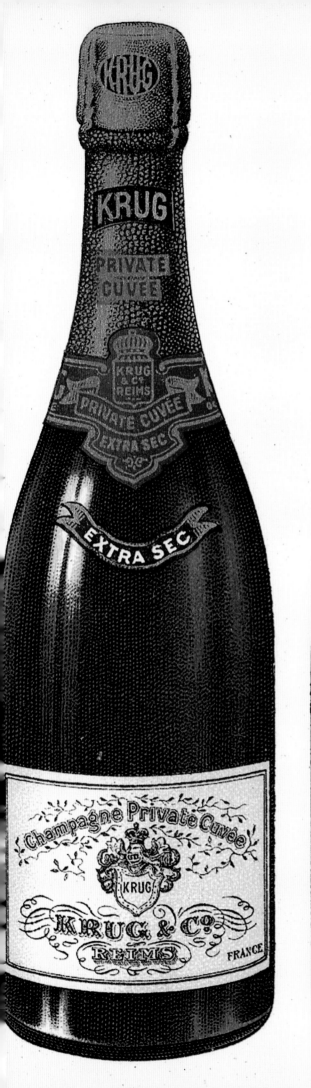
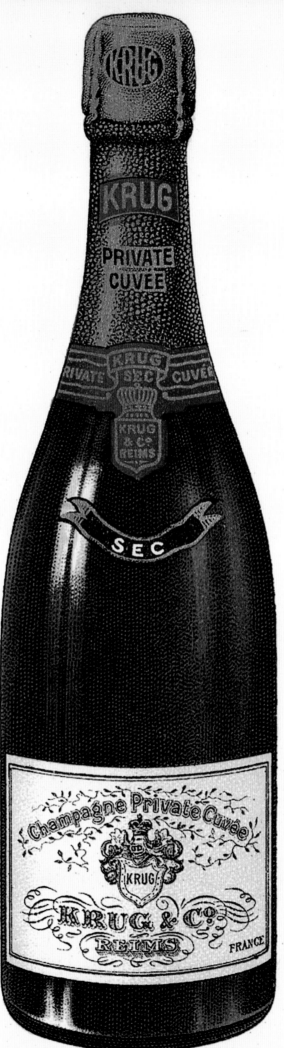
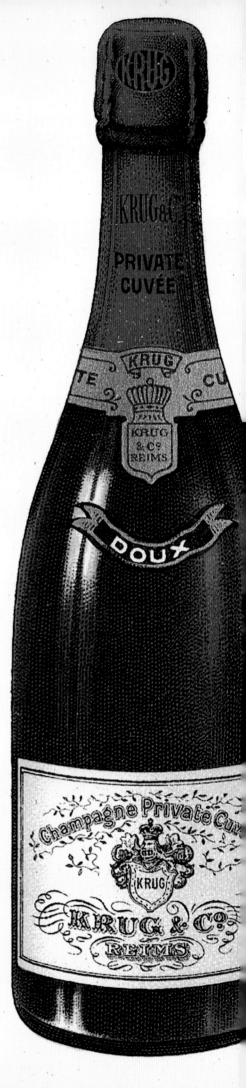

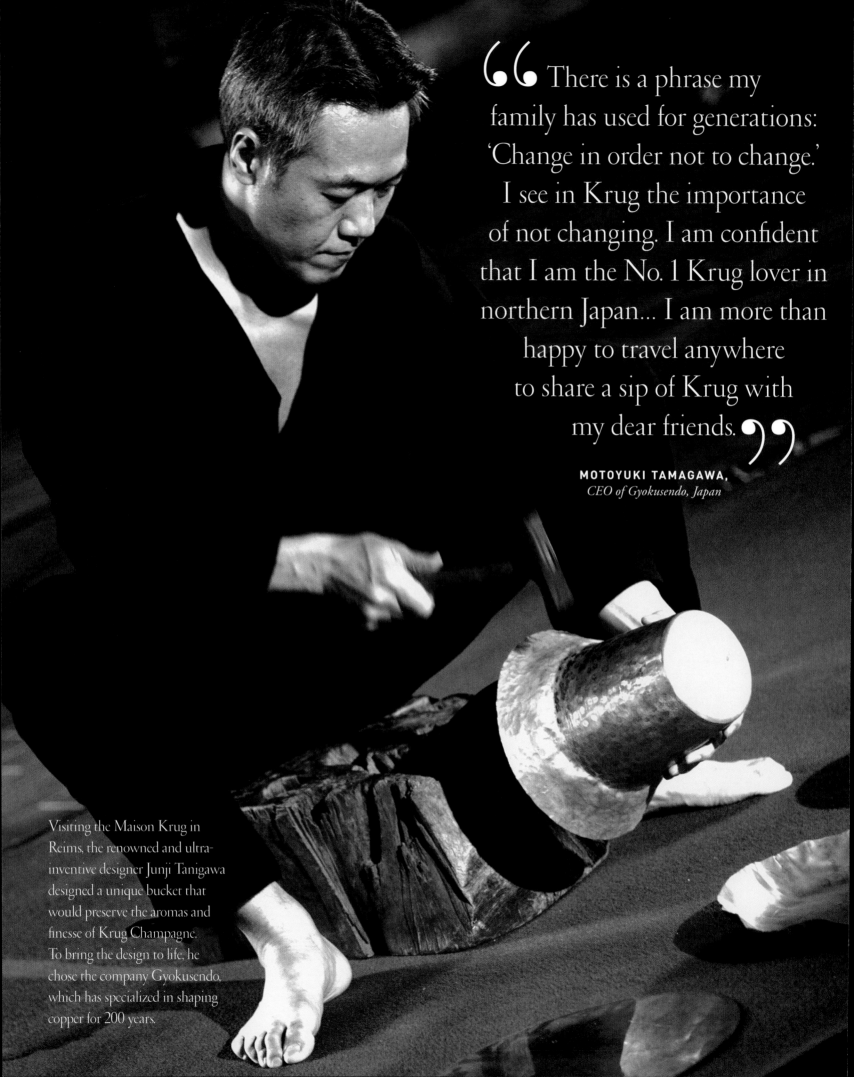

> "There is a phrase my family has used for generations: 'Change in order not to change.' I see in Krug the importance of not changing. I am confident that I am the No. 1 Krug lover in northern Japan... I am more than happy to travel anywhere to share a sip of Krug with my dear friends."

MOTOYUKI TAMAGAWA,
CEO of Gyokusendo, Japan

Visiting the Maison Krug in Reims, the renowned and ultra-inventive designer Junji Tanigawa designed a unique bucket that would preserve the aromas and finesse of Krug Champagne. To bring the design to life, he chose the company Gyokusendo, which has specialized in shaping copper for 200 years.

> "*Extraordinary aesthetic values, refined over generations, cannot be conveyed by text or charts but through memories inherited over a very long period of time.*"

JUNJI TANIGAWA, *designer*

KrugScape

Collection

Clos du Mesnil

Vintage

Grande Cuvée

> **"** I love all the musical allegories Krug uses to describe its Champagne. From the soloist virtuoso, which perfectly encapsulates Krug Clos du Mesnil, to a philharmonic orchestra for Krug Grande Cuvée, the richness of flavours and the fine bubbles all become the essential notes which punctuate Krug's symphony. **"**

SÉBASTIEN LÉON, *musician, artist, designer of Krug en Capitale III*

Between Now and Then, by Sébastien Léon, a multi-channel sound installation made up of nearly 1,000 aluminum pipes.

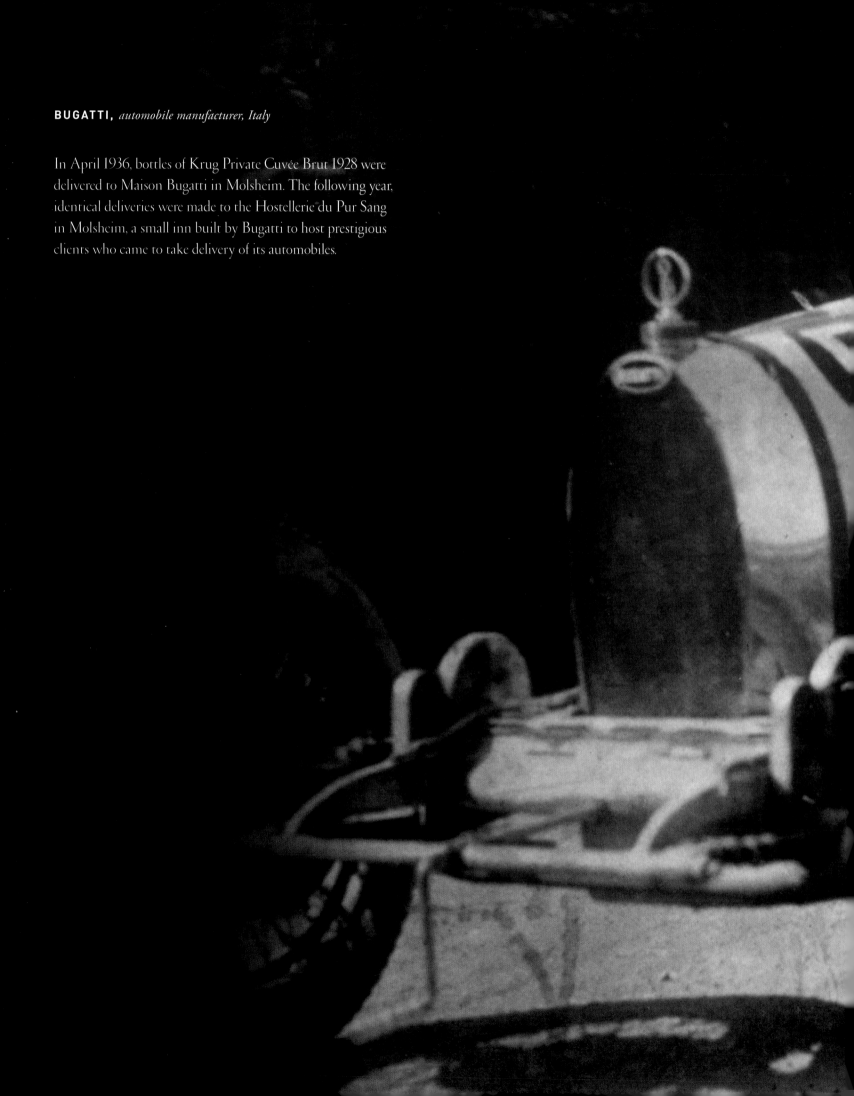

BUGATTI, *automobile manufacturer, Italy*

In April 1936, bottles of Krug Private Cuvée Brut 1928 were delivered to Maison Bugatti in Molsheim. The following year, identical deliveries were made to the Hostellerie du Pur Sang in Molsheim, a small inn built by Bugatti to host prestigious clients who came to take delivery of its automobiles.

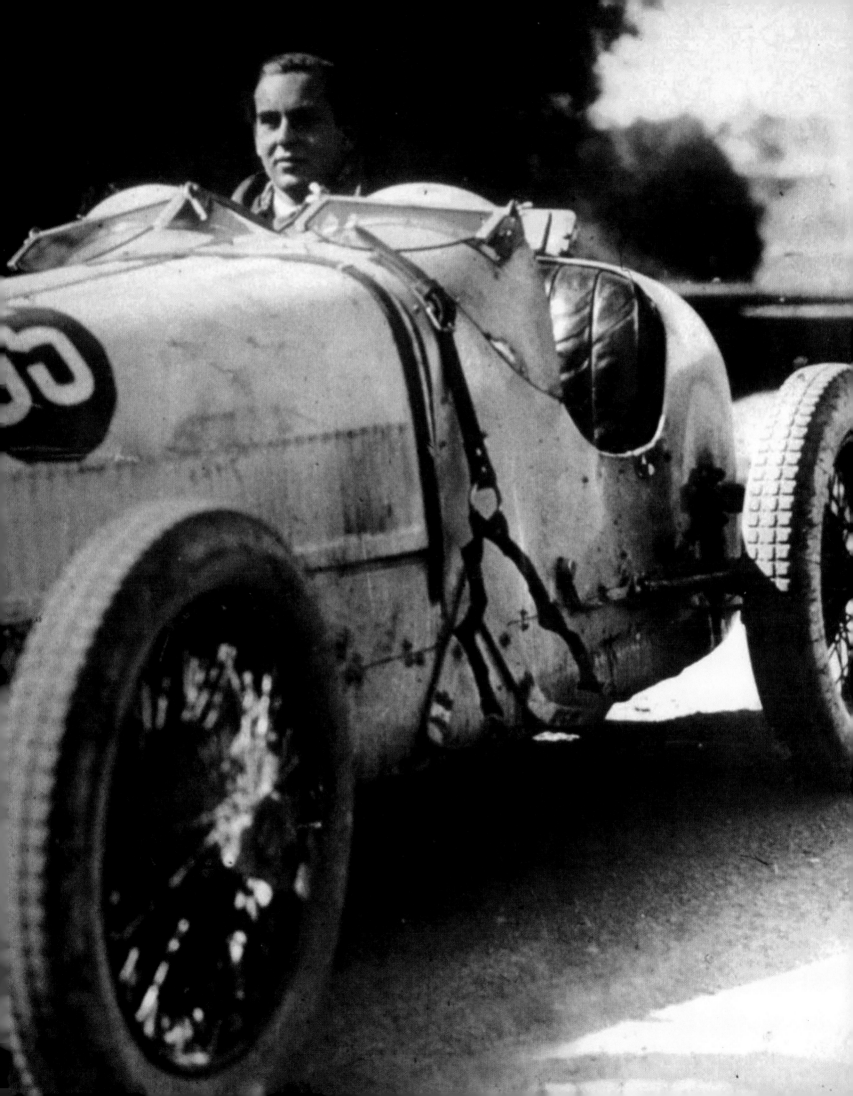

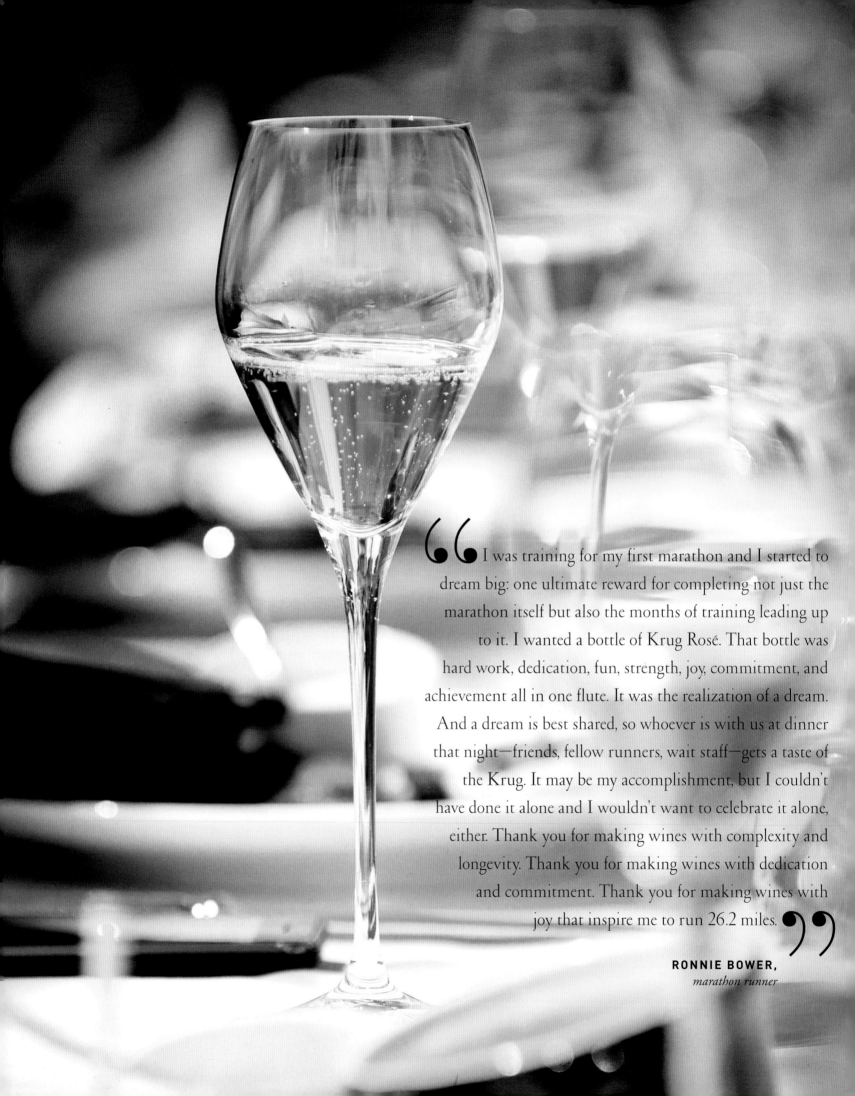

" I was training for my first marathon and I started to dream big: one ultimate reward for completing not just the marathon itself but also the months of training leading up to it. I wanted a bottle of Krug Rosé. That bottle was hard work, dedication, fun, strength, joy, commitment, and achievement all in one flute. It was the realization of a dream. And a dream is best shared, so whoever is with us at dinner that night—friends, fellow runners, wait staff—gets a taste of the Krug. It may be my accomplishment, but I couldn't have done it alone and I wouldn't want to celebrate it alone, either. Thank you for making wines with complexity and longevity. Thank you for making wines with dedication and commitment. Thank you for making wines with joy that inspire me to run 26.2 miles. "

RONNIE BOWER,
marathon runner

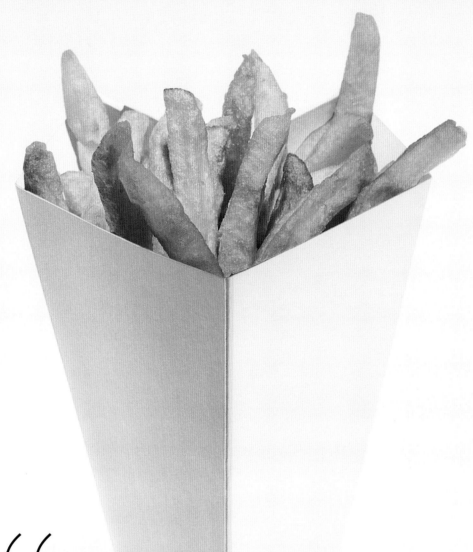

❝ Besides the friend who told me that his
first Krug 'blew his socks off,' another
extraordinary and yet utterly spontaneous
testimonial came from Madonna when she
said on Twitter that her guilty pleasure was
'french fries and Krug Rosé Champagne.' ❞

OLIVIER KRUG, *Director of the House of Krug,*
sixth generation of the Krug family

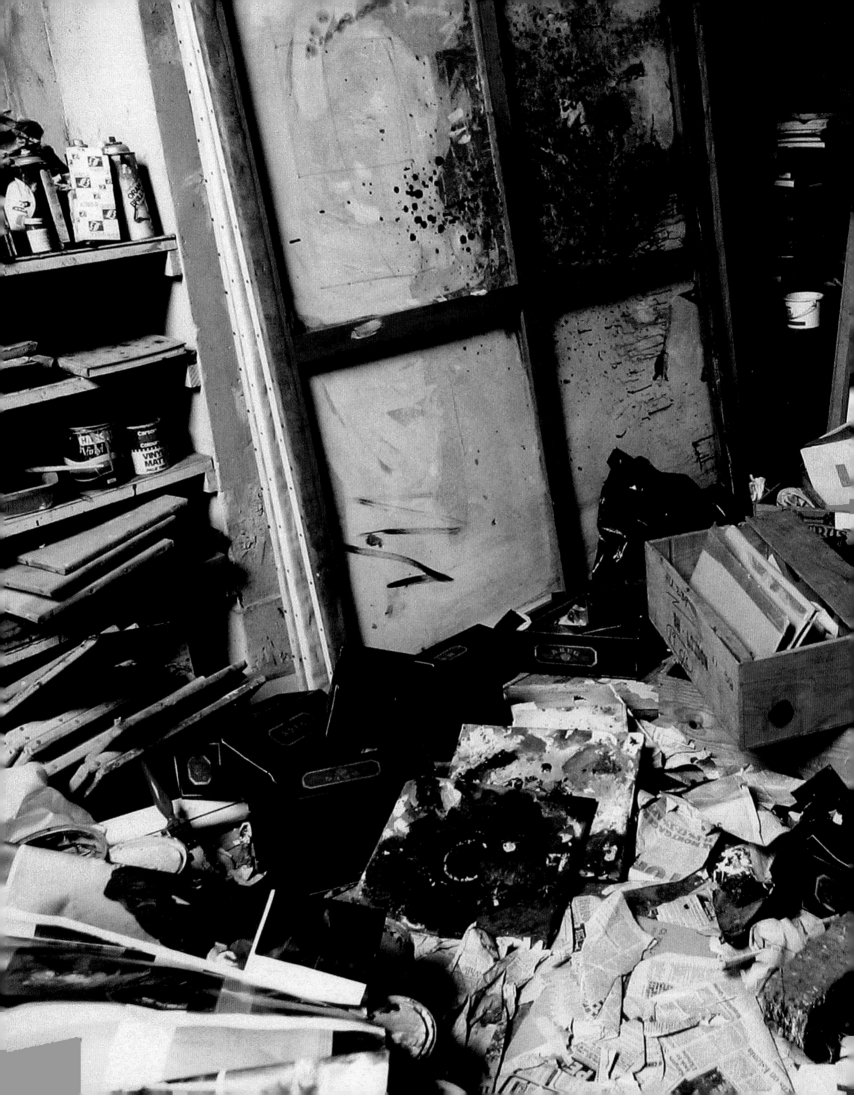

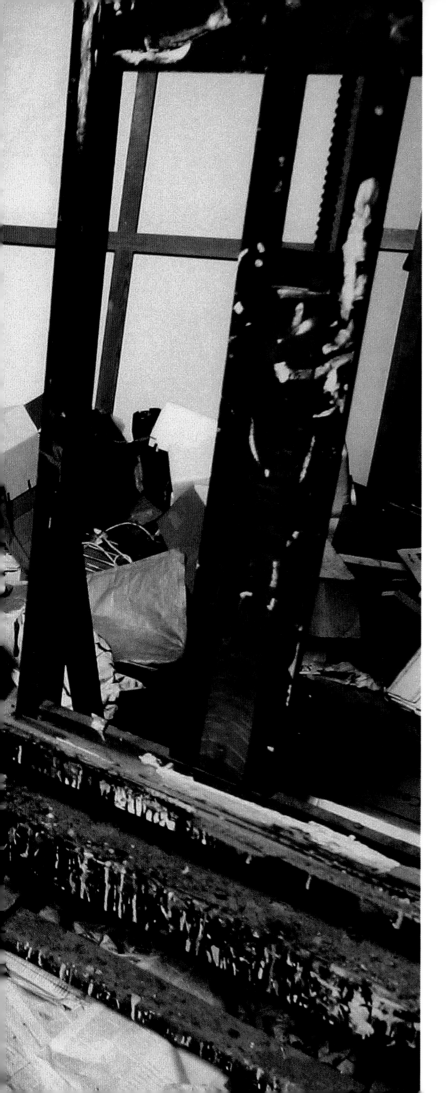

FRANCIS BACON, *artist*

In the autumn of 1961 Francis Bacon moved to 7 Reece Mews, a converted coach house in South Kensington, London, which served as his principal studio and residence until his death in 1992. Bacon eventually accumulated more than 7,500 items in this space, including books, magazines, newspapers, photographs, drawings, handwritten notes, destroyed canvases, artists' materials, clothes, shoes and empty wine and Champagne boxes. Of this cluttered mess Bacon said: "I feel at home here in this chaos because chaos suggests images." The studio became Bacon's complete visual world. Its heaps of torn photographs, fragments of illustrations and artist's catalogues provided nearly all of his visual sources. This small room was to become the locus for the production of some of the most powerful and uncompromising paintings of the twentieth century. After Bacon's death, the studio remained largely untouched until 1998 when his sole heir, John Edwards, presented it to Dublin City Gallery The Hugh Lane. Thus began the mammoth task of removing this prodigious mess from its original home and transporting it to Dublin where it was faithfully reconstructed and opened to the public. Visitors can be an intimate witness to the piles of discarded canvases, paintbrushes, the doors and walls used as a palette and empty boxes of Krug Champagne, which the artist had delivered to Reece Mews, nonchalantly thrown behind the artist's easel, their printed tissue wrapping often spattered in vivid splashes of paint, alluding to the artist's love of the finer things in life.
—*Dr. Margarita Cappock, Head of Collections and Deputy Director, Dublin City Gallery The Hugh Lane*

Installation detail of the reconstitution of Francis Bacon's studio at the Dublin City Gallery The Hugh Lane.

" Soon after I met Francis Bacon in 1976 he invited me to Reece Mews. "People think I live grandly, you know, but in fact I live in a dump." By the time I'd climbed up the steep, wooden stairs, guided by the rope banister, I could see he was right. "You ain't 'alf lamping it a bit, Francis," I thought to myself. I was shocked. He opened a bottle of Champagne, probably vintage Krug, and I stayed the night. "

JOHN EDWARDS

Francis Bacon and John Edwards, 1979.

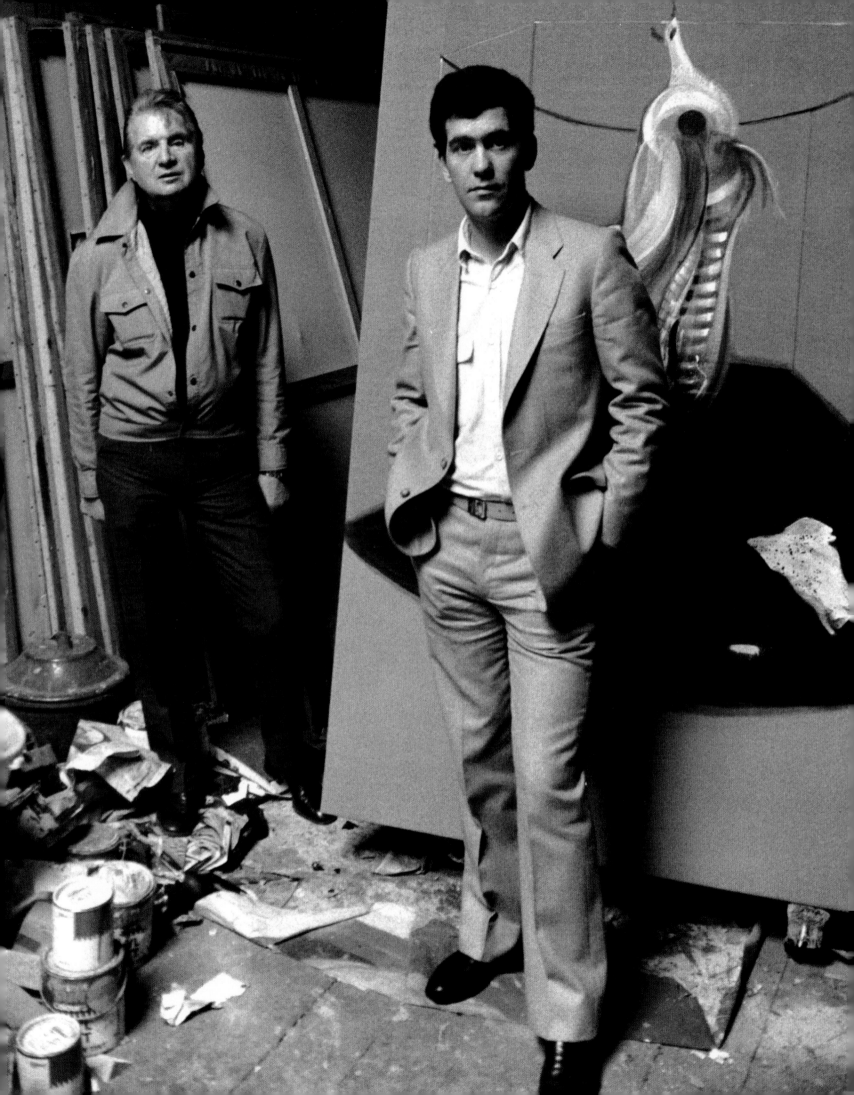

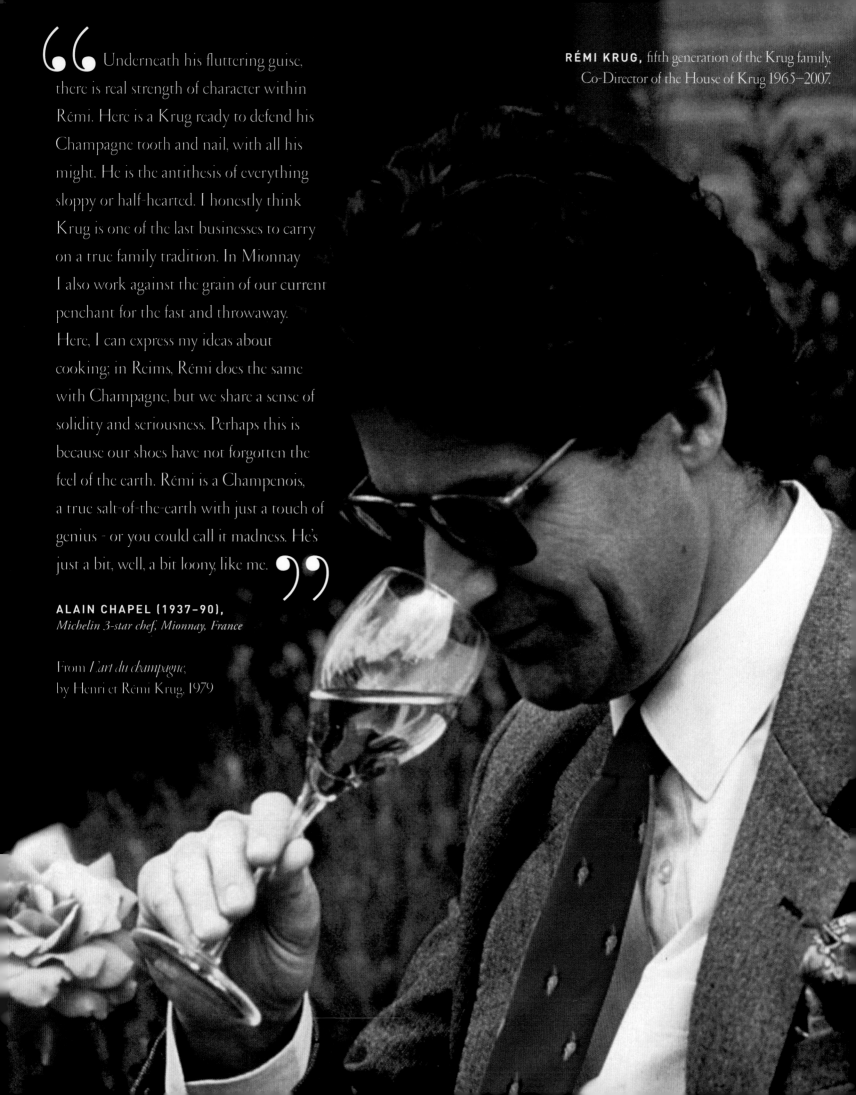

"Underneath his fluttering guise, there is real strength of character within Rémi. Here is a Krug ready to defend his Champagne tooth and nail, with all his might. He is the antithesis of everything sloppy or half-hearted. I honestly think Krug is one of the last businesses to carry on a true family tradition. In Mionnay I also work against the grain of our current penchant for the fast and throwaway. Here, I can express my ideas about cooking; in Reims, Rémi does the same with Champagne, but we share a sense of solidity and seriousness. Perhaps this is because our shoes have not forgotten the feel of the earth. Rémi is a Champenois, a true salt-of-the-earth with just a touch of genius - or you could call it madness. He's just a bit, well, a bit loony, like me."

ALAIN CHAPEL (1937–90),
Michelin 3-star chef, Mionnay, France

From *L'art du champagne,*
by Henri et Rémi Krug, 1979

RÉMI KRUG, fifth generation of the Krug family,
Co-Director of the House of Krug 1965–2007.

INSTITUT DE FRANCE

ACADÉMIE FRANÇAISE

Paris le 9 août 1986

On peut dire qu'il y a un
" atelier Krug ", comme on dit
qu'il y avait un atelier
Breughel ou un atelier Rubens.

Messieurs Krug, depuis cinq
générations, font un champagne
plein de secrets comme la
peinture flamande. Sur leur
palette, il y a la terre, le
raisin, la France, et leur
pinceau fait avec cela un
chef d'œuvre.

Jean Dutourd

In 1986, French writer Jean Dutourd, member of the Académie Française, wrote this letter to Krug, comparing the House's Champagne to a Flemish masterpiece by Breughel or Rubens.

"I actually have the original receipt for Krug Clos du Mesnil 1979 from 1985. There was a wine buyer in Harrods in London named Mr. Burgess, a famous guy that ran the wine department. I went in there about thirty years ago as a wayward American, and he liked me. He said, 'You should buy this.' And I bought a 1979 Krug Clos du Mesnil, the first year it came out. I showed it to Olivier Krug, and he couldn't believe I still had the original receipt. Olivier said he has seen copies, but not an original one."

BRUCE FINGERET,
president, FEA Merchandising

" *People remember the first time they ever drank Krug... and I recall my first experience, a day in 1977, well enough. That first whiff was intriguing, that first sip a revelation...I realized this was a whole new experience.* "

Dan Berger, *Los Angeles Times*

" I have a lifelong, unfailing passion for Krug. In fact, I would also say that many of the key principles that make Krug so very special have a resonance with my own approach to cooking and hospitality. Having recently spent time in Reims during the harvest with Olivier Krug, I am now further driven by the exciting combination possibilities when pairing our food with Krug. "

ANDREW FAIRLIE,
chef- and owner, Andrew Fairlie restaurant, 2 Michelin stars, Gleneagles, Scotland

Closer to the Sea than any other Hotel in Brighton
THE ROYAL ALBION
is moreover, its **Newest Hotel.** Situate on the Centre of the Fron

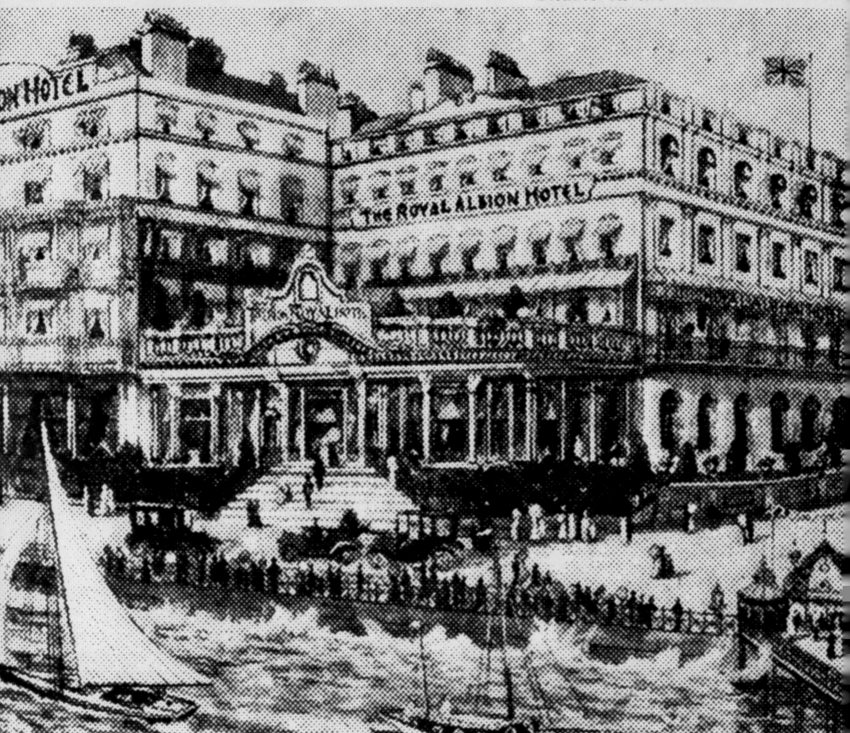

MAGNIFICENT LOUNGE with Beautiful Sea Views
DAGONET (G. R. Sims) says: "The Royal Albion is now one of the most beautiful and luxurious Hotels o
the English Coast.
For Illustrated Brochure and Tariff apply to the Manage

SIR HARRY PRESTON (1860-1936), *hotelier, owner of the Royal Albion and Royal York hotels, Brighton, UK*
In January 1935, Krug sent 96 bottles of Krug Private Cuvée Extra Sec 1928 to the Royal Albion hotel in Brighton.

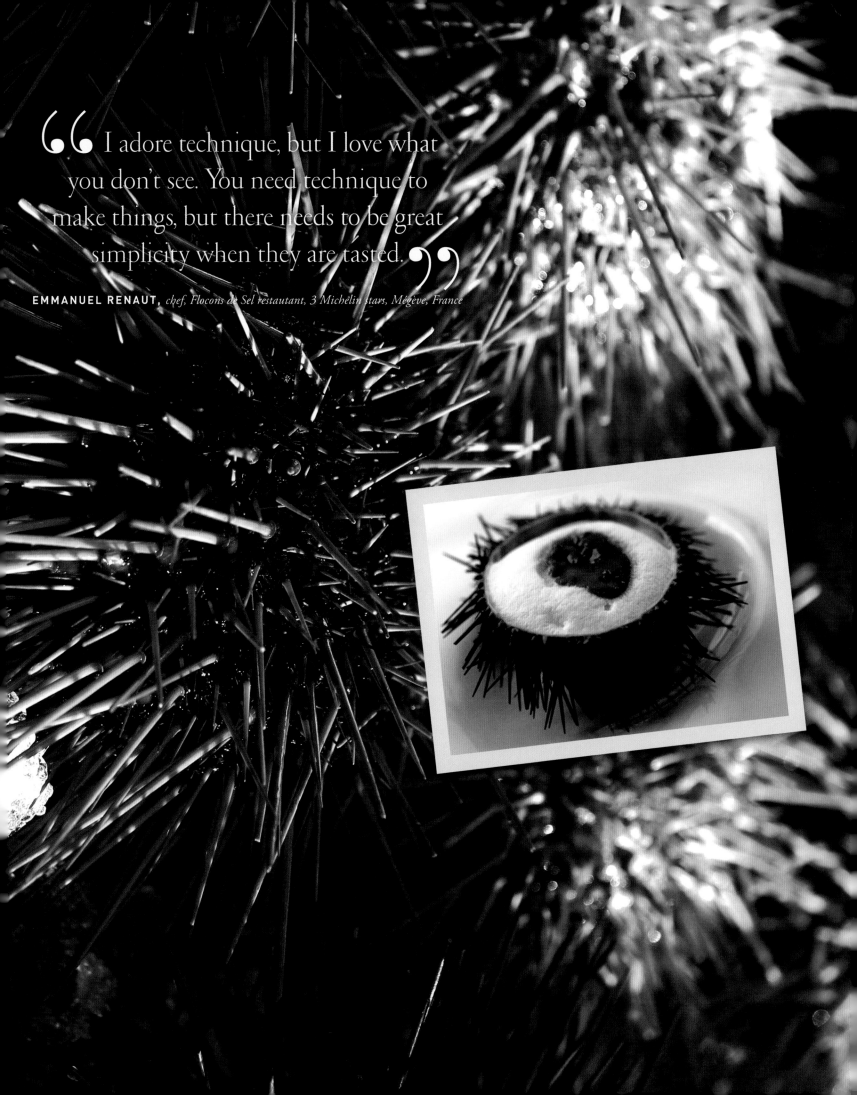

> "I adore technique, but I love what you don't see. You need technique to make things, but there needs to be great simplicity when they are tasted."

EMMANUEL RENAUT, *chef, Flocons de Sel restautant, 3 Michelin stars, Mégève, France*

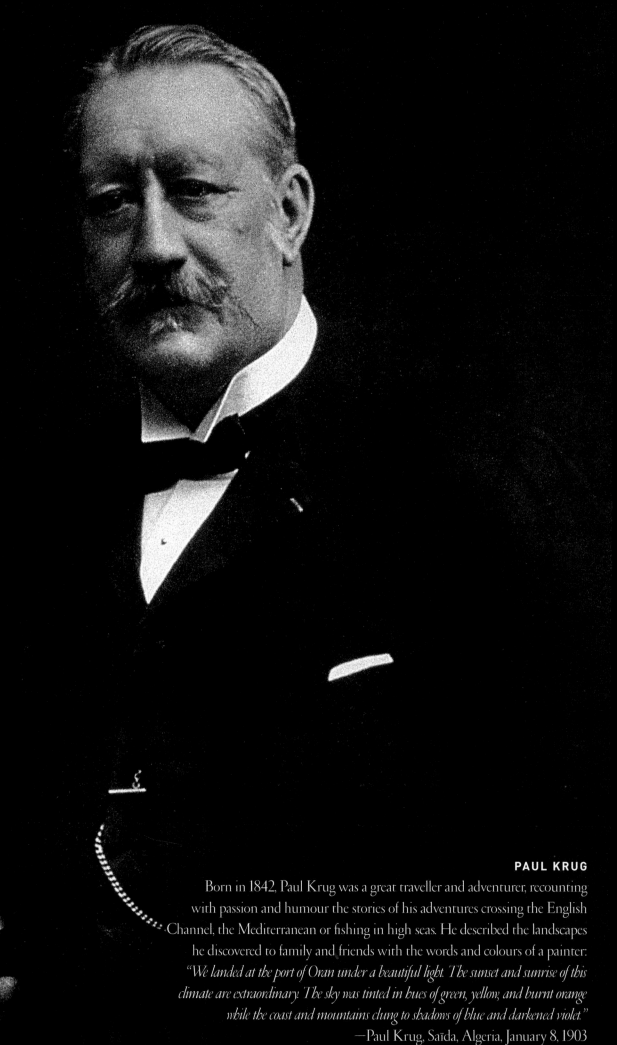

PAUL KRUG

Born in 1842, Paul Krug was a great traveller and adventurer, recounting with passion and humour the stories of his adventures crossing the English Channel, the Mediterranean or fishing in high seas. He described the landscapes he discovered to family and friends with the words and colours of a painter: *"We landed at the port of Oran under a beautiful light. The sunset and sunrise of this climate are extraordinary. The sky was tinted in hues of green, yellow, and burnt orange while the coast and mountains clung to shadows of blue and darkened violet."* —Paul Krug, Saïda, Algeria, January 8, 1903

CHAMPAGNE

PRIVATE CUVÉE

KRUG & Cᵒ

MAISON FONDÉE EN 1843

Cover of an early 20th century brochure presenting the Krug range.

"*Krug has been with us in some of our most important moments.*"

FRANCESCA AND GAETANO VERRIGNI,
owners, L'Antico Pastificio Rosetano Verrigni, Italy

The Krug Is in the Air Champagne hot-air balloon excursion has flown to Los Angeles, Arizona, Miami, Italy, Japan, and Hong Kong.

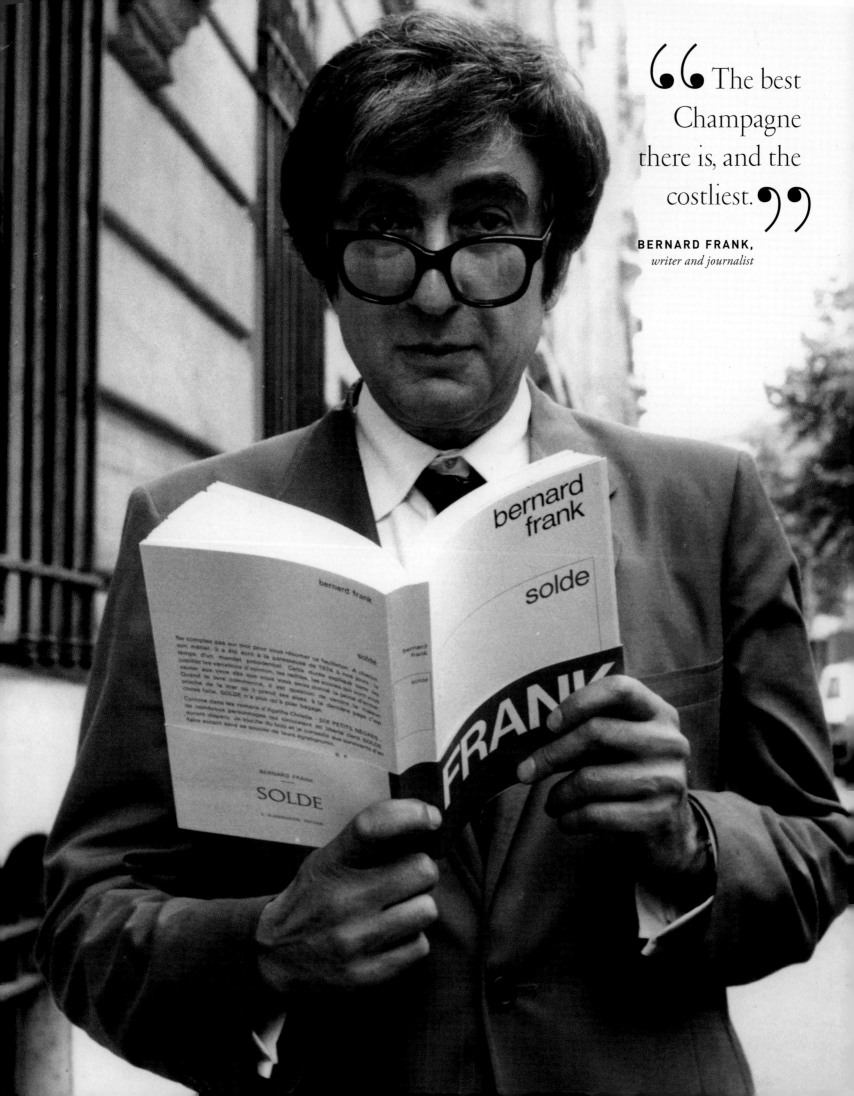

"The best Champagne there is, and the costliest."

BERNARD FRANK,
writer and journalist

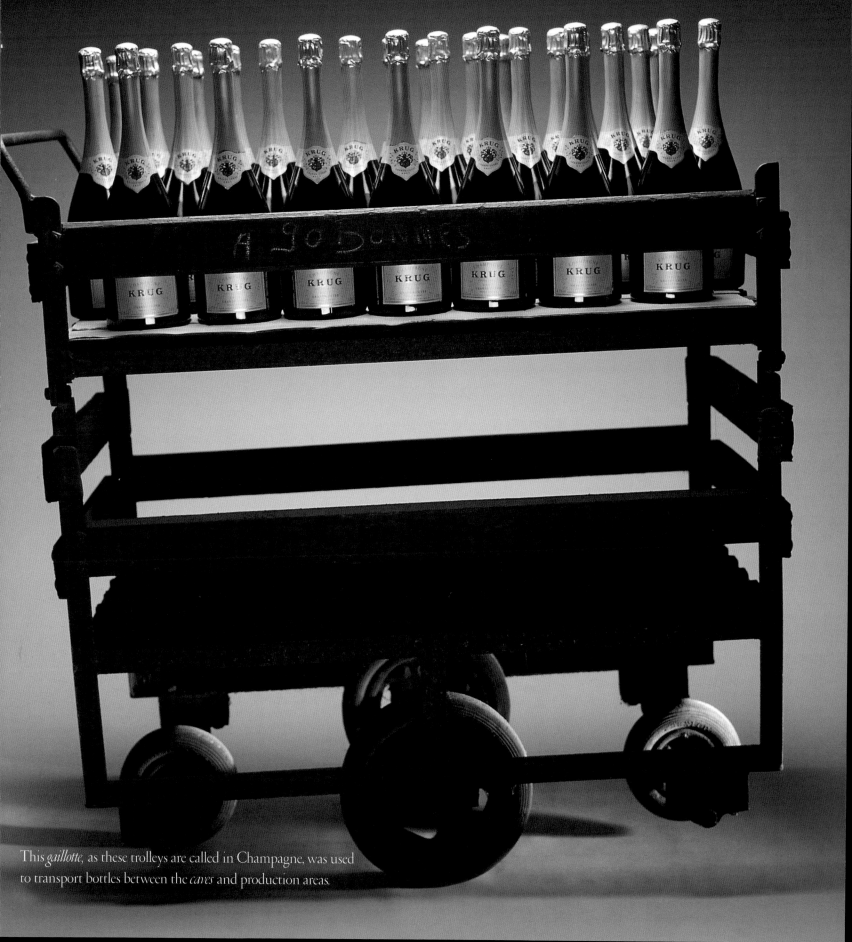

This *gaillotte*, as these trolleys are called in Champagne, was used to transport bottles between the *caves* and production areas.

"I clearly remember Olivier Krug waving his hand at the entrance of the Maison Krug to welcome us when I visited for the first time. This symbolises the heart of Krug: warm, full of love, and that's why I feel pleasure when I drink Krug."

HARUHIKO TATENO,
director, Gentosha; editor in chief, Goethe *magazine, Japan*

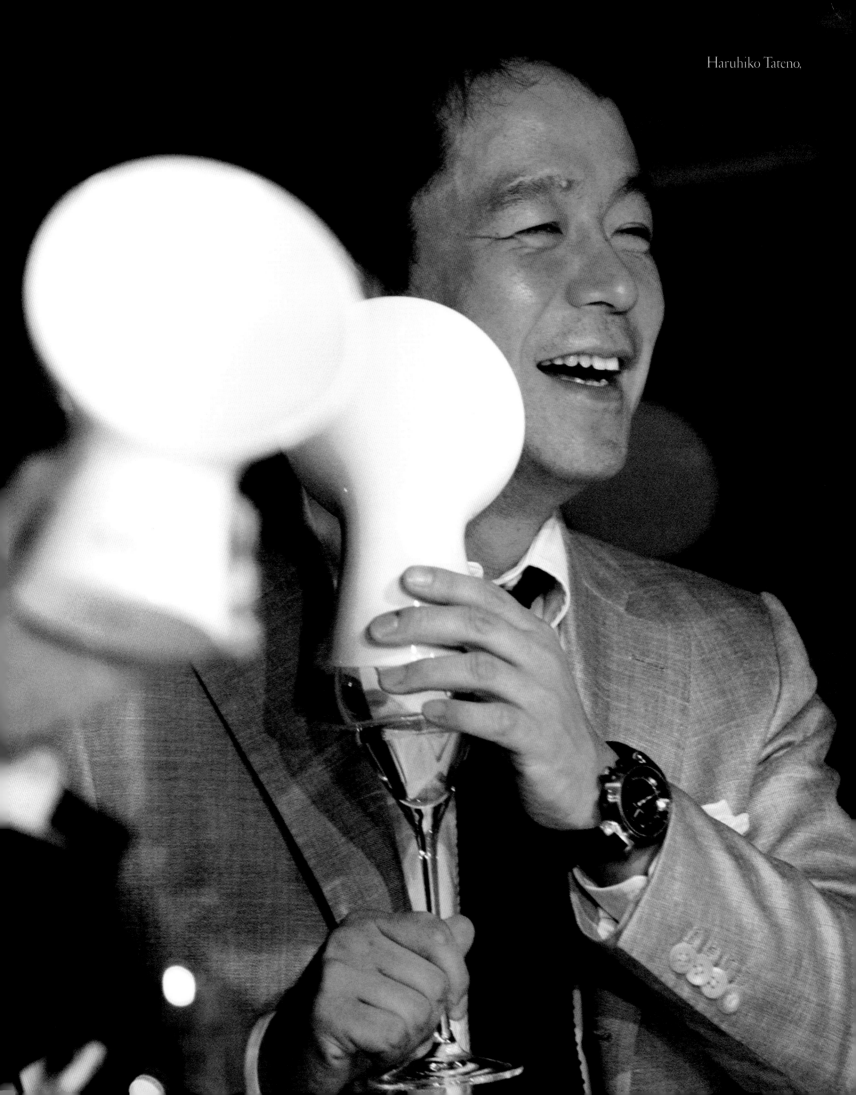

Haruhiko Tateno,

"The essence of our art is to be as close to the wines as we can."

ERIC LEBEL, *House of Krug Chef de Caves*

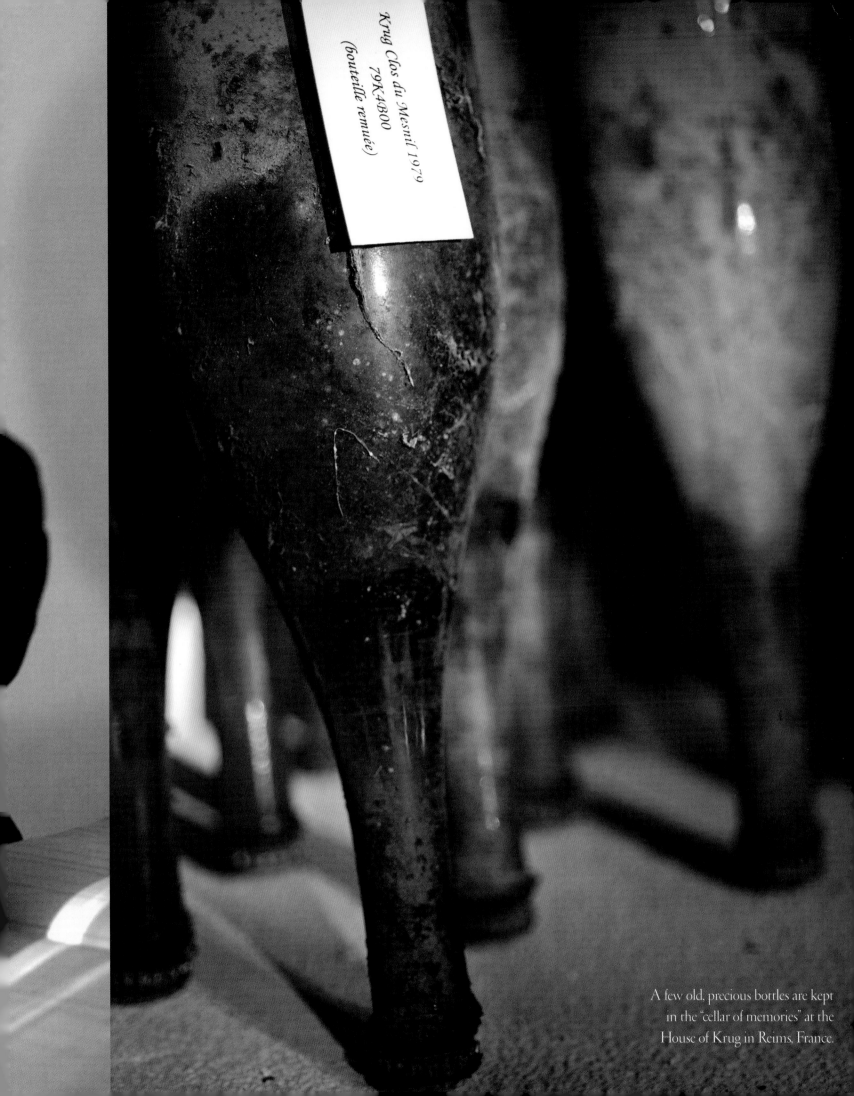

Krug Clos du Mesnil 1979
79K4B00
(bouteille remuée)

A few old, precious bottles are kept
in the "cellar of memories" at the
House of Krug in Reims, France.

un peu trop prolongé.

Bonne note est prise de l'envoi que vous nous annoncez (100 c/ $\left\{{}^{75}_{25}{}^{12/1}_{24/2}\right\}$), et de votre détermination au sujet de la calotte en métal ce qui est au mieux.

Nous sommes enchantés des bonnes nouvelles que vous nous donnez de la vigne. Espérons qu'elle tiendra ce qu'elle promet!

Vous apprendrez avec plaisir que le "Krug Sec" a figuré au banquet offert par la Chambre de Commerce de New York (auquel assistait l'écrivain) aux Officiers de la "Flore" et de l'"Isère", à l'occasion de l'arrivée de la Statue de la Liberté. — Nous ne négligeons aucune occasion d'introduire le vin dans les "upper circles", quand nous pouvons le faire sans nous faire classer parmi les "contemptible Champagne drummers," en évitant avec soin tout ce qui peut ressembler à la carte forcée.

Dans l'attente de vos bonnes nouvelles, nous vous prions d'agréer, chers Messieurs, nos bien cordiales salutations.

Renauld & Niederstadt

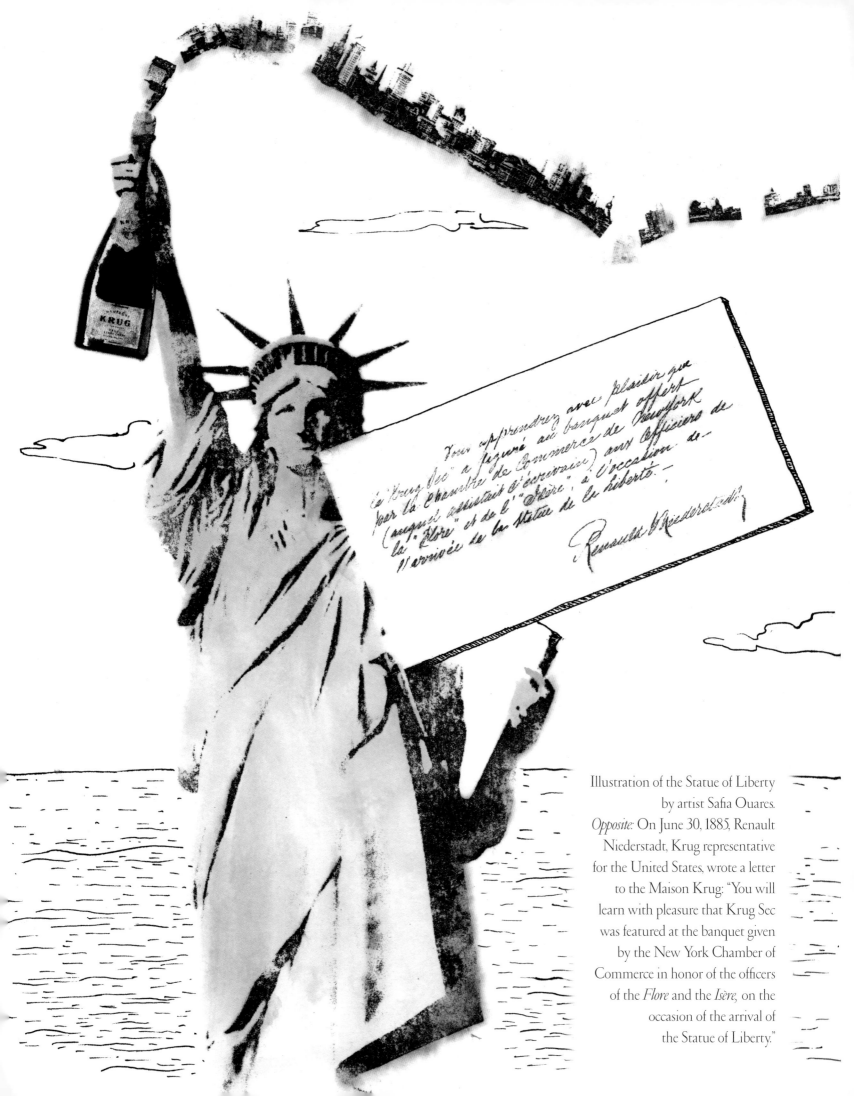

Illustration of the Statue of Liberty by artist Safia Ouares.

Opposite: On June 30, 1885, Renault Niederstadt, Krug representative for the United States, wrote a letter to the Maison Krug: "You will learn with pleasure that Krug Sec was featured at the banquet given by the New York Chamber of Commerce in honor of the officers of the *Flore* and the *Isère,* on the occasion of the arrival of the Statue of Liberty."

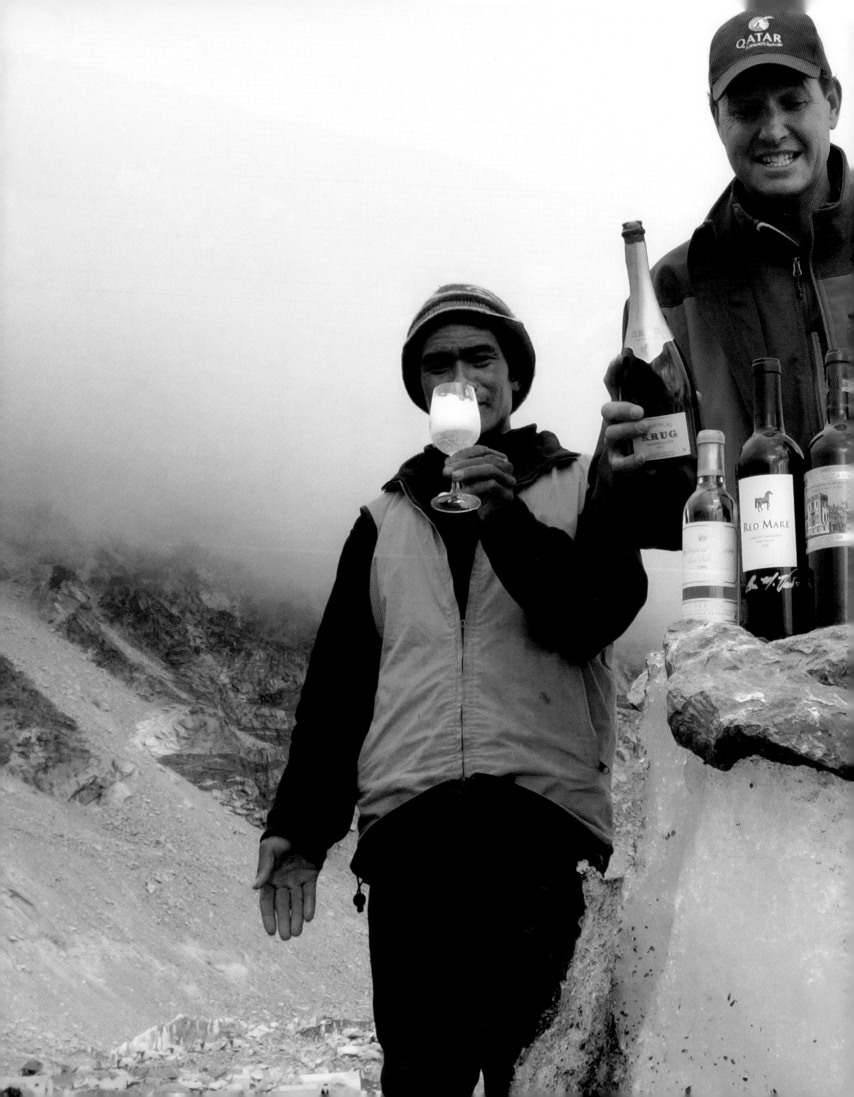

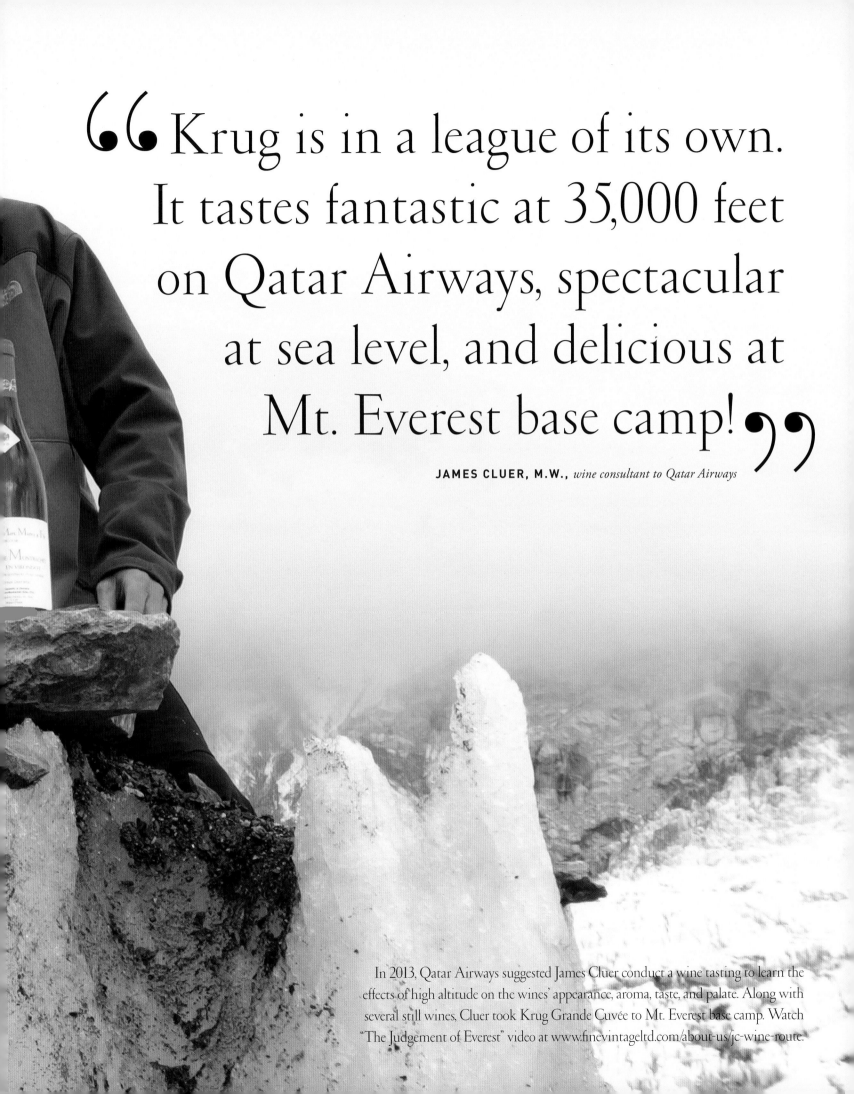

" Krug is in a league of its own. It tastes fantastic at 35,000 feet on Qatar Airways, spectacular at sea level, and delicious at Mt. Everest base camp! "

JAMES CLUER, M.W., *wine consultant to Qatar Airways*

In 2013, Qatar Airways suggested James Cluer conduct a wine tasting to learn the effects of high altitude on the wines' appearance, aroma, taste, and palate. Along with several still wines, Cluer took Krug Grande Cuvée to Mt. Everest base camp. Watch "The Judgement of Everest" video at www.finevintageltd.com/about-us/jc-wine-route.

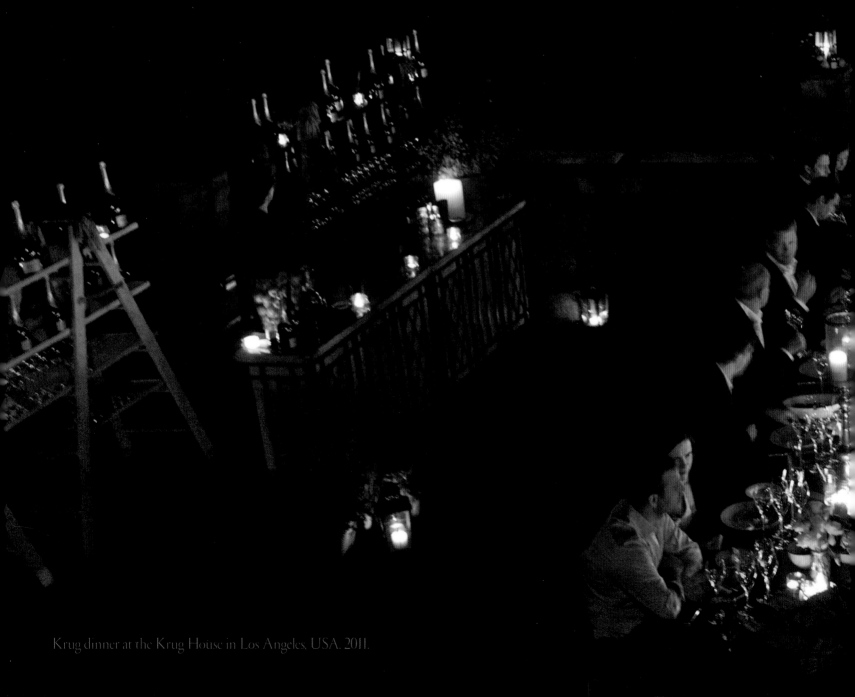

" Krug Champagnes are created with passionate dedication for the people who love the good things in life and enjoy sharing them. Krug enlightens moments, turning them into unforgettable journeys to be treasured forever. "

MARGARETH HENRIQUEZ, *president and CEO of the House of Krug*

Krug dinner at the Krug House in Los Angeles, USA. 2011.

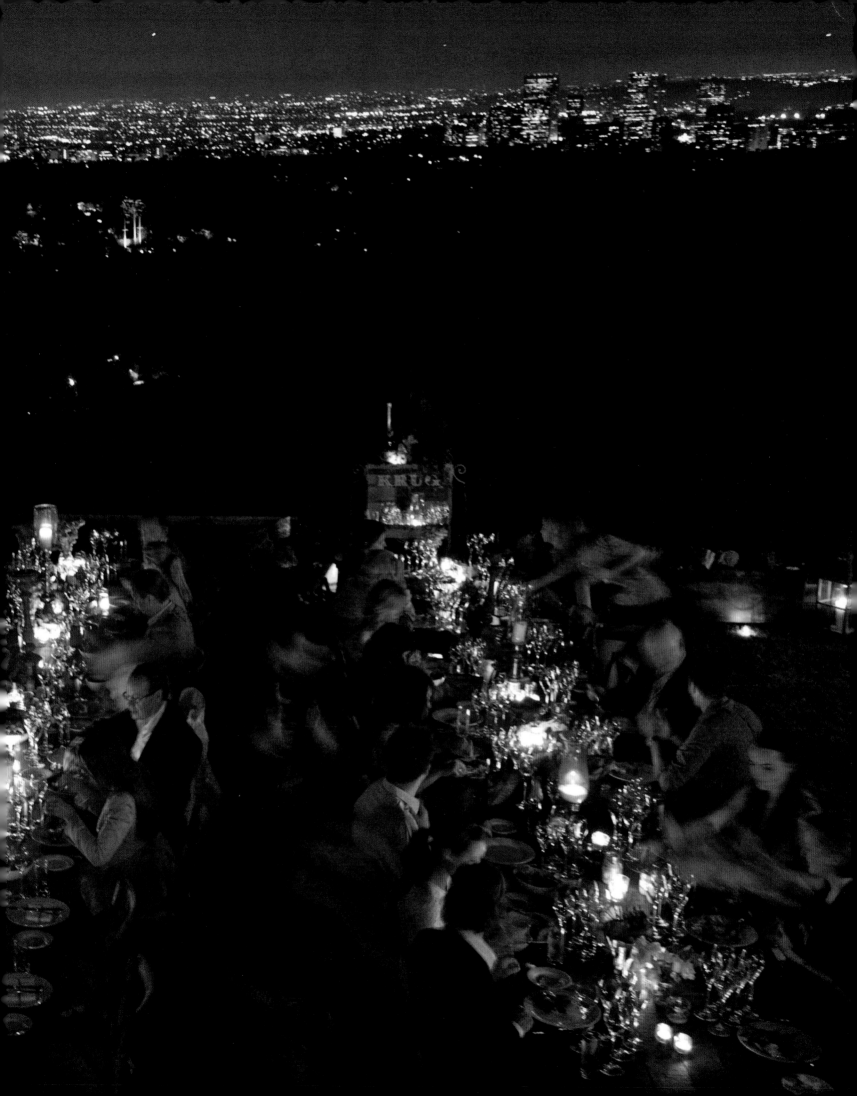

"Champagne is my drink of choice, and I love Krug. It is a drink of passion. That passion comes from the drink itself, the wonderful people who make it and build on its legend, and the love and family caring they continue to put into it. It makes me very happy. I have been blessed to share many wonderful vintages—1947, 1953, 1961, 1962, 1966, 1971, 1976, 1979, and 1979 Clos du Mesnil, and so many more—all are so exceptional, quintessential, and unique. "

MARK BEAVEN, *CEO, Advanced Alternative Media entertainment management and marketing firm, USA*

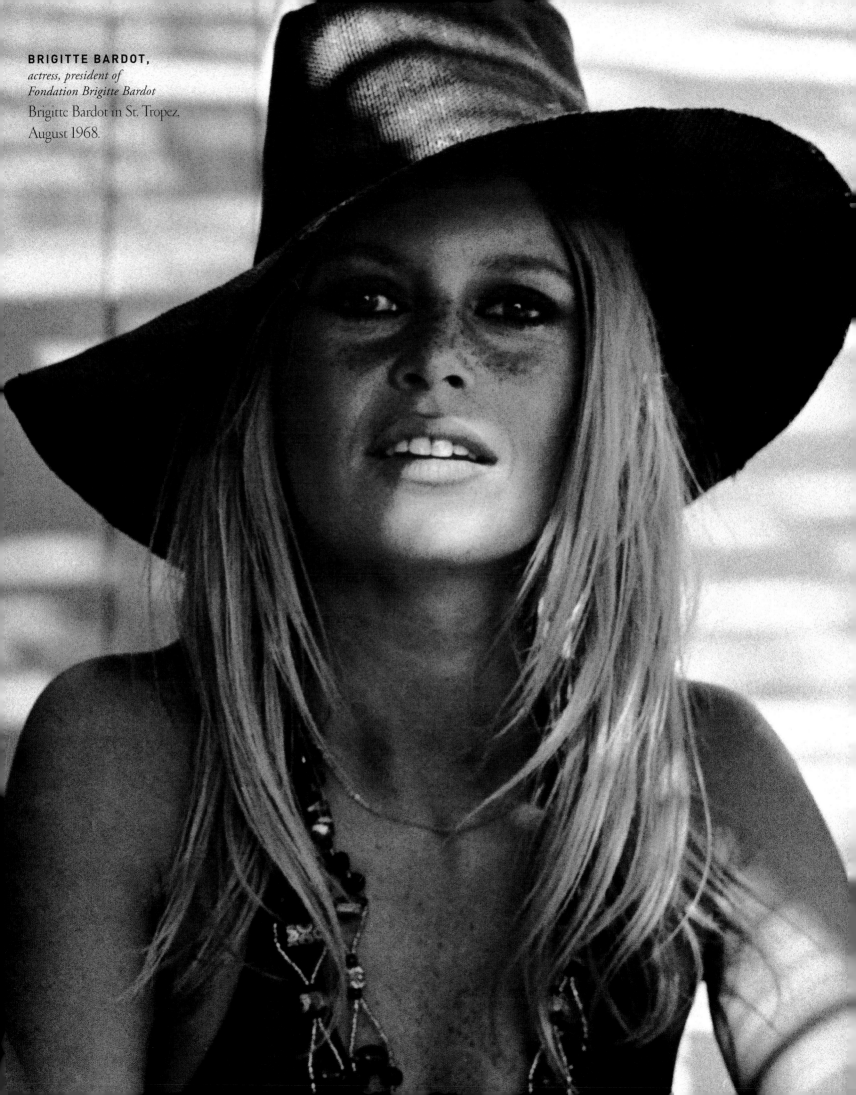

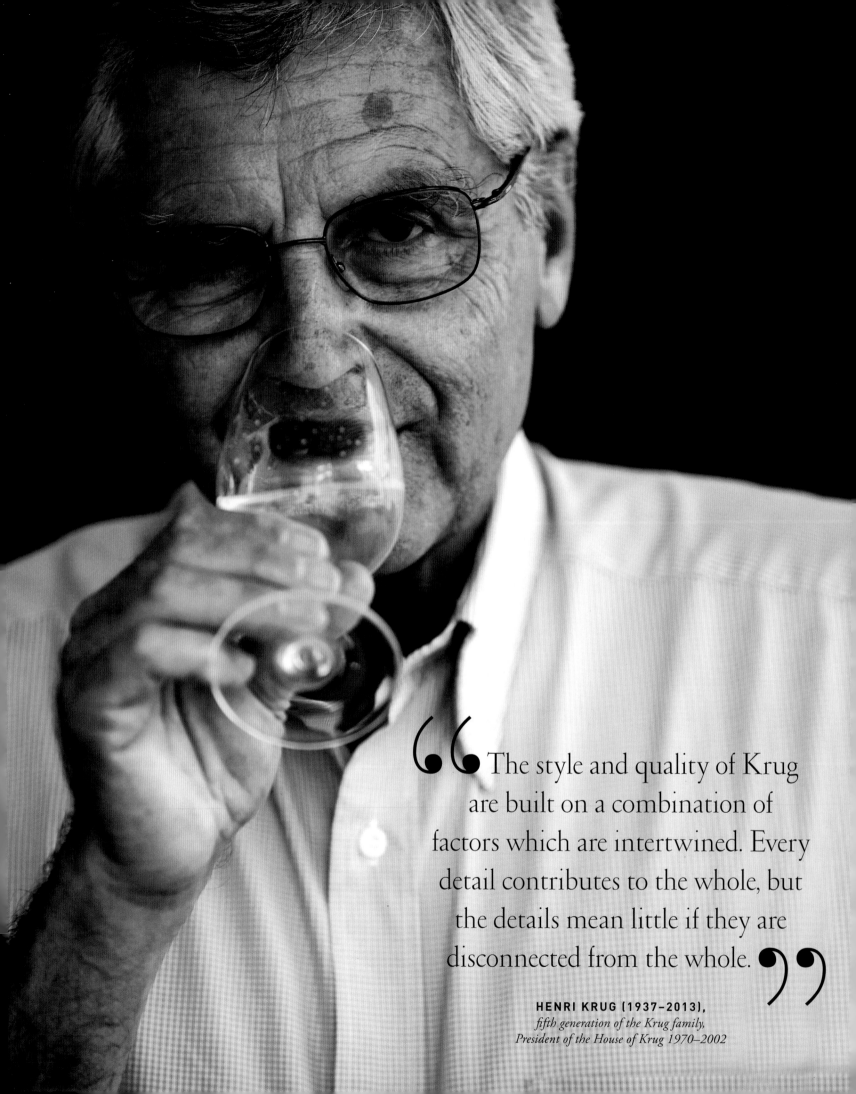

"The style and quality of Krug are built on a combination of factors which are intertwined. Every detail contributes to the whole, but the details mean little if they are disconnected from the whole."

HENRI KRUG (1937–2013),
fifth generation of the Krug family,
President of the House of Krug 1970–2002

"I will never forget the moment in June 2005 when I was back from long travels and, stepping off the plane, was whisked away to Reims. I knew then I was in for a remarkable adventure. As soon as I arrived, I was immediately overwhelmed by the magic spirit of the House; tasting vintages, each one more incredible than the last. The poetry of bubbles and flavours was still alive despite some wines being over thirty years of age. The blonde bubble has marked me! And now, every time I am flirting with a glass of Krug Champagne, it is always an intense pleasure."

FRED PINEL, *founder, Pinel & Pinel, Paris, France*

In 2005, Pinel & Pinel collaborated with Krug to create an exclusive picnic trunk, which has since led to several other designs.

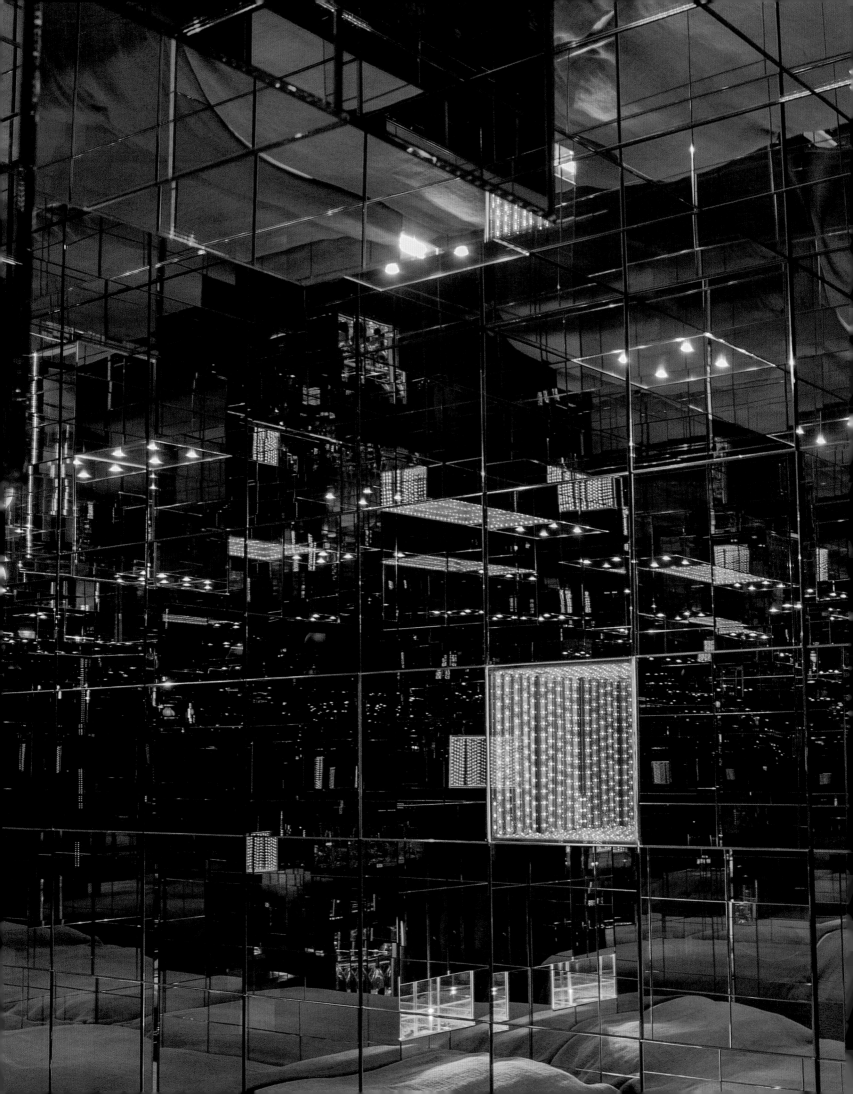

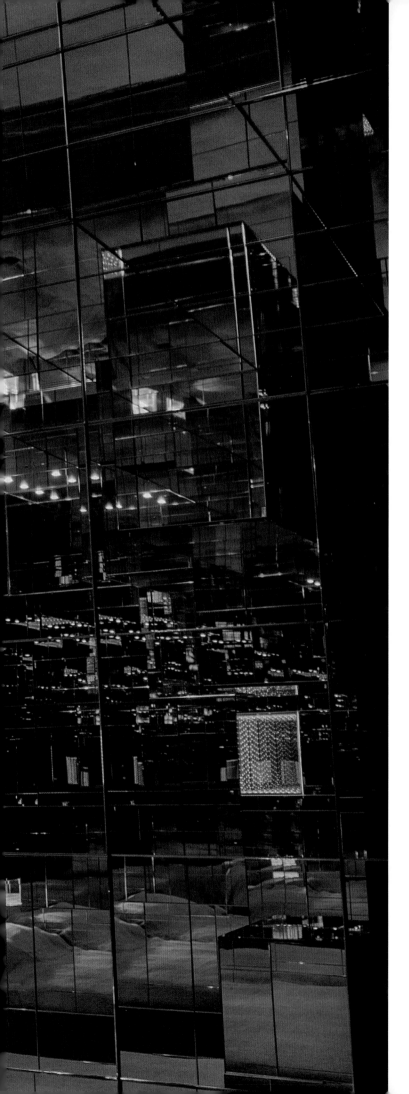

" The experience of tasting Krug Grande Cuvée was quite sincerely a discovery—a real aromatic sensation, mixed with a simple, authentic moment. I sensed the origin, generosity, and values of the founder. It was a great moment. **"**

MATHIAS KISS, *artist*

La Kiss Room hotel in Paris, designed by Mathias Kiss with 1,000 mirrors.

" *Although I had heard of Krug previously, my first Krug experience was in 2007 with my business partner Marcelo, shortly before opening the Kinoshita restaurant at its new location. I was so surprised by the unique complexity of Krug Champagne that I immediately started creating tasting menus specifically designed to be harmonised with their complete line.* "

TSUYOSHI MURAKAMI,
chef and co-owner of Kinoshita restaurant, São Paulo, Brazil

" When I was a baby, my father dipped Krug from the glass and touched my lips. That was my first sip of Krug. "

ALAN WONG, *general manager, Rare & Fine Wines, Hong Kong*

" *Krug is felt rather than told. My girlfriend and I agree that Krug is like a beautiful woman that you admire—her company inspires you. We feel the quality each time we taste a bottle.* "

REZA BUNDY, *managing partner, Provence Capital, USA*

"I first tasted Krug on a cruise ship and remember clearly how I was impressed by the complexity and delicate *perlage* of this fine Champagne. It instantly became my favourite. Several years later I had the honour of meeting Olivier Krug in São Paulo, and I told him how keen I was to share my passion for Krug with my clients. This wish came true at Kinoshita, where we serve Krug by the glass and have one of the four Krug Rooms that exist in the world."

MARCELO FERNANDES,
co-owner of Kinoshita restaurant, São Paulo, Brazil

" I was invited by Krug to attend an event code-named Project ABC. I only knew the date; no further detail was released, as Krug had been keeping this project a secret for over ten years, until October 2007, when Krug decided it was time to unveil it to the world. It was a magical moment to taste the 1995 Krug Clos d'Ambonnay with Rémi and Olivier Krug in Krug's Clos d'Ambonnay. "

GEORGE TONG,
vice president, Wong Hau Plastic Works, Hong Kong

Krug's Clos d'Ambonnay walled vineyard in Ambonnay, France: 0.68 hectares (1.68 acres) on which Pinot Noir is cultivated to create Krug Clos d'Ambonnay; a rare, single-vineyard, single-varietal Champagne, revealed for the first time in 2007

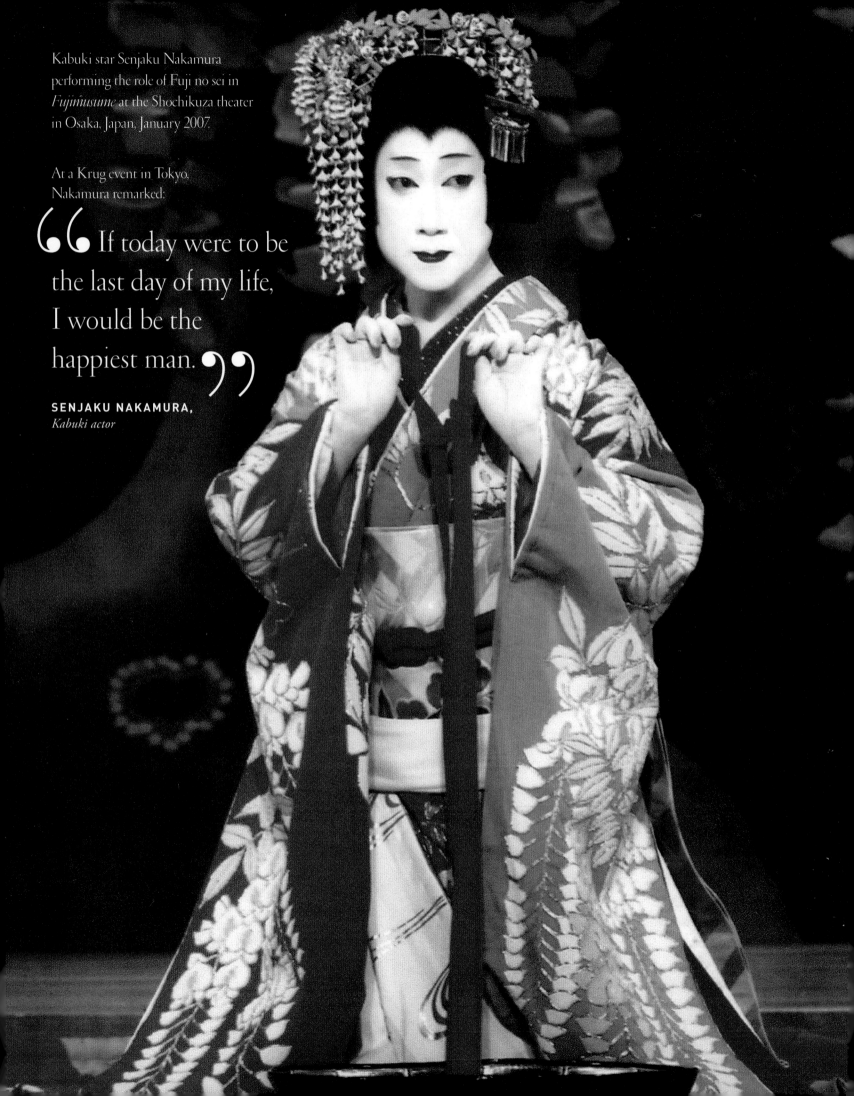

Kabuki star Senjaku Nakamura performing the role of Fuji no sei in *Fujimusume* at the Shochikuza theater in Osaka, Japan, January 2007.

At a Krug event in Tokyo, Nakamura remarked:

"If today were to be the last day of my life, I would be the happiest man."

SENJAKU NAKAMURA,
Kabuki actor

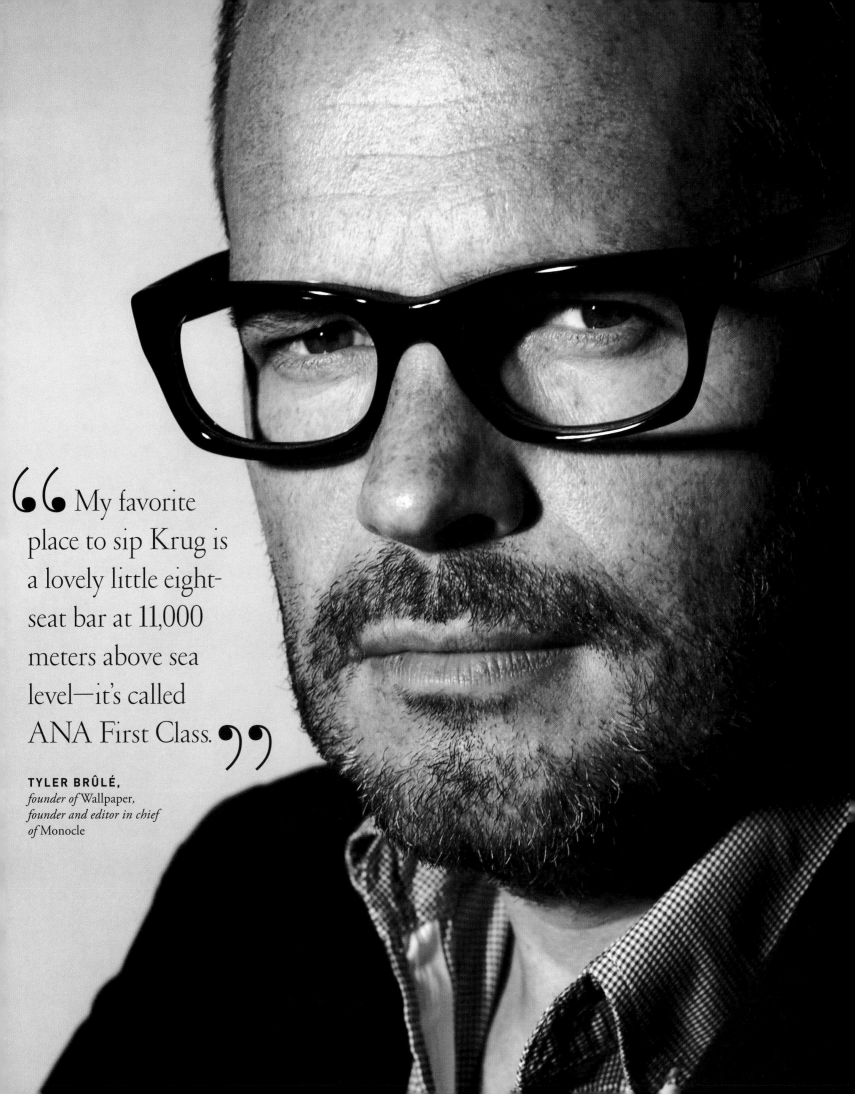

" My favorite
place to sip Krug is
a lovely little eight-
seat bar at 11,000
meters above sea
level—it's called
ANA First Class. **"**

TYLER BRÛLÉ,
founder of Wallpaper,
*founder and editor in chief
of* Monocle

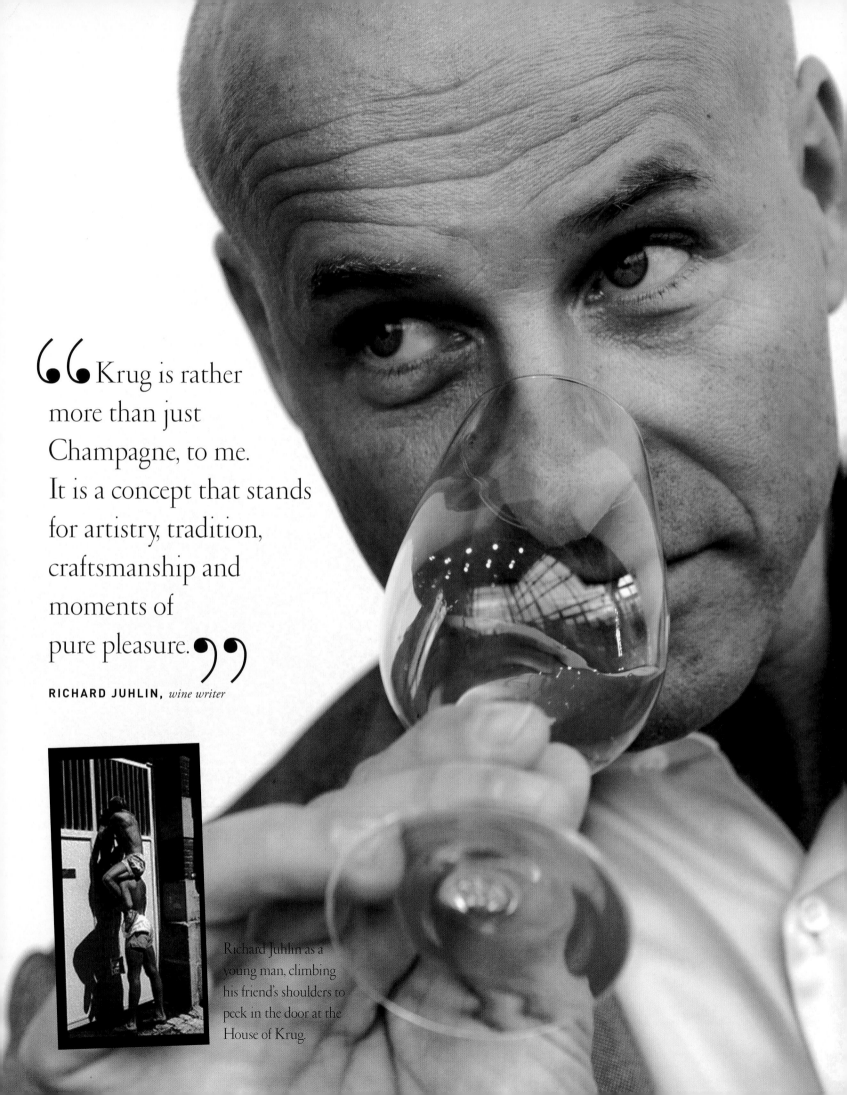

"Krug is rather more than just Champagne, to me. It is a concept that stands for artistry, tradition, craftsmanship and moments of pure pleasure."

RICHARD JUHLIN, *wine writer*

Richard Juhlin as a young man, climbing his friend's shoulders to peek in the door at the House of Krug.

Krug Champagne is served at the
Hôtel du Cap-Eden-Roc, Cap d'Antibes, France.

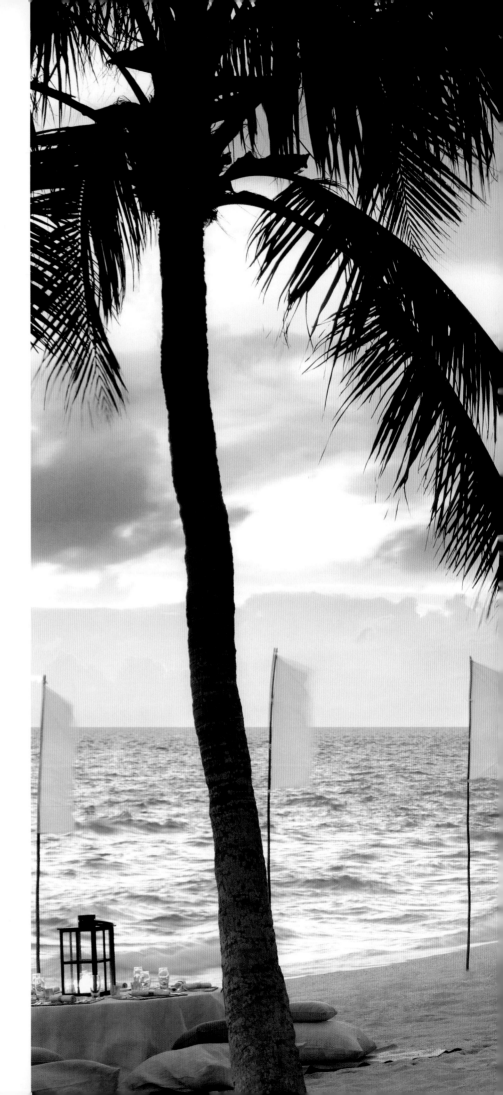

> **" Krug is to Champagne what the Rolls-Royce is to automobiles: a masterpiece for the demanding aesthete. "**

MICHEL GUÉRARD, *chef and owner,*
Les Prés d'Eugénie hotel-restaurant, 3 Michelin stars,
Eugénie-les-Bains, France

Krug Champagne is served at
Shangri-La's Boracay Resort & Spa
in the Philippines.

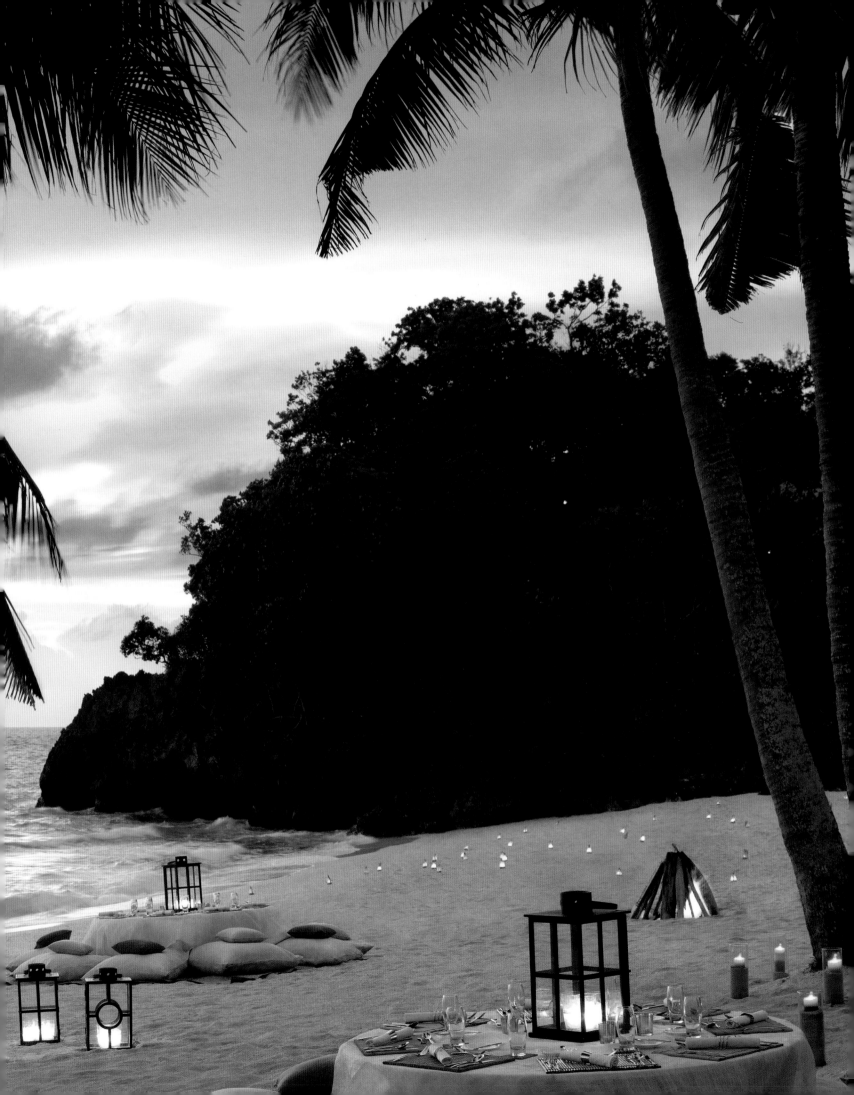

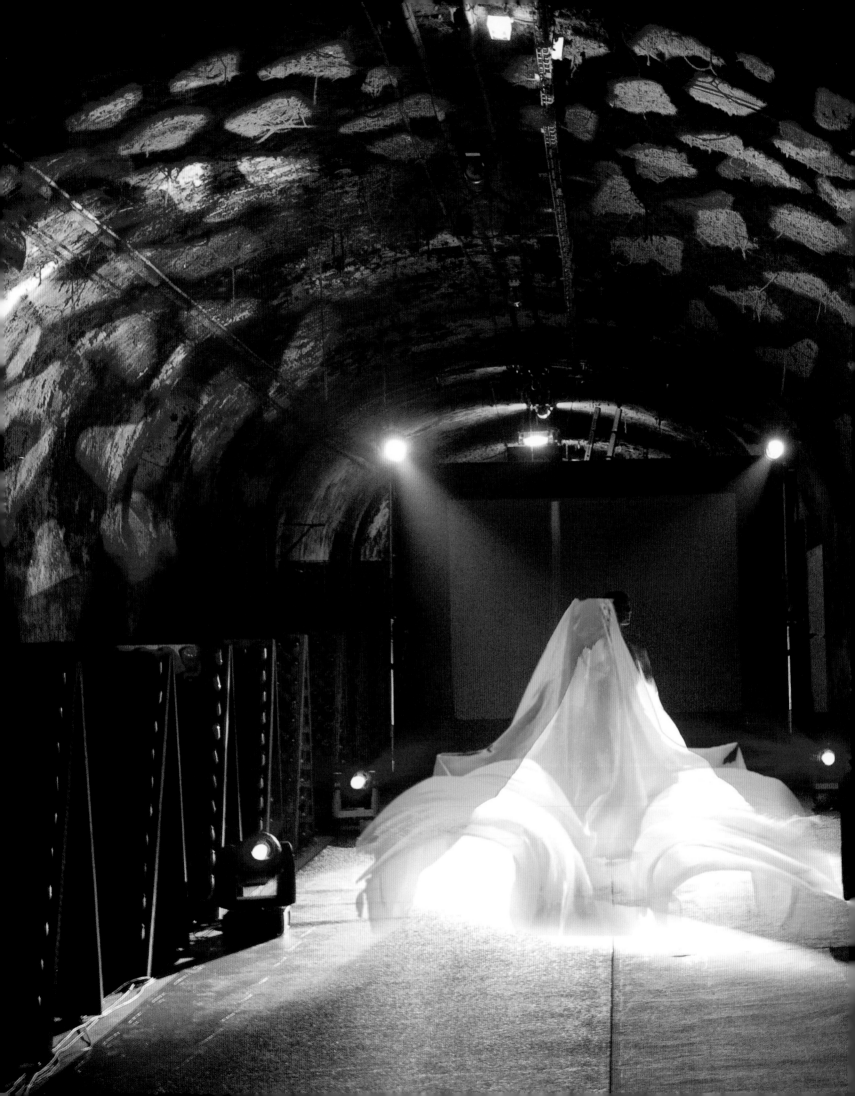

" *The very first sip of Krug awoke within me a multitude of sensations, aromas, and textures. It was a festival of emotions... and it was then I caught sight of those bubbles singing and saw the foam dancing.* "

OSCAR MARTOS, *director and producer,*
Tunnel of Emotions, *in the Krug Cellars*

" Drinking a glass of Krug Grande Cuvée, I remember Henri and feel dignity... Sharing a glass of Krug Grande Cuvée with Olivier Krug, I feel generosity... Both are my Krug. **"**

TOMOKO EBISAWA
senior editor of Vinothèque wine & food magazine, Japan

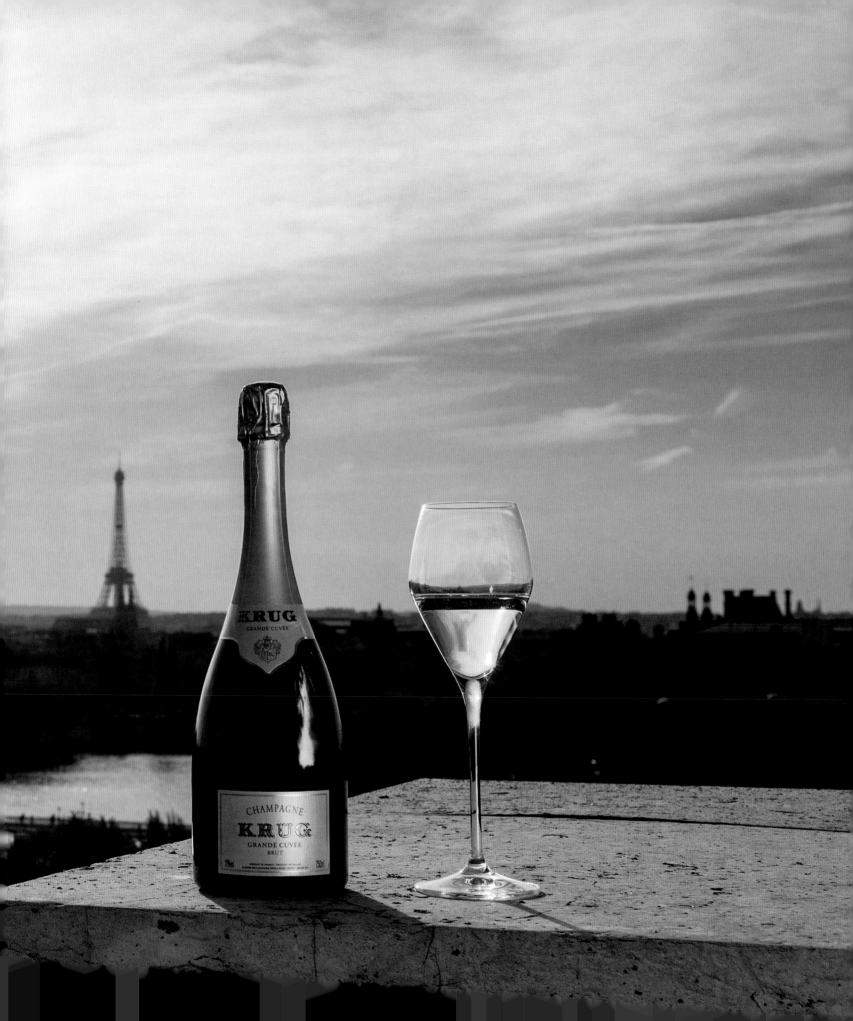

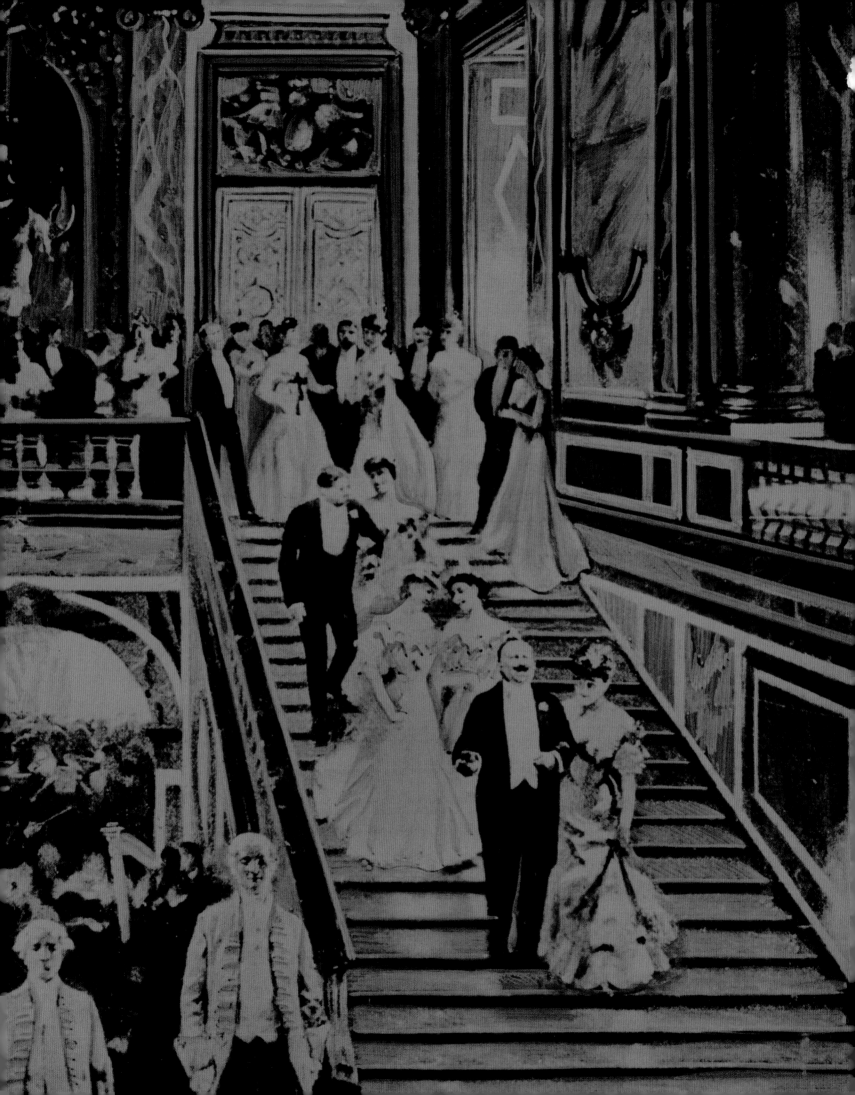

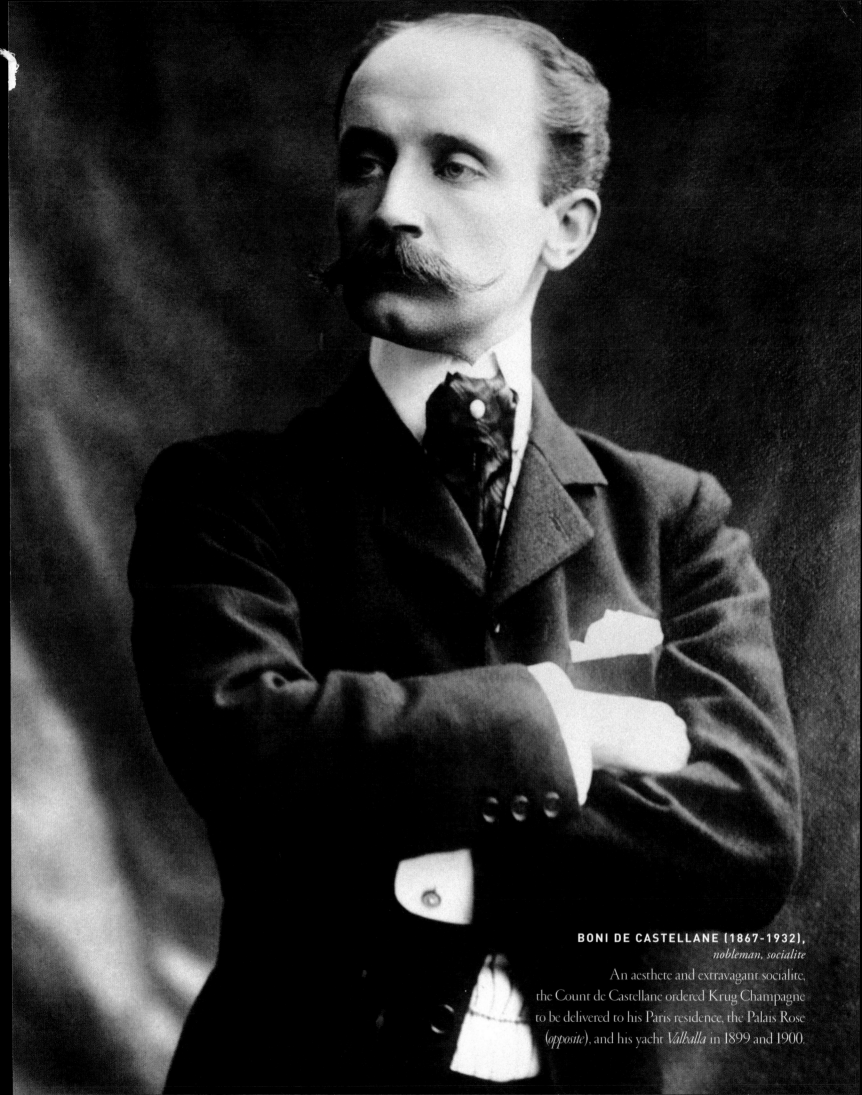

BONI DE CASTELLANE (1867-1932),
nobleman, socialite
An aesthete and extravagant socialite,
the Count de Castellane ordered Krug Champagne
to be delivered to his Paris residence, the Palais Rose
(*opposite*), and his yacht *Valhalla* in 1899 and 1900.

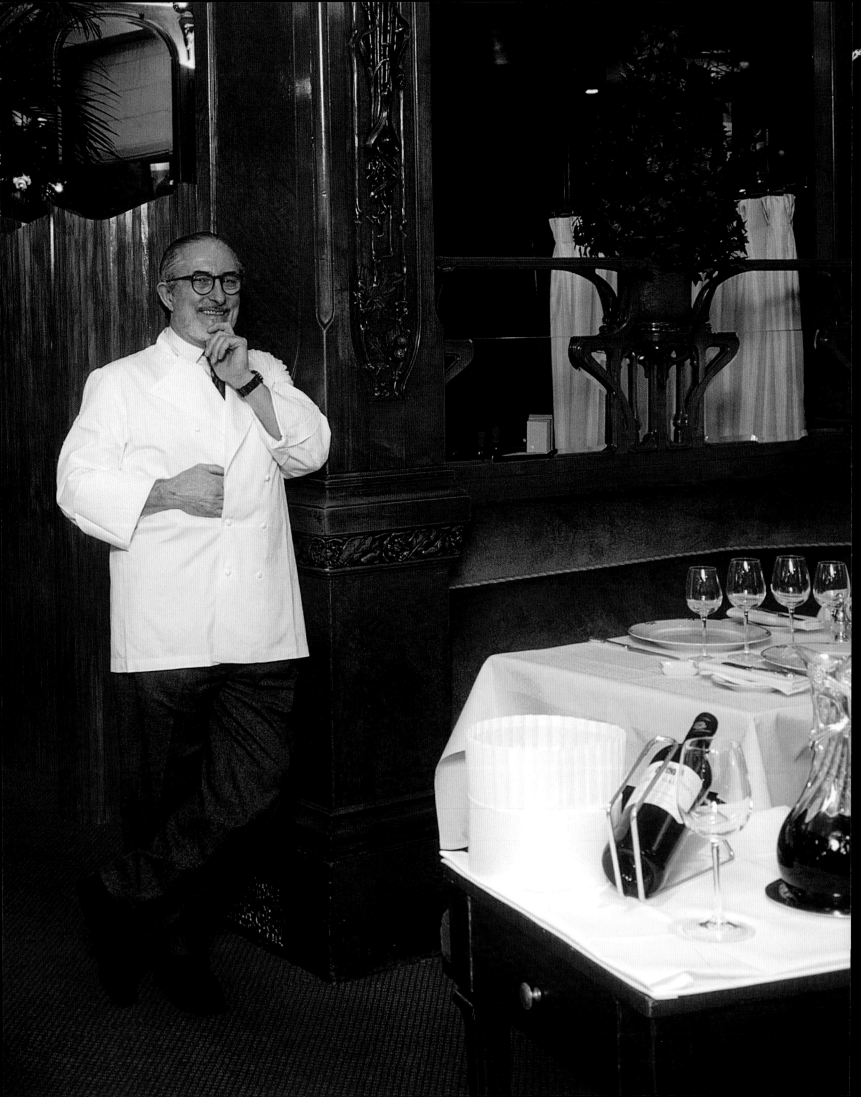

Krug et le Saumon
LES ACCORDS D'ALAIN SENDERENS

LUCAS CARTON, LE 19 JUIN 1986

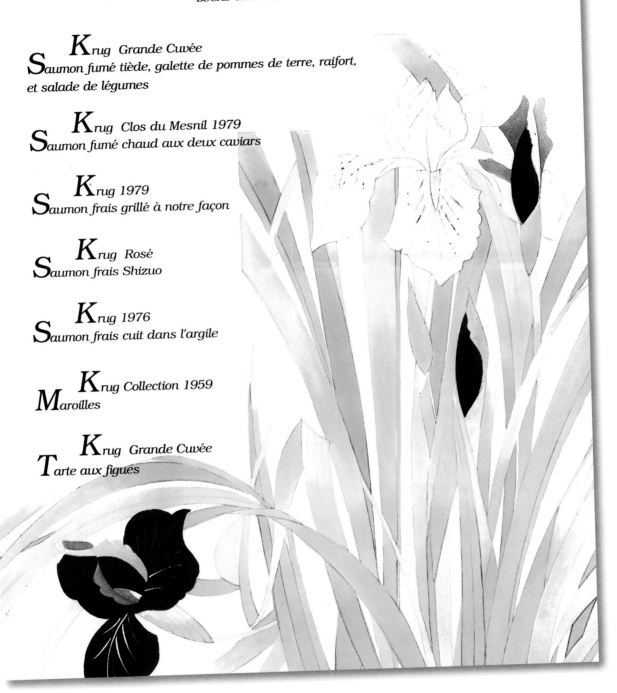

Krug Grande Cuvée
Saumon fumé tiède, galette de pommes de terre, raifort, et salade de légumes

Krug Clos du Mesnil 1979
Saumon fumé chaud aux deux caviars

Krug 1979
Saumon frais grillé à notre façon

Krug Rosé
Saumon frais Shizuo

Krug 1976
Saumon frais cuit dans l'argile

Krug Collection 1959
Maroilles

Krug Grande Cuvée
Tarte aux figues

A menu by chef Alain Senderens at the Lucas Carton restaurant from 1986, pairing various salmon dishes with Krug vintages.
Opposite: Alain Senderens in the Lucas Carton restaurant, Paris, France, 1997.

"*Krug correlates with the restaurant's ethos that craftsmanship from start to finish creates a wonderful and harmonious magic. The structure of Krug is so unique, layer upon layer of character that makes it work well with food. For me, it is not just the Champagne you are drinking, you are tasting elegance, craftsmanship, and magic in a glass… and hopefully sharing it with special people at special times!*"

SONAL CLARE,
restaurant manager, Purnell's, 1 Michelin star, Birmingham, UK

"*For me, Krug Champagne is a signature on a work of art.*"

GEORGES LEPRÉ,
master sommelier, author of Krug chapter in
Le Grand Larousse du Vin

"We could say in jest that creating a Krug Grande Cuvée is similar to making a ratatouille, a typical French dish.

This comparison may surprise, but there are two ways of preparing a ratatouille. You can cook all the vegetables together in a pressure cooker and it is ready in twenty minutes.

Or you decide to preserve and respect the character of each vegetable by cooking it separately and then mixing all the vegetables together at the end. That way, you obtain the very best from each element and this creates a sublime dish.

It is more difficult, of course, but the food gains in colour, flavour and texture.

At Krug we endeavour to harness the best of each plot, to leave it the time it needs for its grapes to fully express their potential, and only then to blend them with others.

In the tasting room, we see what we have done and we know that we have used the right plot in the right place."

JULIE CAVIL, *winemaker at Krug*

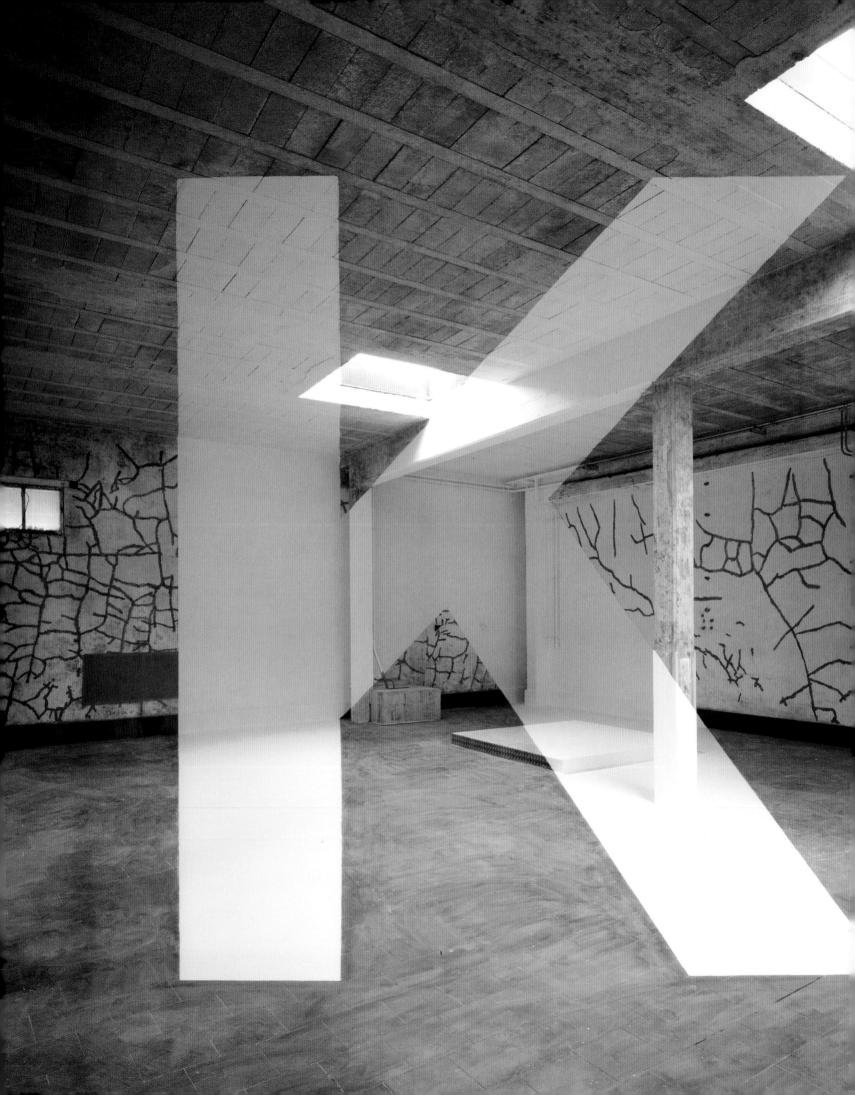

" My photograph and Krug are inseparable. This room where the small oak barrels were prepared was undergoing restoration, and these seemingly cracked walls were graphically very interesting to me. Each day Rémi Krug would come to see the appearance of the letter K, accompanied by sublime bottles of Champagne whose bubbles resonated in the empty space... Unless I only dreamed it...? **"**

GEORGES ROUSSE, *artist and sculptor*
Rousse created this monumental letter K
in a warehouse at the House of Krug.

"You become a Krug Lover by virtue of taste—or rather, good taste, should I say."

Jo Gryn, Chambertin, *Le Marché*

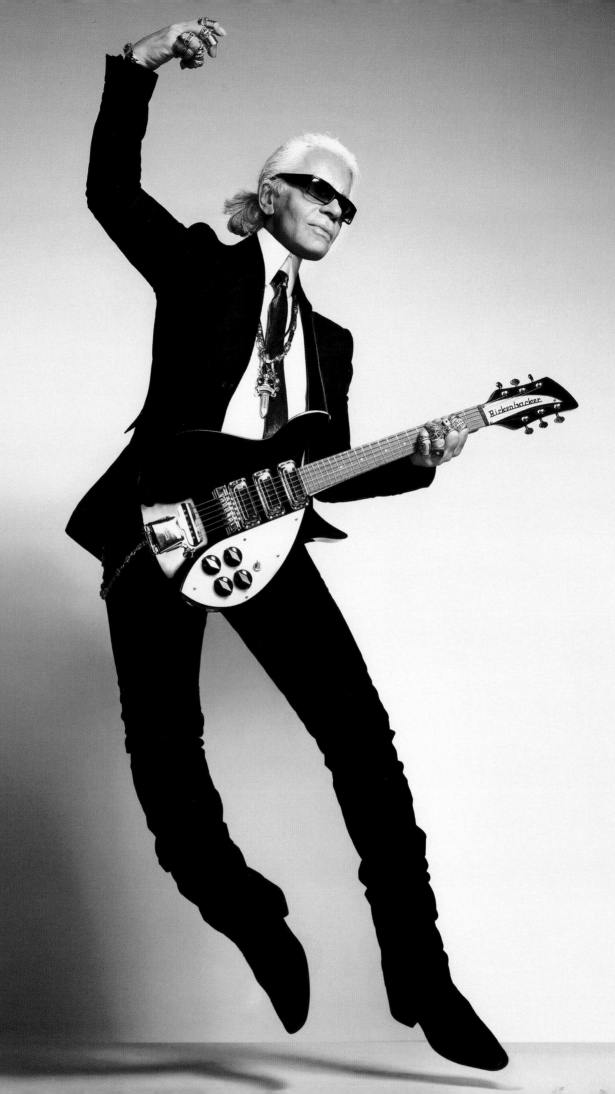

KARL LAGERFELD,
fashion designer, photographer

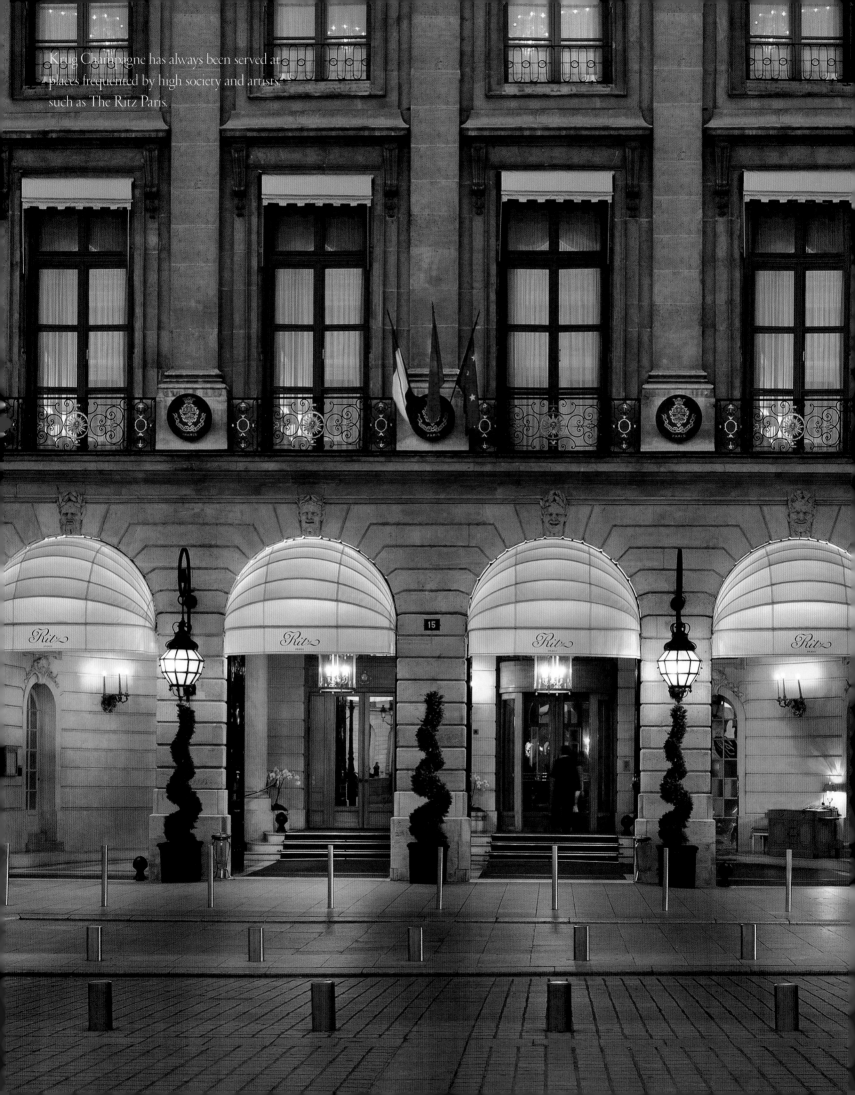

Krug Champagne has always been served at places frequented by high society and artists, such as The Ritz Paris.

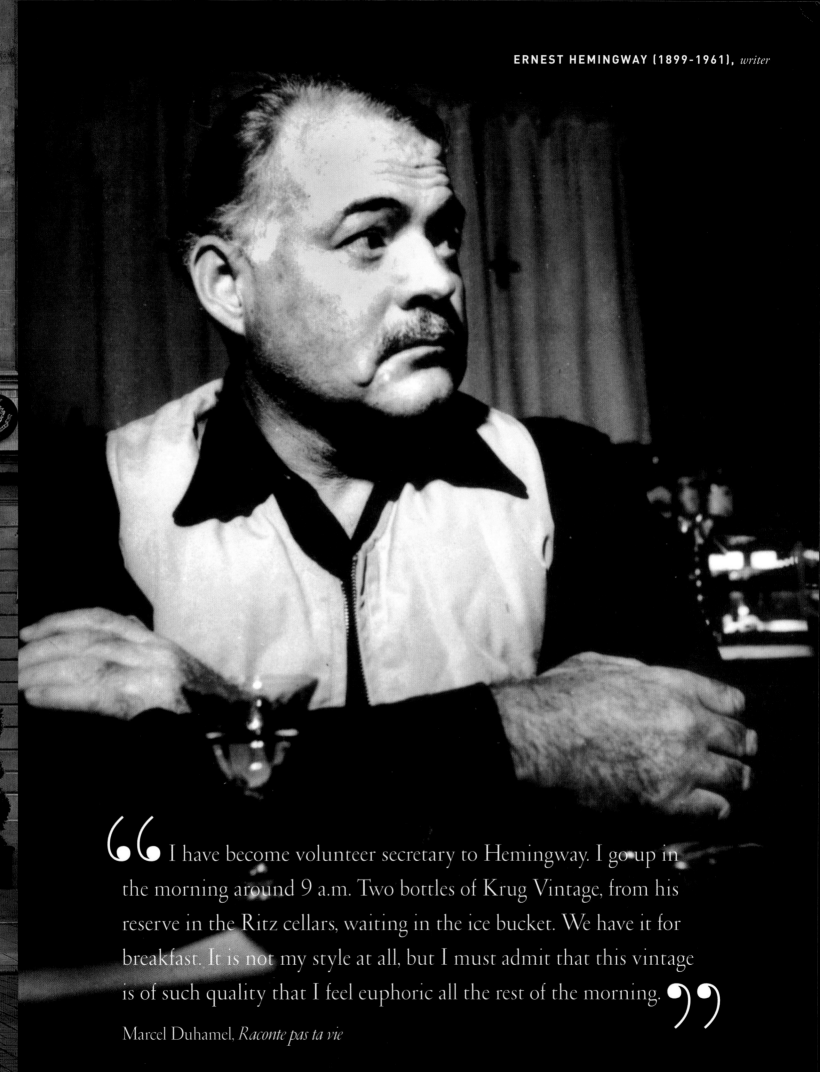

" I have become volunteer secretary to Hemingway. I go up in the morning around 9 a.m. Two bottles of Krug Vintage, from his reserve in the Ritz cellars, waiting in the ice bucket. We have it for breakfast. It is not my style at all, but I must admit that this vintage is of such quality that I feel euphoric all the rest of the morning. "

Marcel Duhamel, *Raconte pas ta vie*

INTERNATIONAL EXHIBITION

HONI SOIT QUI MALY PENS

DIEU ET MON DROIT

IMPORTED BY

F. E. MORRISH &

FROM

KRUG & Cº REIMS

> *There is a kind of sensitivity, an absolute demand for perfection, the integrity of an artist creating a work greater than himself... The same quality of craftsmanship and absolute, uncompromising perfection; the certainty, among the men and women who make the wine, that they are nothing more than the messengers of a culture, a music that is always being reinterpreted.*

JÉRÔME COHEN,
baritone and stage director

Label adorning the Krug Private Cuvée bottles sold at refreshment stands at the 1862 International Exhibition in London. Joseph Krug and his son Paul traveled to London for the event to introduce Krug Champagne to Great Britain.

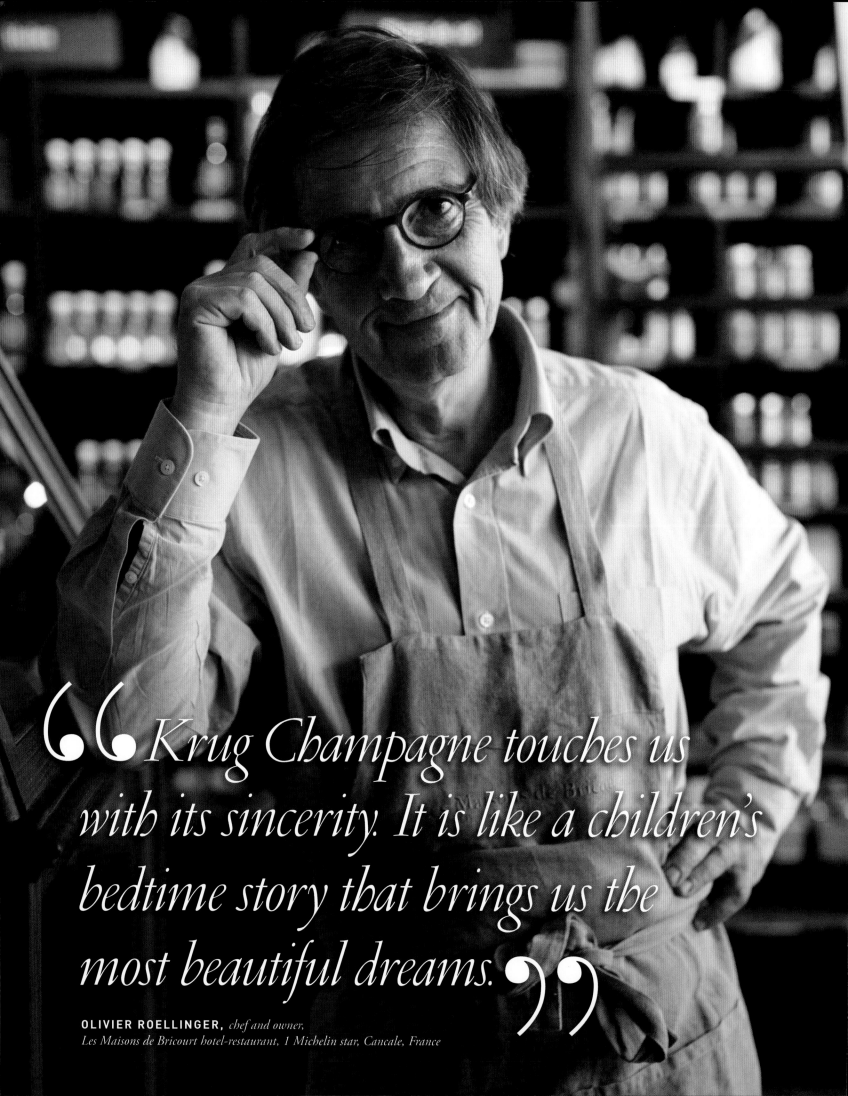

"*Krug Champagne touches us with its sincerity. It is like a children's bedtime story that brings us the most beautiful dreams.*"

OLIVIER ROELLINGER, *chef and owner,*
Les Maisons de Bricourt hotel-restaurant, 1 Michelin star, Cancale, France

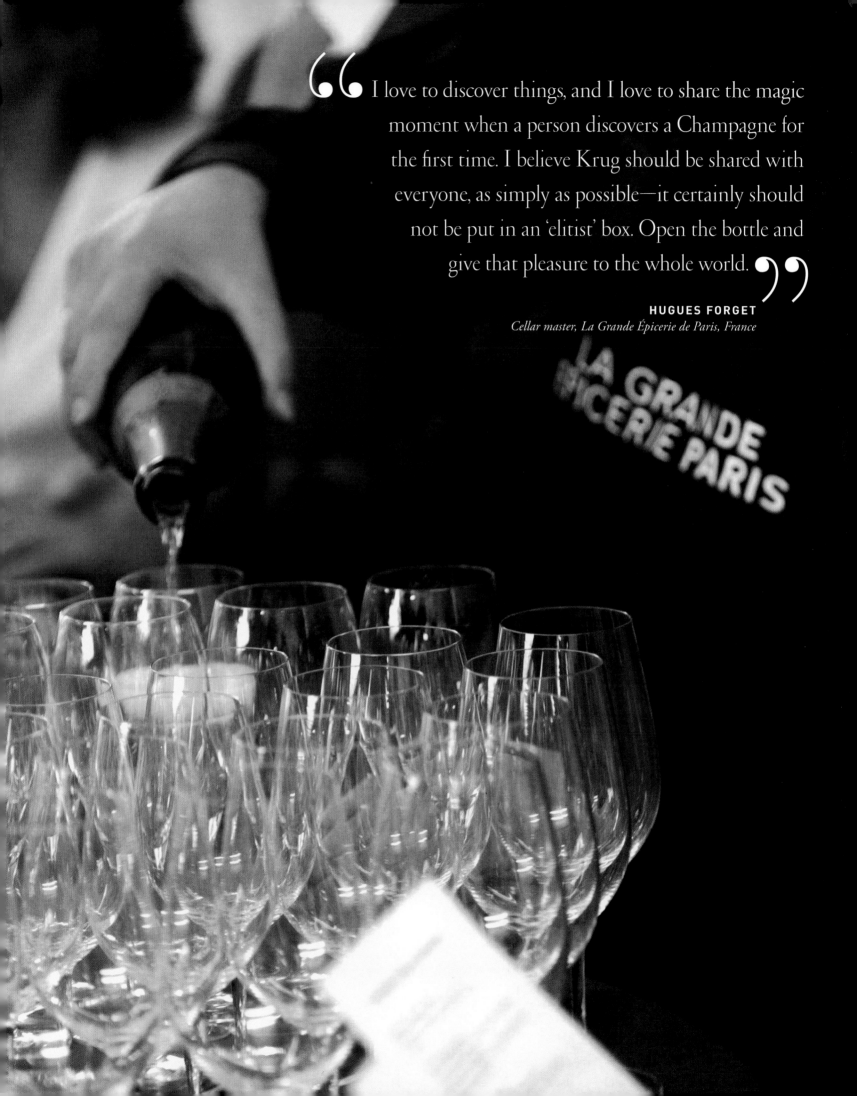

"I love to discover things, and I love to share the magic moment when a person discovers a Champagne for the first time. I believe Krug should be shared with everyone, as simply as possible—it certainly should not be put in an 'elitist' box. Open the bottle and give that pleasure to the whole world."

HUGUES FORGET
Cellar master, La Grande Épicerie de Paris, France

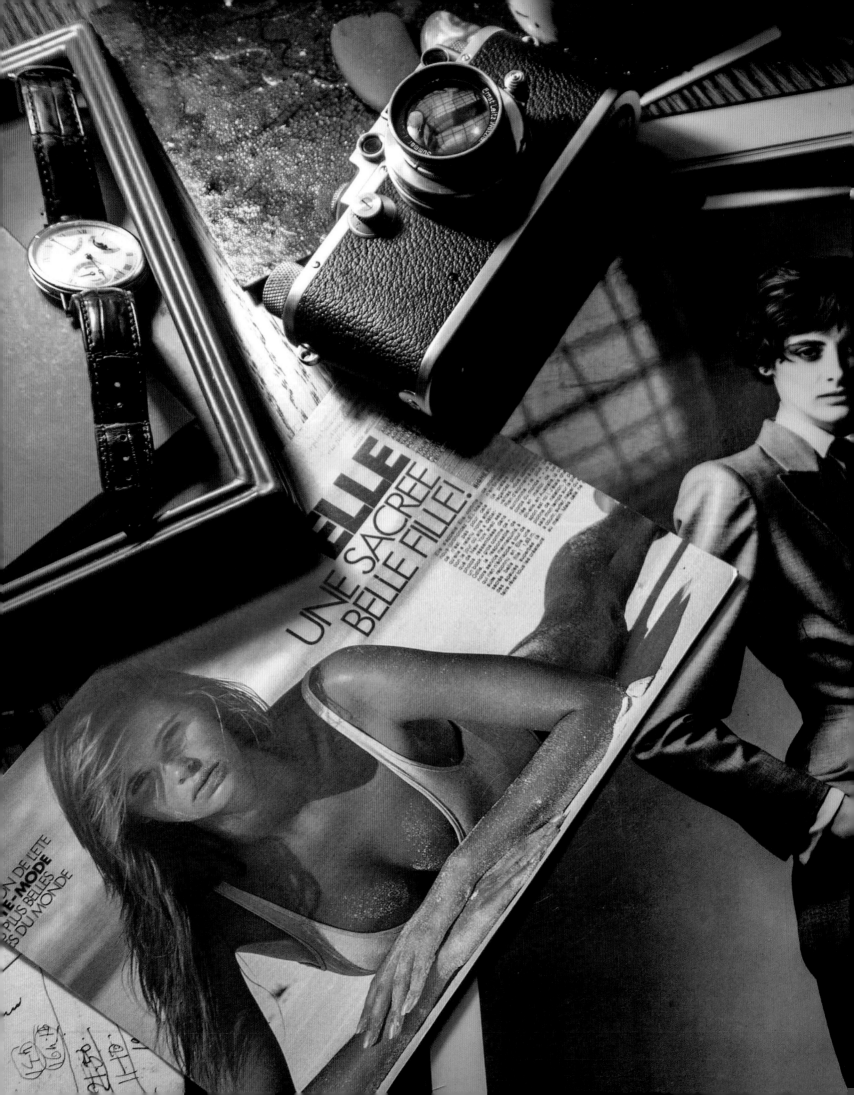

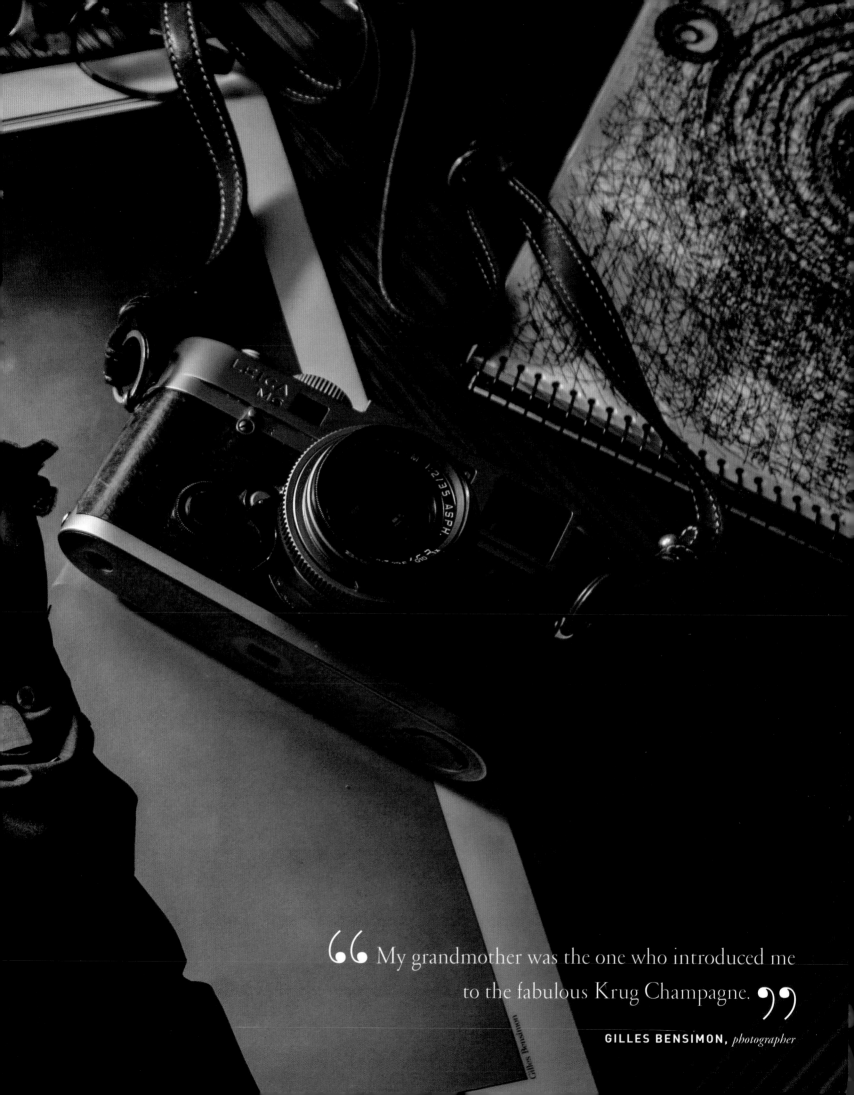

" My grandmother was the one who introduced me
to the fabulous Krug Champagne. "

GILLES BENSIMON, *photographer*

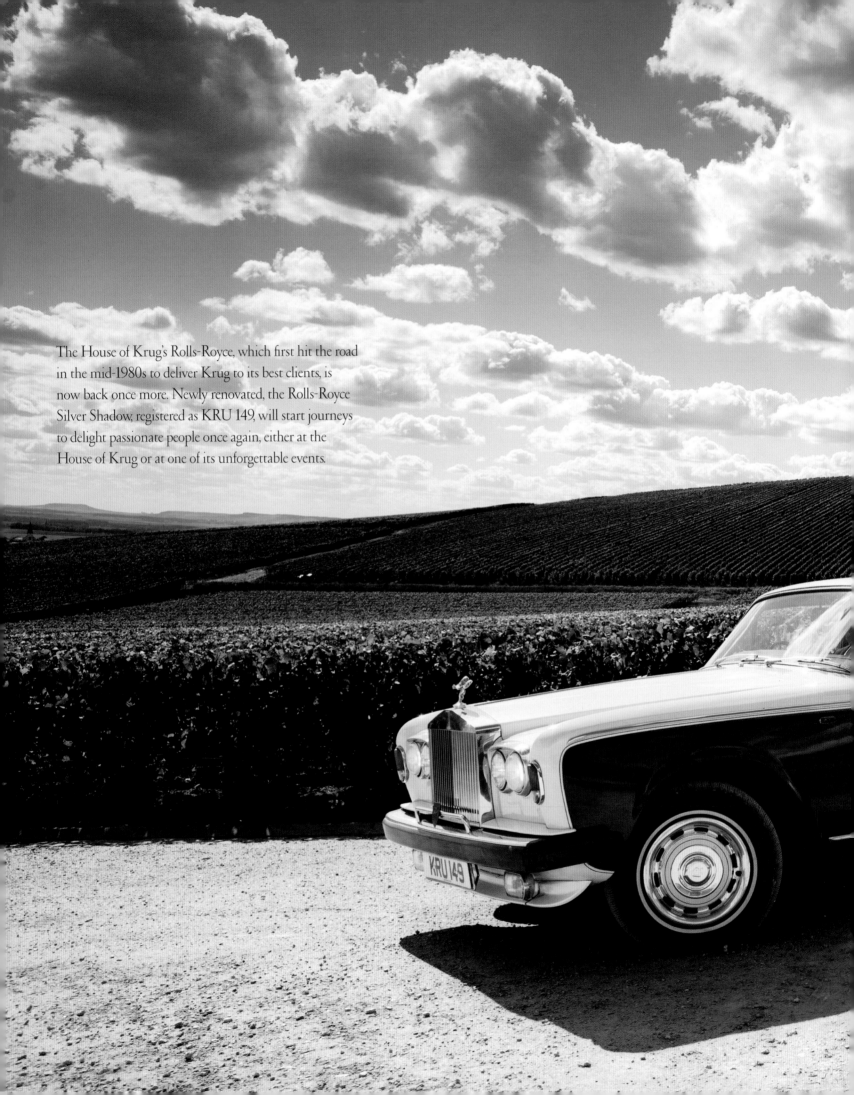

The House of Krug's Rolls-Royce, which first hit the road in the mid-1980s to deliver Krug to its best clients, is now back once more. Newly renovated, the Rolls-Royce Silver Shadow, registered as KRU 149, will start journeys to delight passionate people once again, either at the House of Krug or at one of its unforgettable events.

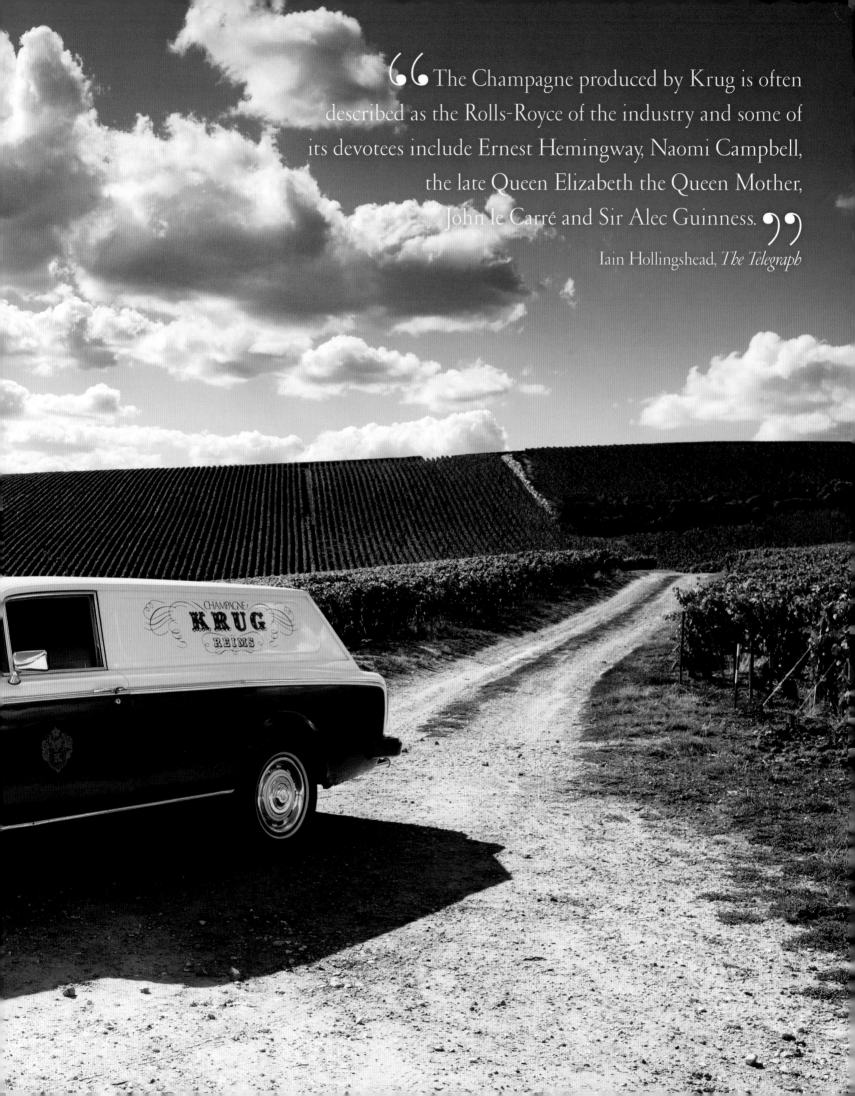

"The Champagne produced by Krug is often described as the Rolls-Royce of the industry and some of its devotees include Ernest Hemingway, Naomi Campbell, the late Queen Elizabeth the Queen Mother, John le Carré and Sir Alec Guinness."

Iain Hollingshead, *The Telegraph*

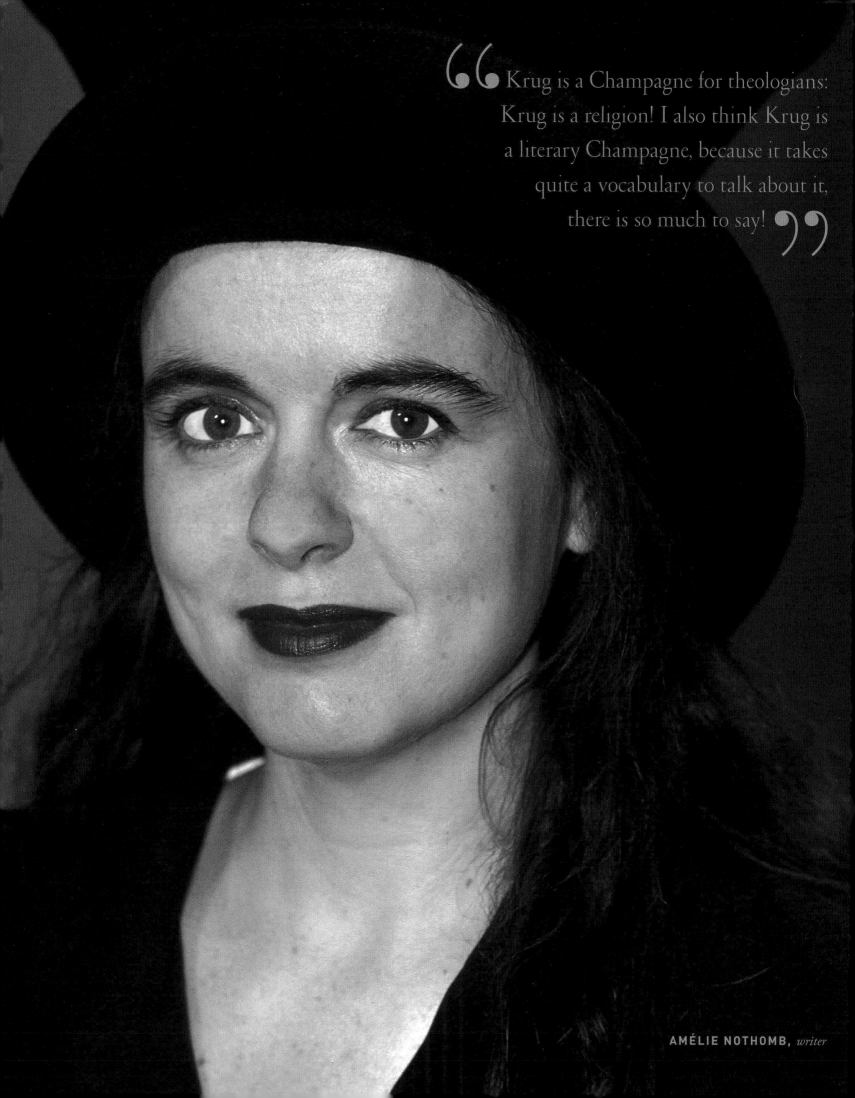

"Krug is a Champagne for theologians: Krug is a religion! I also think Krug is a literary Champagne, because it takes quite a vocabulary to talk about it, there is so much to say!"

AMÉLIE NOTHOMB, *writer*

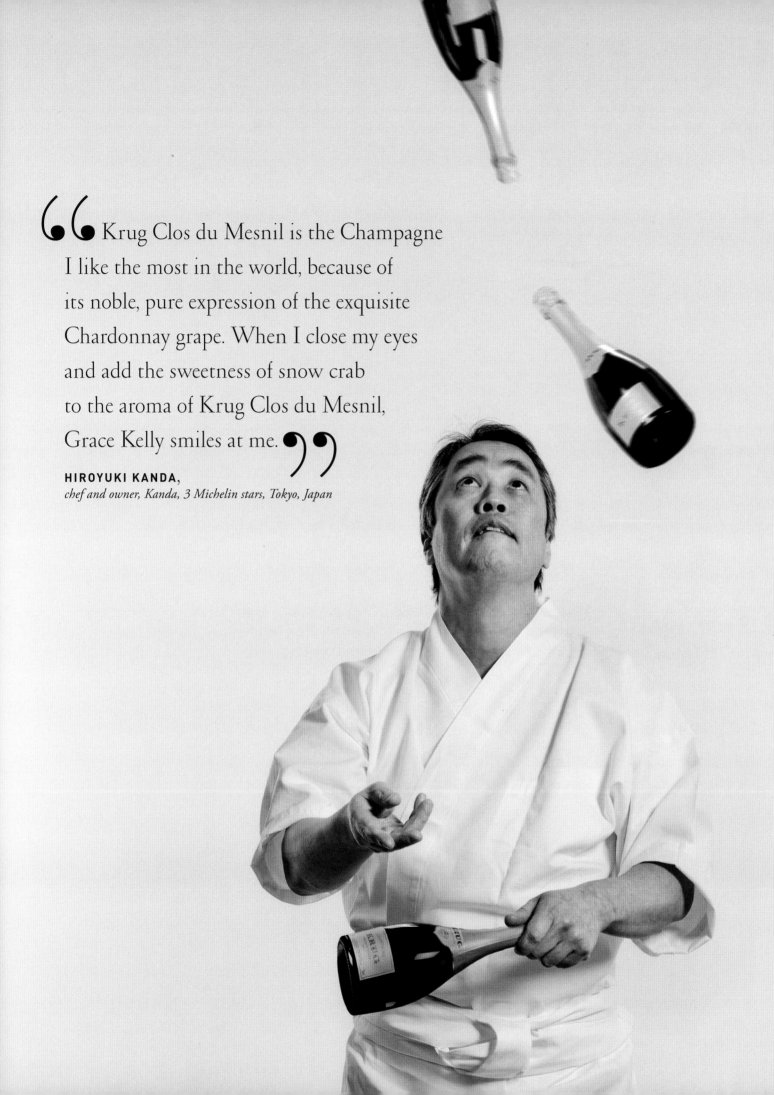

"Krug Clos du Mesnil is the Champagne I like the most in the world, because of its noble, pure expression of the exquisite Chardonnay grape. When I close my eyes and add the sweetness of snow crab to the aroma of Krug Clos du Mesnil, Grace Kelly smiles at me."

HIROYUKI KANDA,
chef and owner, Kanda, 3 Michelin stars, Tokyo, Japan

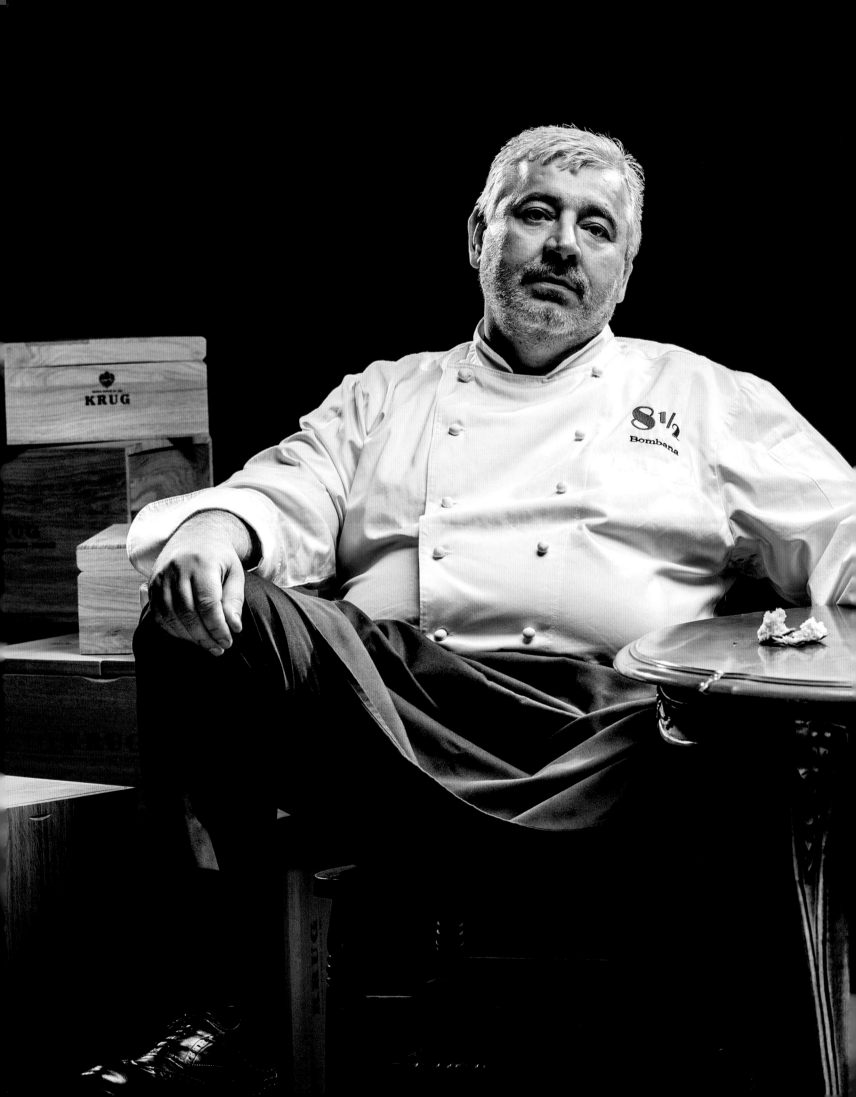

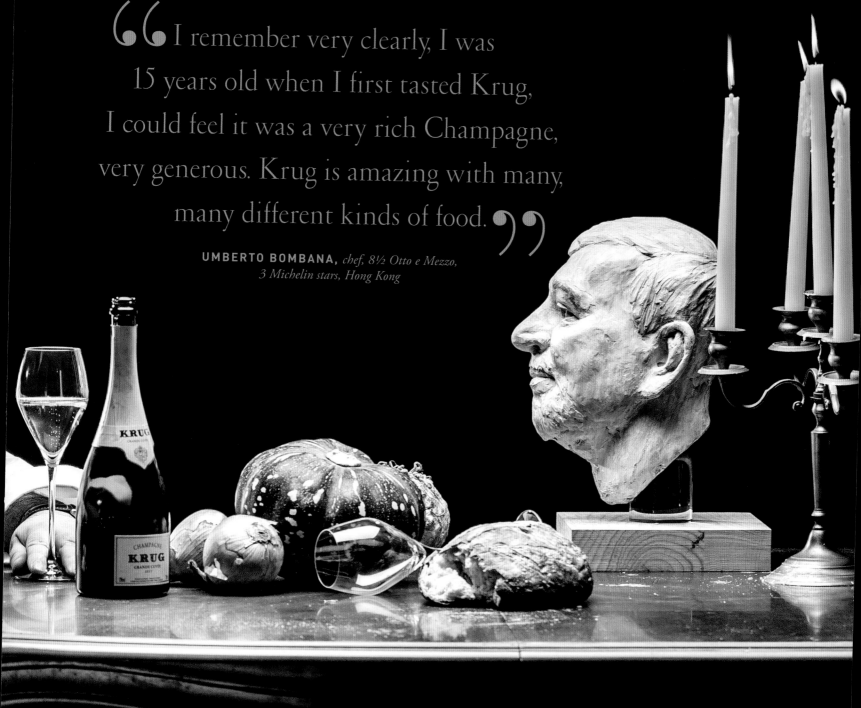

“I remember very clearly, I was 15 years old when I first tasted Krug, I could feel it was a very rich Champagne, very generous. Krug is amazing with many, many different kinds of food.”

UMBERTO BOMBANA, *chef, 8½ Otto e Mezzo, 3 Michelin stars, Hong Kong*

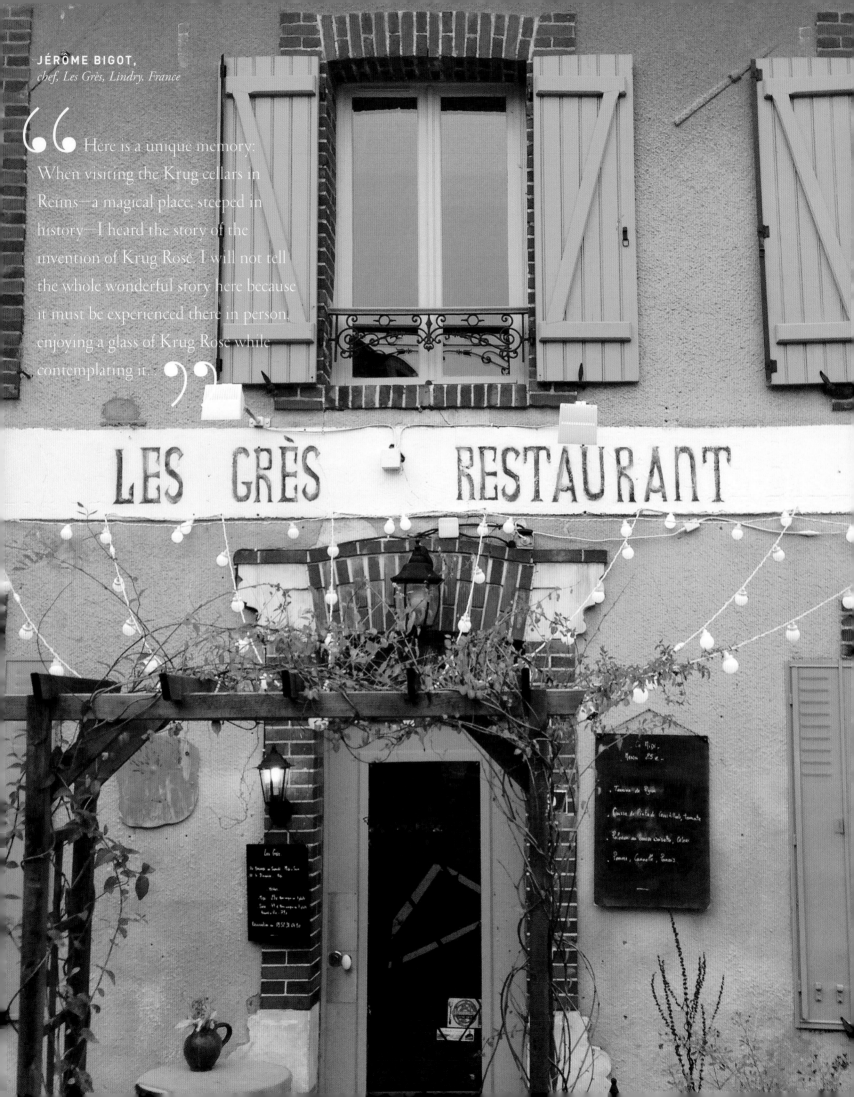

JÉRÔME BIGOT,
chef, Les Grès, Lindry, France

"Here is a unique memory: When visiting the Krug cellars in Reims—a magical place, steeped in history—I heard the story of the invention of Krug Rosé. I will not tell the whole wonderful story here because it must be experienced there in person, enjoying a glass of Krug Rosé while contemplating it."

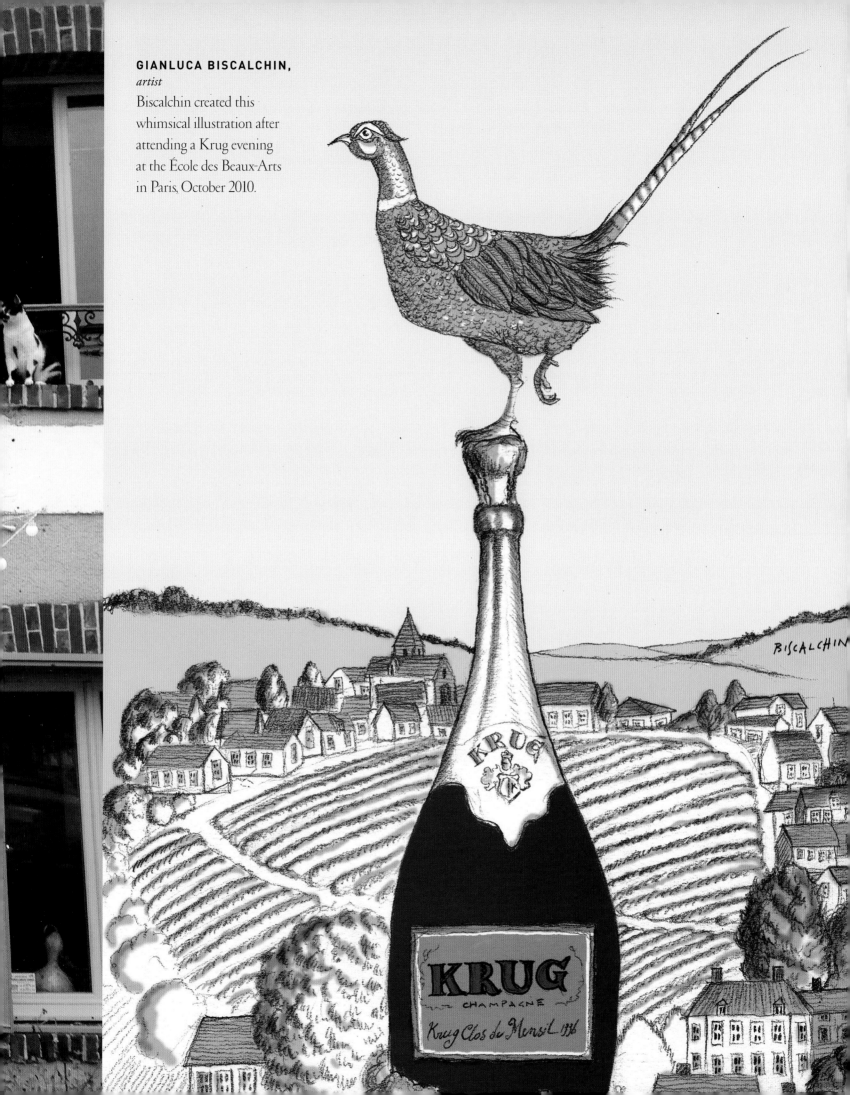

GIANLUCA BISCALCHIN,
artist
Biscalchin created this whimsical illustration after attending a Krug evening at the École des Beaux-Arts in Paris, October 2010.

BISCALCHIN

KRUG

CHAMPAGNE

Krug Clos du Mesnil 1996

"*With Krug, there is no such thing as an 'ordinary' Krug release, but there are many delightful surprises, such as the 1971 or the 1962.*"

PETER GAGO, *chief winemaker, Penfolds, Australia*

"Krug is evidence of a specific taste, an immediate pleasure combined with the fascinating discovery of a subtle complexity. My first encounter with Krug Champagnes took place at the table of Marc Veyrat, through exceptional pairings with his singular and poetic dishes. In my memory, Krug Clos du Mesnil 1981 and Krug Collection 1964 remain summit wines, abiding, timeless, moving."

JEAN-PHILIPPE DURAND, *gastronomy consultant, member of the Association Professionnelle des Chroniqueurs et Informateurs de la Gastronomie, writer for Atabula, author of several books including* D'un hiver à l'autre *with Jean Sulpice*

"There are many magical little moments that make Krug something very special. It is enough to simply experience the Champagne bubbling in the glass. And when the acidity hits the palate and the salty minerality lines the mouth, goose bumps make the hairs on your arm stand up. Magic Krug."

SASCHA SPEICHER, *deputy editor in chief, Weinwirtschaft magazine, Germany*

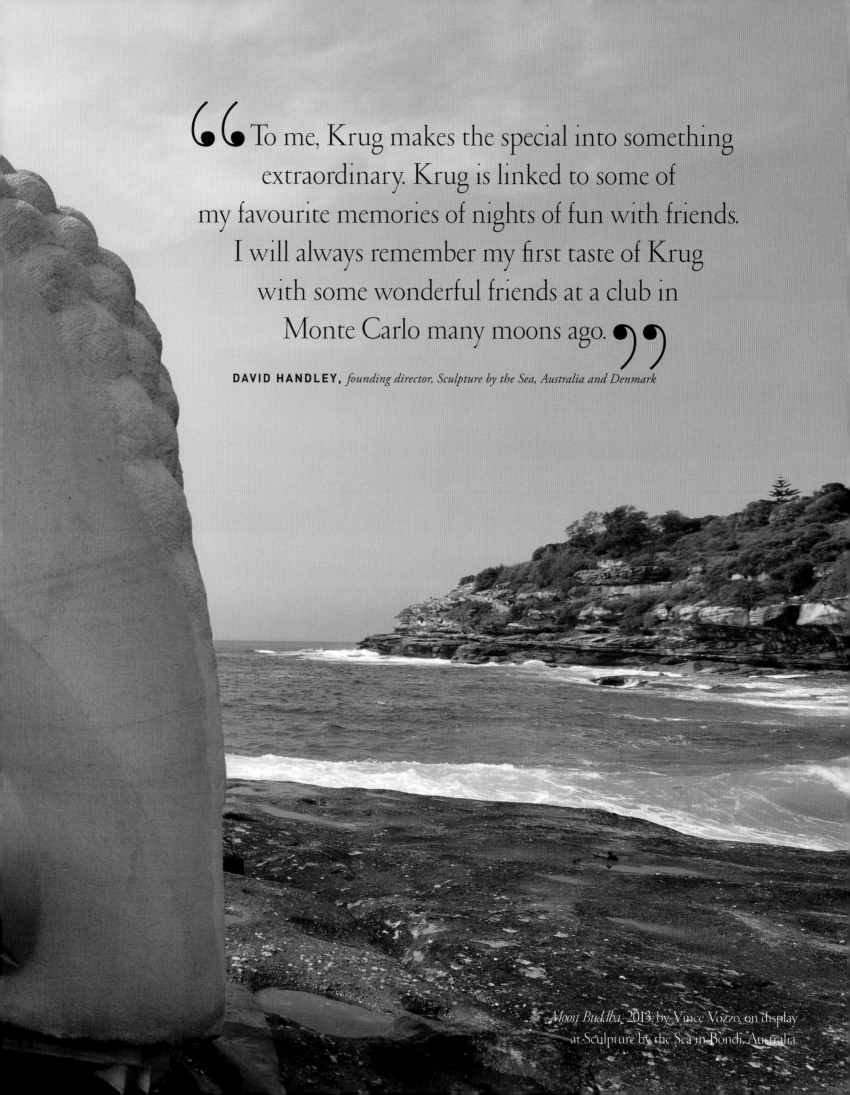

> "To me, Krug makes the special into something extraordinary. Krug is linked to some of my favourite memories of nights of fun with friends. I will always remember my first taste of Krug with some wonderful friends at a club in Monte Carlo many moons ago."

DAVID HANDLEY, *founding director, Sculpture by the Sea, Australia and Denmark*

Moon Buddha, 2013, by Vince Vozzo, on display at Sculpture by the Sea in Bondi, Australia.

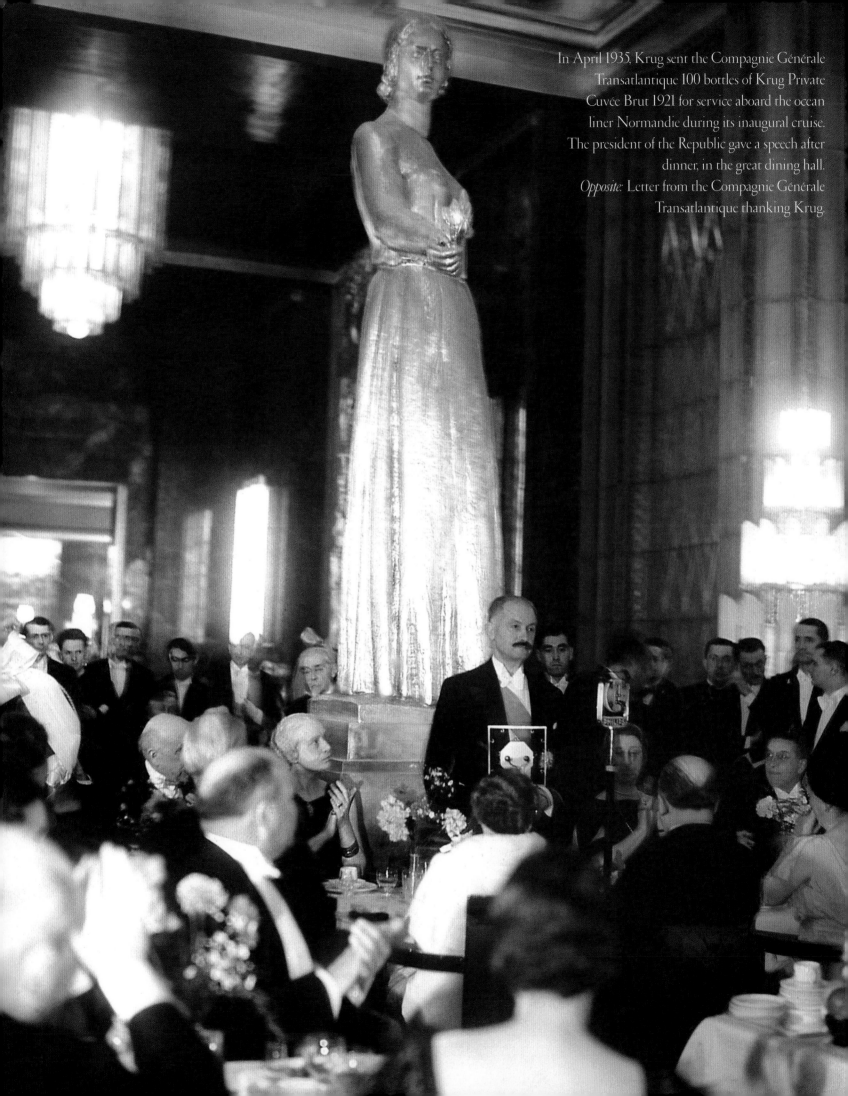

In April 1935, Krug sent the Compagnie Générale Transatlantique 100 bottles of Krug Private Cuvée Brut 1921 for service aboard the ocean liner Normandie during its inaugural cruise. The president of the Republic gave a speech after dinner, in the great dining hall.
Opposite: Letter from the Compagnie Générale Transatlantique thanking Krug.

COMPAGNIE GÉNÉRALE TRANSATLANTIQUE

Société Anonyme au Capital de 216.044.250 Frs

SIÈGE SOCIAL : 6, RUE AUBER
PARIS (IX·)

French Line

PARIS, LE 15 Avril 1935

DIRECTION Gᵉ : OPÉRA 02-01 & suite
PASSAGES..... : OPÉRA 02-44 & suite
BAGAGES.... : OPÉRA 49-52, 92-01
FRET......... : PROV. 15-41 & suite

CHÈQUES POSTAUX PARIS 362-34
ADRESSE TÉLÉGR. : TRANSAT - PARIS
REG. COMMERCE SEINE N° 64.483

APPROVISIONNEMENTS
————
M/F

Champagne KRUG & Cie
REIMS

Messieurs,

Brut
1921

 Vous avez bien voulu mettre à la disposition de notre
Compagnie, à l'occasion de la mise en service de notre nouveau
paquebot "NORMANDIE", 100 bouteilles de vin millésimé, dont 34
à titre gracieux et 66 au prix uniforme de 20 Frs. Nous vous en
remerçions et vous serions reconnaissants de nous faire savoir,
par un très prochain courrier, quel genre de vin et quel millésime
vous comptez nous proposer. Il est indispensable que nous soyons
fixés à ce sujet pour l'impression de nos menus.

 Veuillez agréer, Messieurs, nos salutations distinguées.

Le Chef du Service des Approvisionnements,

Pour L'ADMINISTRATEUR DIRECTEUR GÉNÉRAL
UN DIRECTEUR,

❝ Our unconventional approach, the way we make choices that are not the easiest ones and go beyond the rules when needed illustrates our vision—a constant since the very foundation of the House of Krug. **❞**

OLIVIER KRUG

LIONEL HAMPTON (1908-2002),
jazz musician, bandleader, and composer

Legendary jazz bandleader Lionel Hampton performing at the Knebworth Capital Radio Jazz Festival, Britain, 1982.

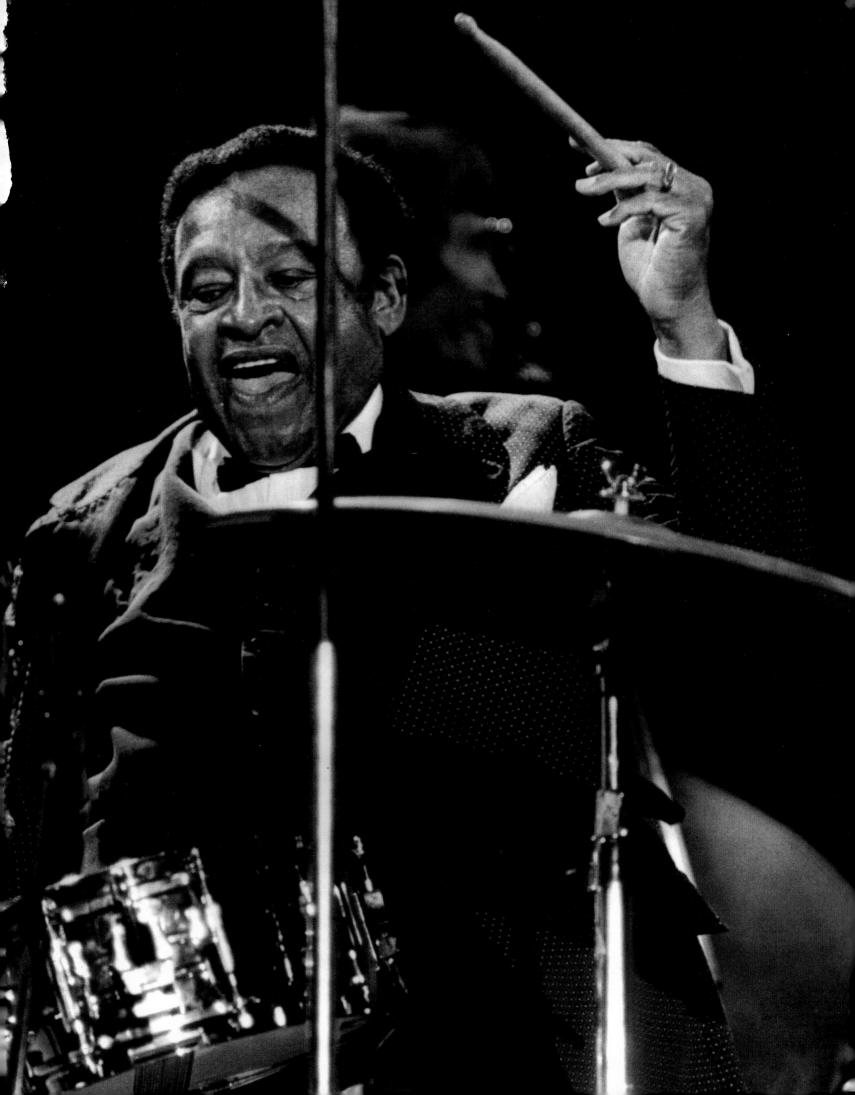

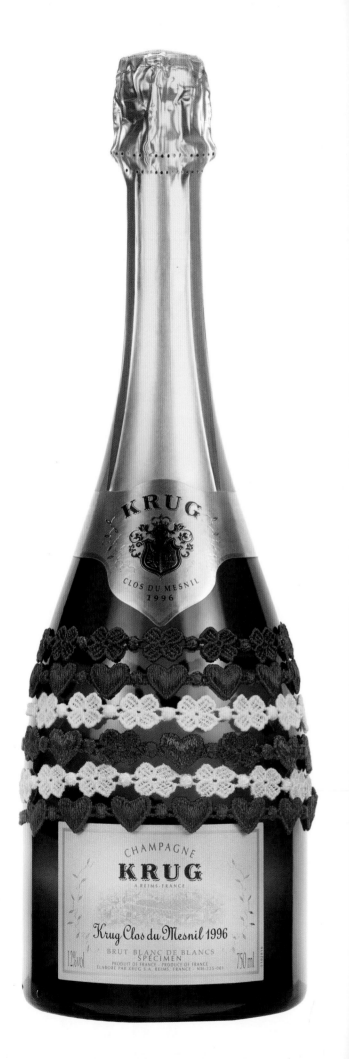
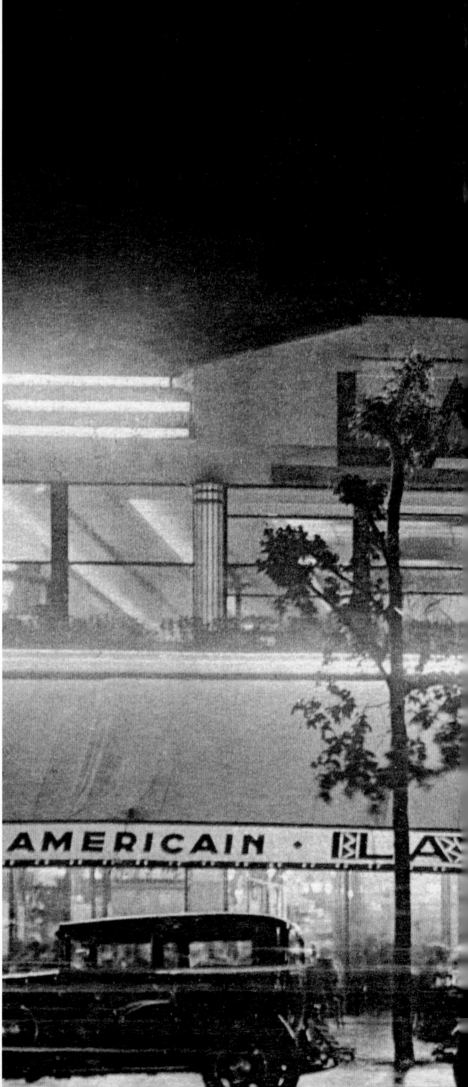

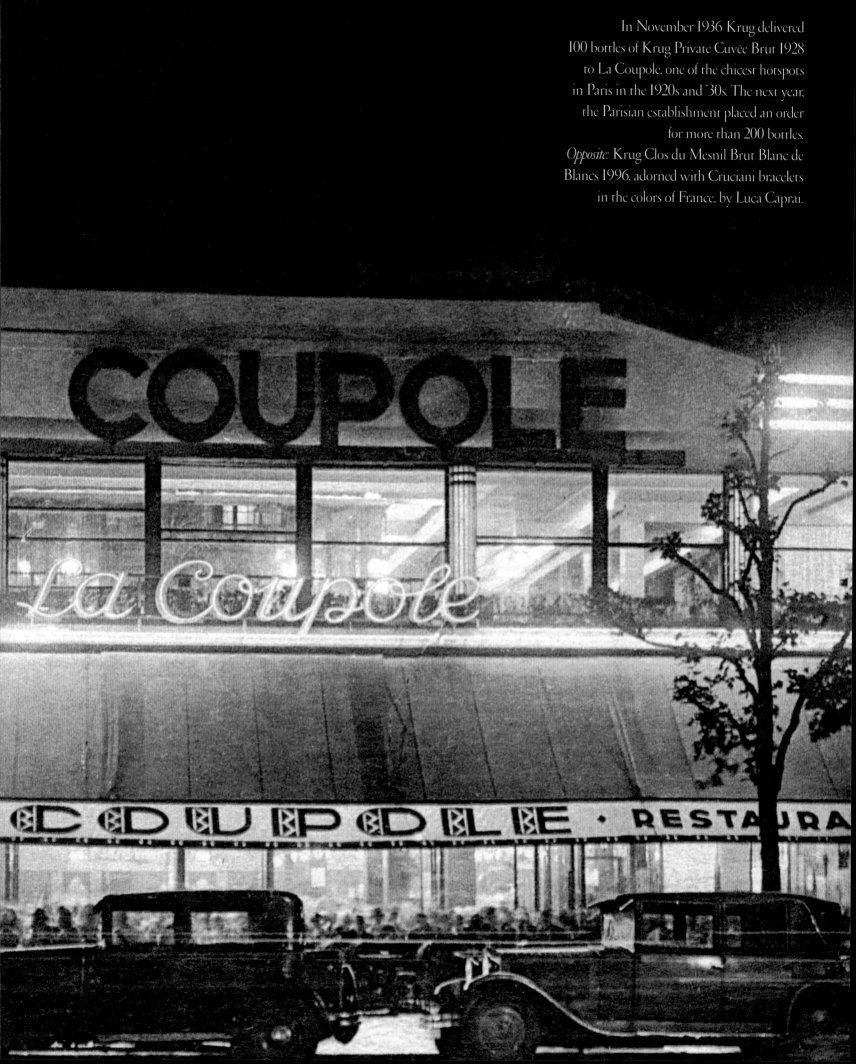

In November 1936 Krug delivered
100 bottles of Krug Private Cuvée Brut 1928
to La Coupole, one of the chicest hotspots
in Paris in the 1920s and '30s. The next year,
the Parisian establishment placed an order
for more than 200 bottles.
Opposite: Krug Clos du Mesnil Brut Blanc de
Blancs 1996, adorned with Cruciani bracelets
in the colors of France, by Luca Caprai.

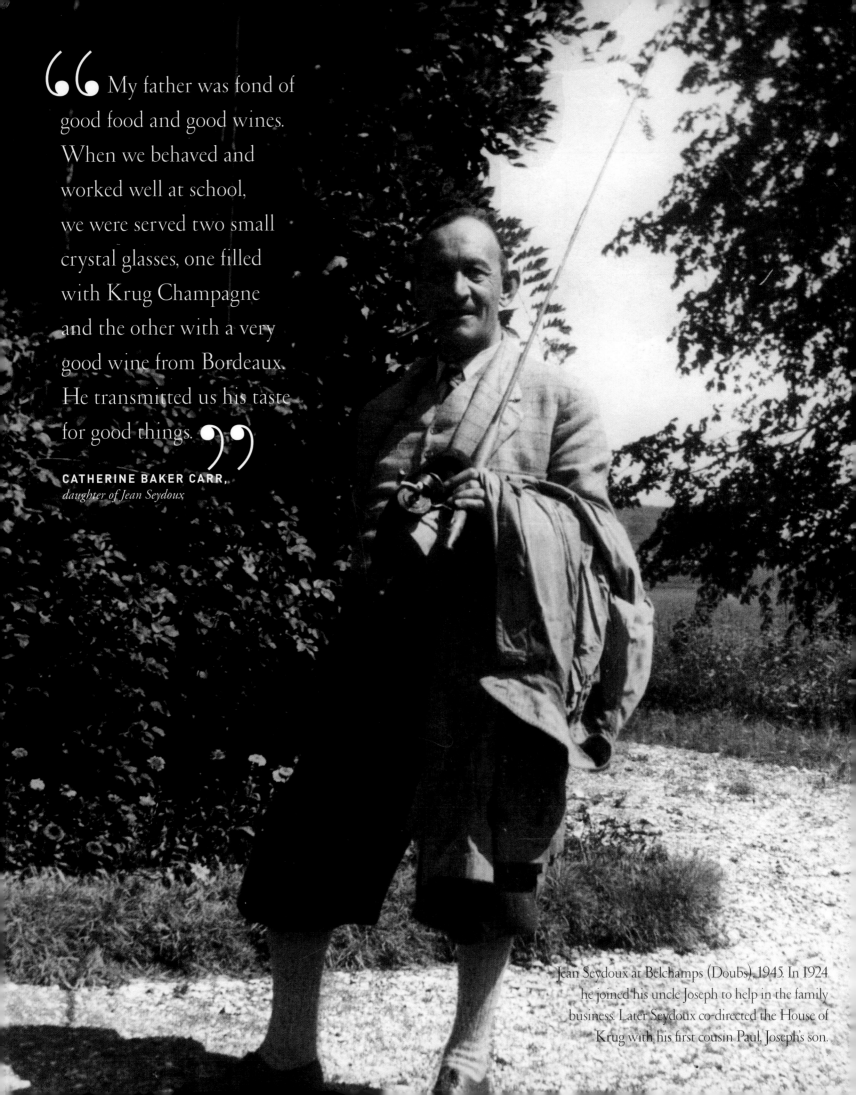

> My father was fond of good food and good wines. When we behaved and worked well at school, we were served two small crystal glasses, one filled with Krug Champagne and the other with a very good wine from Bordeaux. He transmitted us his taste for good things.

CATHERINE BAKER CARR,
daughter of Jean Seydoux

Jean Seydoux at Belchamps (Doubs), 1945. In 1924 he joined his uncle Joseph to help in the family business. Later Seydoux co-directed the House of Krug with his first cousin Paul, Joseph's son.

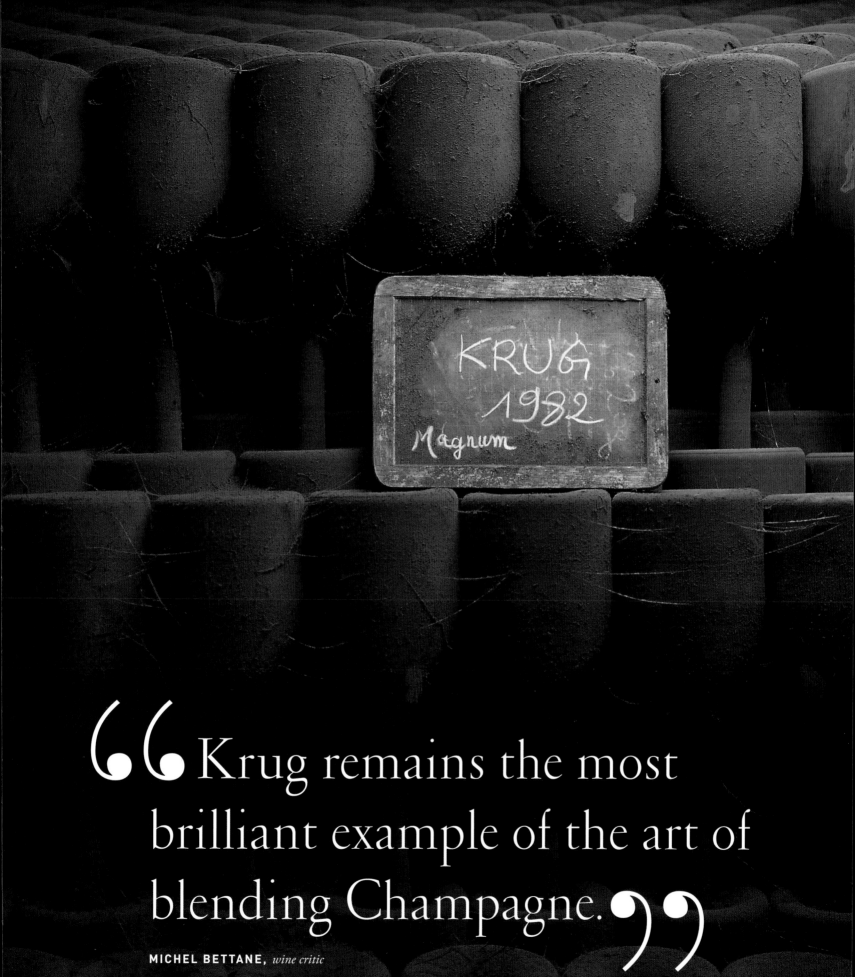

66 Krug remains the most brilliant example of the art of blending Champagne. 99

MICHEL BETTANE, *wine critic*

> " During the most emblematic and unforgettable moments of my career, after long struggles and complete deliverance into the arms of my audience, I have been feted on numerous occasions. On a few of these marvellous occasions, I had the privilege to taste a true nectar of life and passion: This nectar is Krug. It transported my taste buds to an infinite universe, a festival of aromas, flavours and colours, similar to the many shades and musical cadences that have accompanied me throughout the length of my career. Krug, magic lyricism and utterly unique... I repeat, UNIQUE. "

> " These are the words I heard from Montserrat Caballé on the occacion of the twenty-second anniversary of the magazine she cofounded, *Opera Actual,* in October 2013 at the Liceo de Barcelona theatre. "

OSCAR MARTOS, *tenor, director, producer, member of* Opera Actual *magazine*

MONTSERRAT CABALLÉ, *soprano*

Montserrat Caballé in London, 1992.

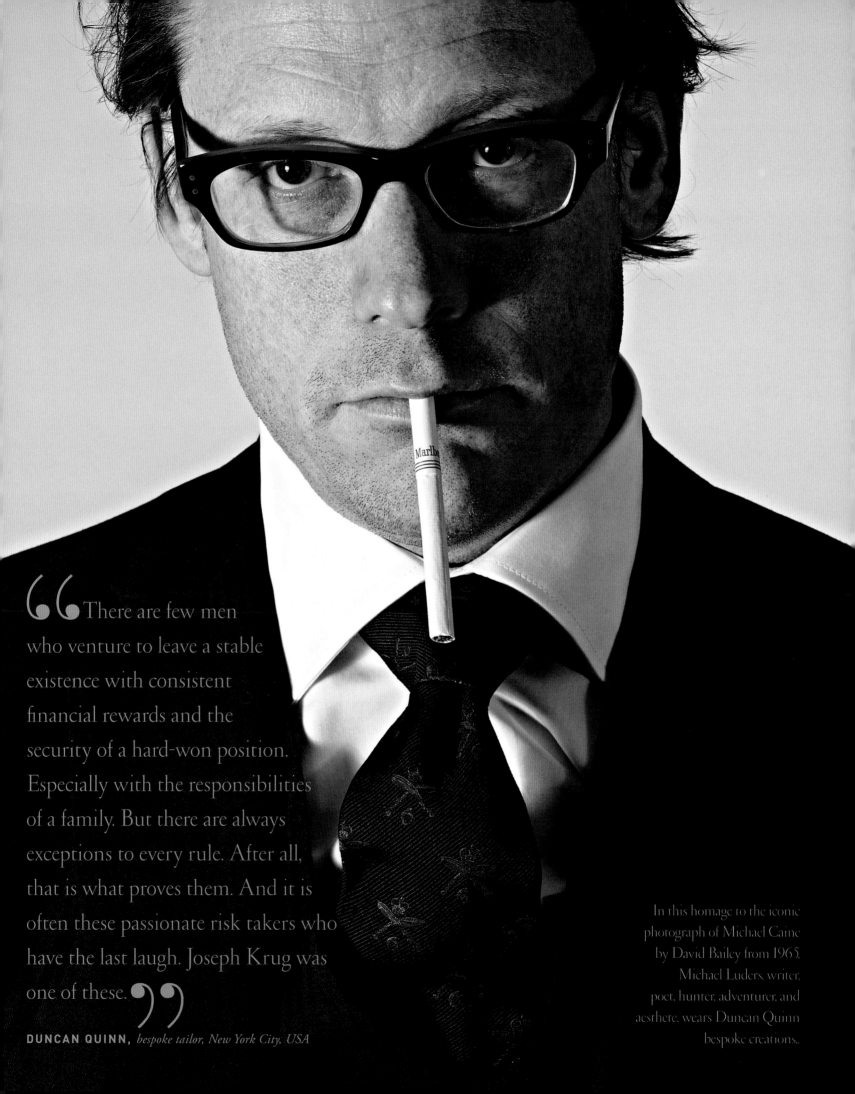

"There are few men who venture to leave a stable existence with consistent financial rewards and the security of a hard-won position. Especially with the responsibilities of a family. But there are always exceptions to every rule. After all, that is what proves them. And it is often these passionate risk takers who have the last laugh. Joseph Krug was one of these."

DUNCAN QUINN, *bespoke tailor, New York City, USA*

In this homage to the iconic photograph of Michael Caine by David Bailey from 1965, Michael Luders, writer, poet, hunter, adventurer, and aesthete, wears Duncan Quinn bespoke creations..

"I love Champagne, preferably Krug Grande Cuvée."

DAME STELLA RIMINGTON, *former director general, MI5 Security Service, UK*

CONNAUGHT HOTEL. *London, UK*
Krug Champagne is served in the Champagne Room.

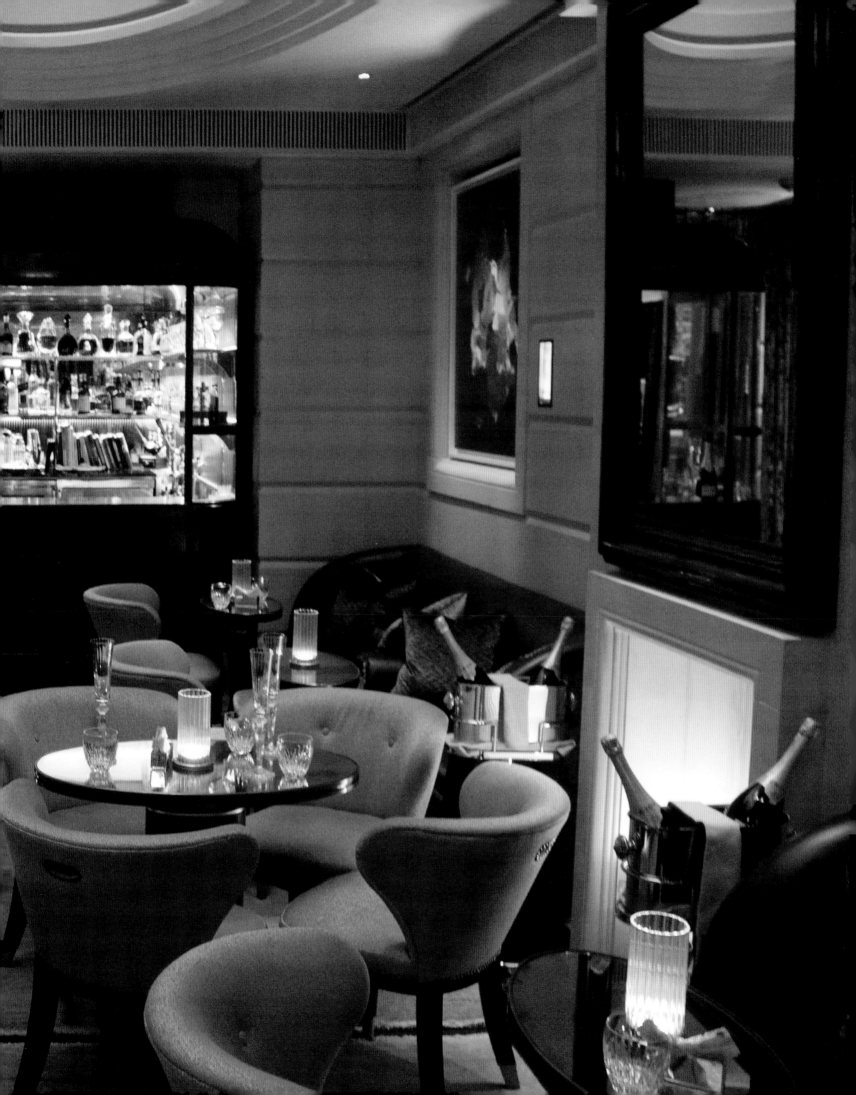

66 I once compared the experience
of drinking Krug rosé to a dream I had of
kissing Sharon Stone; I suspect that
drinking the 1990 in a few years will be
something like kissing Angelina Jolie. **99**

"The Cult of Krug" chapter, *Bacchus & Me: Adventures in the Wine Cellar*
JAY McINERNEY, *novelist and wine writer*

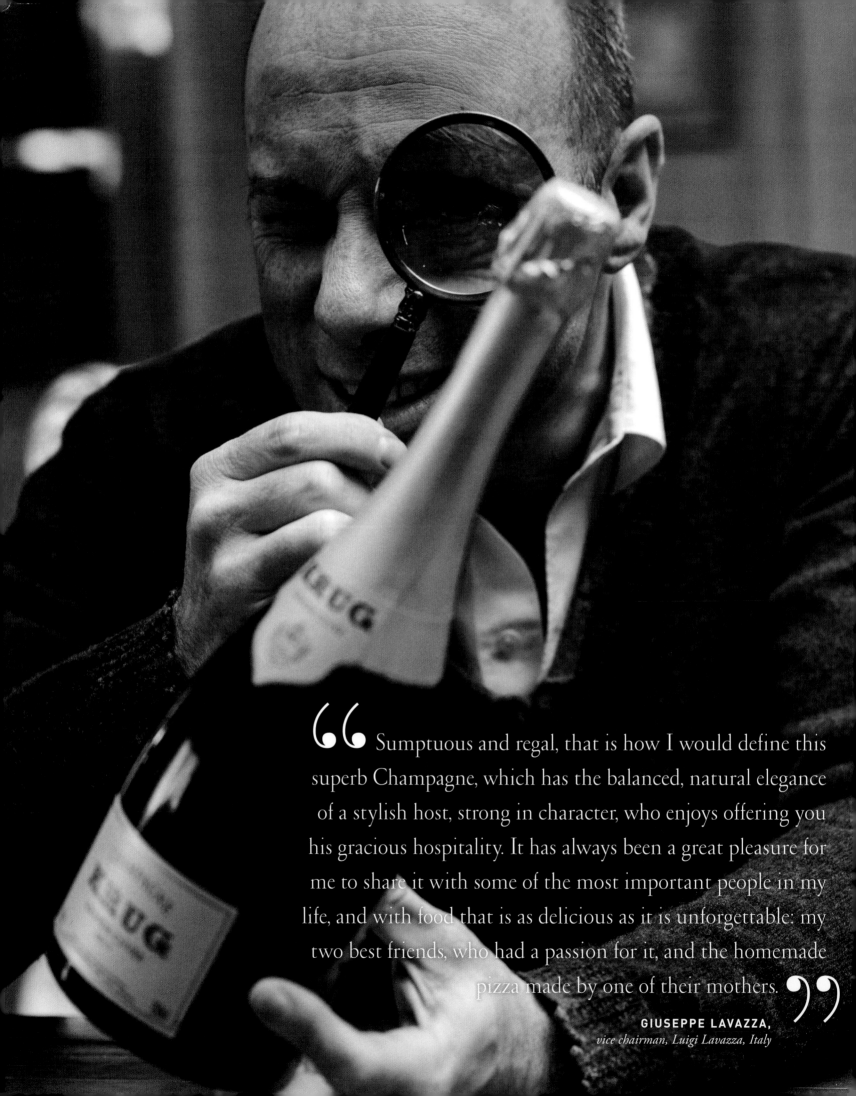

" Sumptuous and regal, that is how I would define this superb Champagne, which has the balanced, natural elegance of a stylish host, strong in character, who enjoys offering you his gracious hospitality. It has always been a great pleasure for me to share it with some of the most important people in my life, and with food that is as delicious as it is unforgettable: my two best friends, who had a passion for it, and the homemade pizza made by one of their mothers. "

GIUSEPPE LAVAZZA,
vice chairman, Luigi Lavazza, Italy

When asked to describe his most memorable wine experience:

"A magnum of Krug Clos du Mesnil Champagne,
enjoyed with a galette..."

ALAIN PASSARD, *chef, Restaurant Arpège,*
3 Michelin stars, Paris, France

"Throughout my life, I have considered myself very lucky to have been introduced to Krug Champagne by the great Arthur Rubinstein."

DANIEL BARENBOIM,
musician, conductor

Daniel Barenboim conducting the West-Eastern Divan Orchestra at the Ravello Festival, 2008.

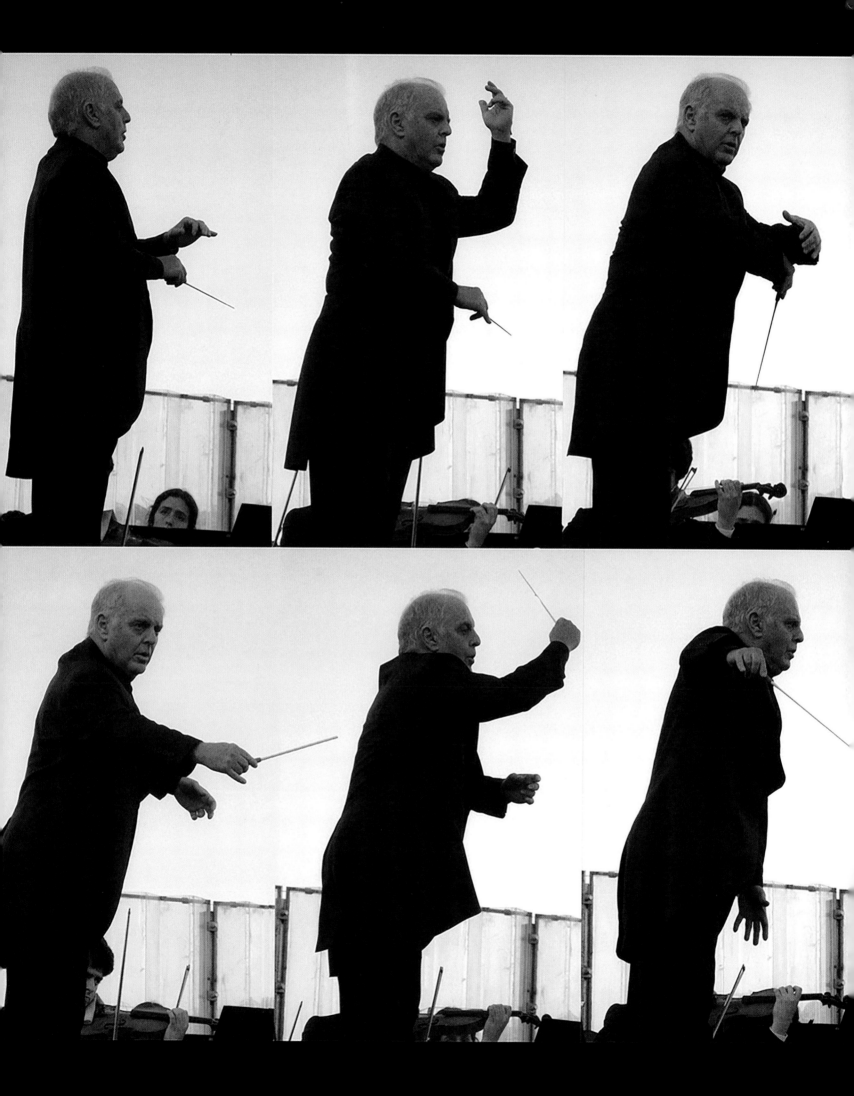

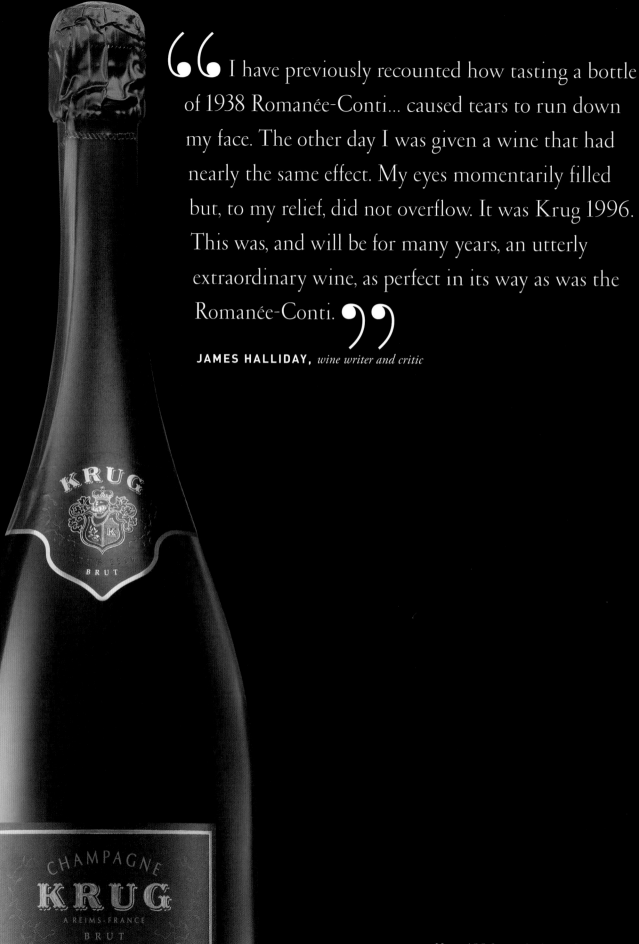

"I have previously recounted how tasting a bottle of 1938 Romanée-Conti... caused tears to run down my face. The other day I was given a wine that had nearly the same effect. My eyes momentarily filled but, to my relief, did not overflow. It was Krug 1996. This was, and will be for many years, an utterly extraordinary wine, as perfect in its way as was the Romanée-Conti."

JAMES HALLIDAY, *wine writer and critic*

Krug 1996 was the last to be overseen by three generations of the Krug family: Paul, Henri, Rémi, and Olivier, *opposite*, photographed in 1993.

> 66 All his life, my grandfather avoided
> any form of exaggeration, but this time
> he looked at us and said,
> 'I think this could well be the next 1928.' 99

OLIVIER KRUG, *commenting on Krug 1996 when blended in 1997*

"The bar at the Normandy was one of the first, if not the first, bars to get people talking about Krug, when we began serving it by the glass. I also had the opportunity to participate in many Krug events and thereby meet passionate Krug fans. In our bar, I attach particular importance to the "theatre" of service in general, particularly when it comes to serving Krug. Each time we serve a glass of Krug we present the bottle to the client, and all glasses are served at the table in front of the customer. My preferred method for tasting Krug Grande Cuvée is to take the chilled bottle from the refrigerator for the appetizer and then—without putting it on ice—let it come up to room temperature during the remainder of the meal. A revelation of aromas and flavors gain momentum as the temperature rises."

MARC JEAN,
head bartender, Normandy Barrière hotel, Deauville, France, a member of the Lucien Barrière Group

“We had rented a huge house, and as we went to discover all the rooms in it... We opened the fridge, hoping that we might get lucky. It was a long shot, but sure enough, in there, glowing in the dark, was a perfectly chilled Krug 1988... I remember removing the foil, the dry sound of the pop. The cork was dark and soaked—it smelled like nuts and toast and honey. From that day on, Krug became something sacred to me.”

THOMAS HARGREAVE, *photographer, creative director*

“*When I take a sip of Krug Champagne, the ideas and food combinations just start coming to me.*”

JIŘÍ ŠTIFT, *executive chef, Essensia, Mandarin Oriental, Prague, Czech Republic*

ANNABEL'S *club, London, UK*
Krug Champagne is served at the
famed Annabel's club.


“ The moon on the bay, the gentle movement of the boat on a warm summer's eve, good friends, soft music, and Krug... perfection! ”


CHRIS DE BURGH,
musician, songwriter

Enjoying Krug Champagne during the Calvi on the Rocks
festival, 2007, Corsica, France.

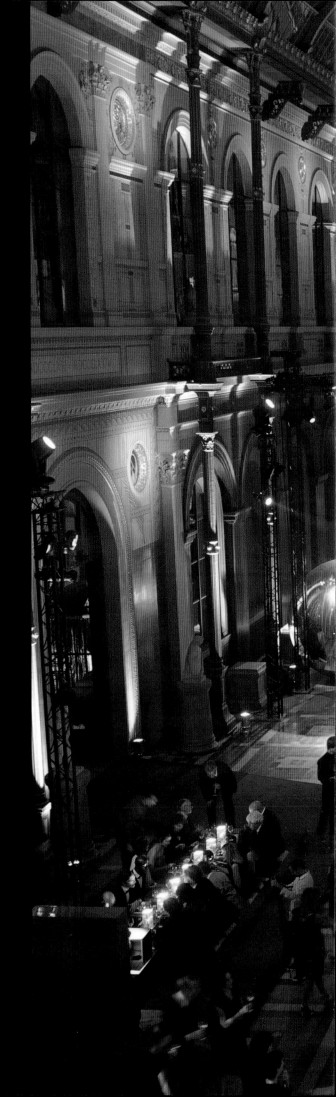

"The soirée was chic as hell. We passed through a corridor hung with illustrations of Krug drinkers from Dalí to Oscar Wilde....

And under the magnificent glass ceiling ... were assembled the Beautiful People from nearly everywhere....

No less than six great chefs from around the world created some deluxe food. And to wash it down, glasses of very good bubbly: Krug 1995, Clos du Mesnil 1998, the kind of sweets that one does not sip every day...."

Guillaume Crouzet, *L'Express*

ÉCOLE DES BEAUX-ARTS, *Paris, October 8, 2010*

Krug invited an exclusive guest list to experience an unconventional voyage through the constellations of the Krug universe, from Krug Clos du Mesnil 1998 to Krug 1995 and Krug 1998 to Krug Grande Cuvée and Krug Rosé. It was an unforgettable evening of unexpected encounters between each of these Champagnes, featuring six esteemed chefs from around the world: Tim Raue, Angela Hartnett, Uwe Opocensky, Roberto Okabe, Arnaud Lallement, and Tsuyoshi Murakami.

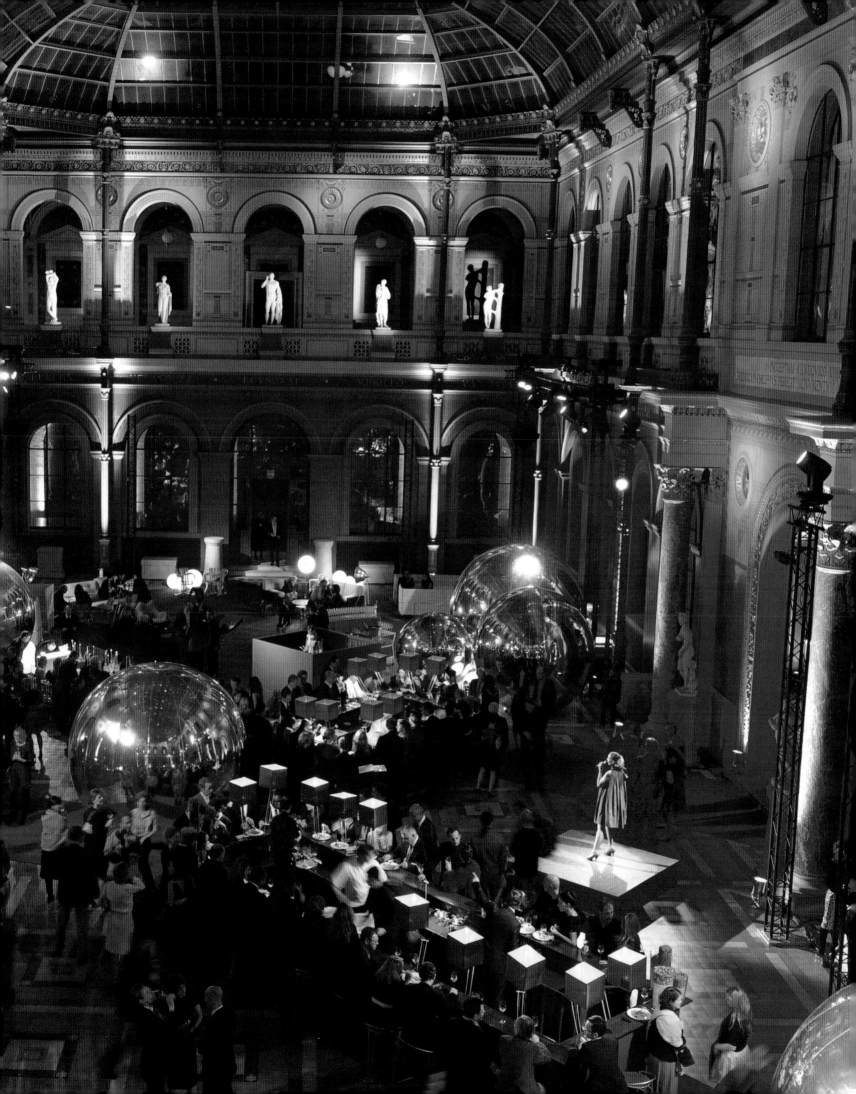

Birth of Joseph Krug in Mainz,
part of the French Empire (1800–14).

Joseph Krug begins
a secret collaboration
with Hippolyte de
Vivès, who later
invites him to take
over his Champagne
house as a major
shareholder.

Shipping voucher
confirming the first
shipment of Krug
champagne to the
United Kingdom.
Calais, June 1, 1844.
Maison Krug archives.

Krug sends its first shipments to the
United Kingdom and the United States.

Joseph Krug was granted a
travel permit by the Grand
Duchy of Hesse, describing
him as a "trader and
commercial traveller."

Joseph Krug
founds the house
of Krug in Reims.

Krug creates its
first vintage.
Krug sends its first
shipment to Sweden.

1800 1834 1841 1842 1848
 1824 1839 1843 1844 1846

Birth of Paul Krug.

Joseph Krug arrives
at Jacquesson,
a champagne merchant
in Châlons-sur-Marne.

Joseph Krug wrote in
his dark-cherry leather
notebook his messages,
vision and beliefs to guide
his son in later years.

Joseph Krug marries
Emma Jaunay.

Letter from Joseph Krug to Adolph
Jacquesson: "It is very flattering to me—
the friendship you bring as much as the
evidence of your satisfaction with my
humble services." Châlons-sur-Marne,
October 23, 1836. Maison Krug archives.

Marriage contract of
Joseph Krug, head
of accounting at
Jacquesson & Fils in
Châlons-sur-Marne,
and Emma Jaunay,
signed February 16, 1841.
Maison Krug archives.

Death of Joseph Krug.
Paul Krug succeeds
his father as the head
of the House of Krug.

Krug Private Cuvée is
introduced in Great Britain at
the International Exposition in
London with much success.

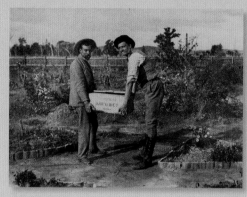

Two Australians carrying a case of Krug Champagne, early 20th century.
Note on back of photo: "Copied from the collections of the State Library of New
South Wales. Paul Wenz, Nanima Station, Forbes" (cote MSS 464 Hen 4).

Krug makes an important
purchase of a property on
rue Coquebert in Reims, where
the House still is today.

Birth of Joseph II, son of
Paul Krug and Caroline Harlé.
Krug sends its first shipments to
Australia and Japan.

1857 1865

1856 1862 1866 1869

For the first time, Joseph
names his Champagne
Krug Private Cuvée.

Krug 1865 is an excellent expression of a
beautiful year in Champagne.

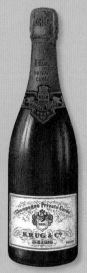

Illustration of Krug
Private Cuvée bottle.
Early 20th century.
Maison Krug archives.

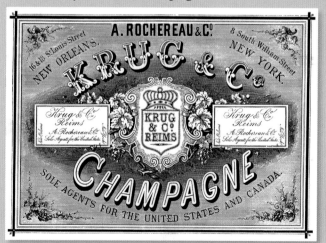

Advertisement by A. Rochereau & Co, Krug brand agent in
the United States and Canada. Maison Krug archives.

Paul Krug, president of the Trade Union of Wines of Champagne, receives the Legion of Honor for his commitment to Champagne during the International Exhibition in Paris.

Joseph II Krug is called up for service in World War I.

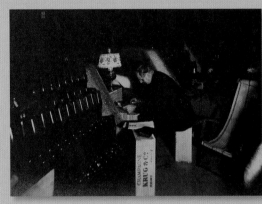

During World War I, life and work carried on in the company cellars. Maison Krug archives.

Letter to the Maison from its United States agents, informing that Krug Champagne was served during the banquet.

Krug Champagne is served at a banquet given by the New York Chamber of Commerce in honor of the French officers on the ships escorting the Statue of Liberty to New York.

1874 1893 1904 1910

1885 1900 1914

Joseph II Krug succeeds his father, Paul, as the head of the House.

Joseph II joins the army to become a marine, but returns to the House to later succeed his father.

Joseph II Krug, son of Paul, marries Jeanne Hollier-Larousse.

Champagne-making facilities are built at 5 rue Coquebert in Reims.

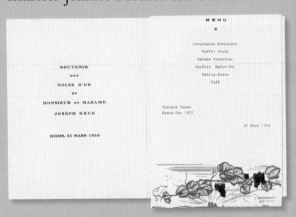

Menu of the meal served at the golden anniversary festivities for Joseph and Jeanne Krug. Reims, March 21, 1954. Maison Krug archives.

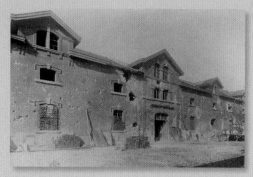

The House storerooms in 1918. Maison Krug archives.

The Krug 1928 vintage is recognized as magnificent, both then and still today.

Joseph II Krug returns from war so weakened it was expected he would soon die, but he recovered and continued managing the House of Krug for many years.

Joseph II Krug is taken prisoner of war; his wife Jeanne manages the company. Creation of 1915 vintage.

Birth of Henri Krug.

1917

1924

1933

1915

1918

1921

1928

1937

The evacuation of Reims forces Jeanne Krug and the Krug workers to leave the city.

Jean Seydoux is appointed joint manager to assist his uncle Joseph Krug.

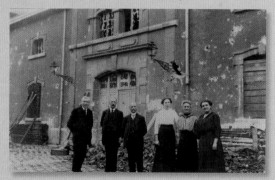

Jeanne Krug and staff members in front of the company storeroom, 1917. Maison Krug archives.

This year produces an excellent vintage. Krug 1921 was the expression of a very good year in Champagne.

Paul II Krug participates in his first blending tasting.

Krug acquires the
Clos du Mesnil vineyard
in Mesnil-sur-Oger.

Death of Joseph II Krug.

Henri's brother
Rémi Krug
joins the House.

Henri and Rémi Krug
offer a glass of their
new potential Krug
Rosé to their father in
a blind tasting. Paul
Krug approves the
Champagne because
"It was a Krug before
being a rosé."

1942		1962			1976	
	1959		1967	1971		1983

Henri Krug joins his
father, Paul II Krug,
at the head of the House.

Henri and Rémi Krug
find the Pinot Noir
grapes of the House-
owned plot in Aÿ ready
to be made into red wine.
They decide to embark
on an initial experiment
for a Krug Rosé.

Birth of
Rémi Krug.

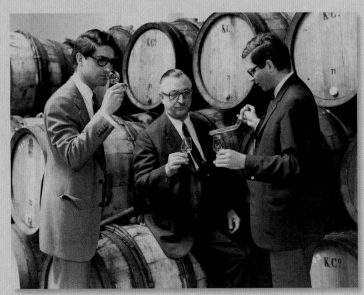

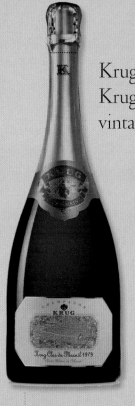

Krug presents the first
Krug Clos du Mesnil
vintage, created in 1979.

LVMH acquires
the House of Krug.

Margareth Henriquez is
appointed President and CEO
of the House of Krug.

Éric Lebel becomes
Cellar Master.

Krug: A Journey Through History is published.
This is the first book
of the history of the
House published in
five languages.

1994

2007

1986

1998

1999

2009

2013

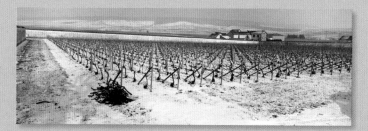

Krug presents the first
Krug Clos d'Ambonnay,
the vintage 1995.

Olivier Krug becomes
House Director;
Rémi Krug retires.

After nine years of research to find the best plot
of vines from which to obtain a pure expression
of Pinot Noir in Ambonnay, Krug purchases
Clos d'Ambonnay.

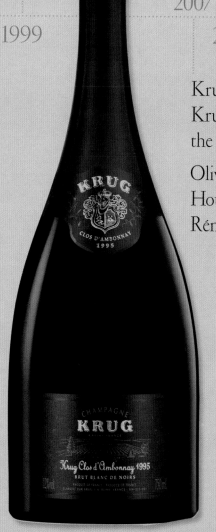

ACKNOWLEDGEMENTS

I would like to express my gratitude to both Prosper and Martine Assouline who, from our very first meeting, immediately believed in and shared my dream. After publishing the history of the House of Krug and discovering so much of the beauty of its long, rich and varied life, I began to imagine a new and special book which could express this history in a different way. Martine helped us immeasurably with her vision, commitment and dedication, her great understanding of art, as well as her deep appreciation for the timeless nature of the Houses, where the House of Krug particularly has such an emblematic role.

I would also like to take this opportunity to give my heartfelt thanks to all the Krug Lovers, their families and the many Foundations surrounding these unforgettable, iconic names who all joined in this adventure with such characteristic enthusiasm; without you this book would not be possible.

I also extend my gratitude to every single one of the passionate, hard-working people on both sides of the Atlantic, more particularly Assouline New York editorial director Esther Kremer, editor Amy Slingerland, art director Camille Dubois, Paris editor Valérie Tougard, and photo editors Véronique Ristelhueber and Beatrix Mahd Soltani, who were always supportive and patient. Together they united to create the vivid team spirit alongside those at the House of Krug, resulting in this beautiful labour of love.

I would also like to thank Rémi Krug and Fabienne Moreau for their contribution in putting so much of the information together.

A special mention of appreciation I must also extend to my dearest friend and highly respected colleague Serena Sutcliffe for having taken time out of her very busy schedule to write such a marvelous, charismatic and meaningful introduction.

On behalf of everyone at Krug, I am sure I speak for us all when I express my eternal gratitude to all of those who, in one way or another, helped us in the joy of publishing this book.

Margareth Henriquez

Assouline heartily thanks everyone at the House of Krug who collaborated so graciously on this book, including Olivier Krug, Margareth Henriquez, Anne-Céline Michel, Lauranne Bismuth, Magali Borel, Fabienne Moreau, Isabelle Pierre, Déborah Troper, and Sonia Voskoboinikoff. Special thanks to Serena Sutcliffe for her wonderful introduction, to all the Krug Lovers who responded so enthusiastically to our requests to contribute their quotes and personal anecdotes, and to Taeko Takeda at LVMH Japan for her valuable assistance. Thanks also to Jihyun Kim, Beatrix Mahd Soltani, Véronique Ristelhueber, and Valérie Tougard for all their patient hard work.

Assouline would also like to extend special thanks to the following: Theo Dawson, Agence Admanagement (Mathias Kiss and Sébastien Léon); Claire Riffard, Agence Openart (Brigitte Bardot); Catherine Laignel (Serge Gainsbourg) and Anna Morin (Pierre Arditi), Agence VMA; Alexa Agnelli; Patricia von Ah; Quitterie Allard (Michel Bettane); Adriana Rotaru, American Zoetrope; Björnstierne Antonson; Jan Thornton, The Artists Partnership Ltd.; Hannah Rhadigan, Artists Rights Society; Lucie Lesueur, L'Assiette Champenoise (Arnaud Lallement); Beby Benazir, Ayana Resort and Spa Bali; Catherine de Baecque (Maurice Herzog); Nathalie Baetens; Marine Benady; Manuela Höhne, Bugatti; Allen Burry; Stéphane Cardinale; Denis Chapouillé; David Charlins; Suzie Clark; Oscar Espaillat, Corbis; Helen Cowley; Rachele Longo, Cruciani; Jean-Baptiste Degez; Antoine Delage De Luget; Thomas Deron; Dr. Margarita Cappock, Dublin City Gallery The Hugh Lane; Roger Decker; Wolfgang Frei, Edward Quinn Archives; Christophe Dejean, The Estate of Francis Bacon; Eventattitude/A. de Villenfagne; Marla A. Metzner, Fashion Licensing of America, Inc.; Paula Fitzherbert; Aliénor de Foucaud (Amélie Nothomb); Georgia Sears, Four Seasons Hôtel George V; Tim Francis; Léa Gabourg and Vincent Lebon (Fred Pinel); Charley Galley; Sarah Zimmer, Getty Images; Stefania Giudice; Stephan Gladieu; Silka Quintero and Ellen Sandberg, The Granger Collection; Inelee Castro, Greenlight, A Division of Corbis Entertainment; Matthew Guinness; Adam Hayes; Loren Haynes; Jean-Pascal Hesse, Pierre Cardin; Anne Benichou, Hôtel Ritz Paris; Mia Meliava, Iconoclast Image; Alexis Jacquin; Michael Katakis; Michel Labelle; Xavier Lavictoire; Teresa Lee; Andrew J. Loiterton; Claudio Marioto; Pollyanna Midwood; Jean-Baptiste Mondino; Reid Myers, My Young Auntie; Judith Neuhoff; Danielle Goodman, Nonoo; Sophie Orbaum; Alice d'Orglandes; Thierry des Ouches; Doug McKeown, Photofest Digital; Delphine Pinet and Karine Rawyler (Francis Kurkdjian); Giuseppe Pisano; Mathieu Raffard; Restaurant Flocons de Sel; Bruno Pouchin and Ophélie Strauss, Roger-Viollet; Clémentine Rousseau (Alain Passard); Kevin Bacon, Royal Pavilion and Museums; Catherine Terk, Rue des Archives; François Schmidt; Nazneen Shahid; Patricia Javier, Shangri-La's Boracay Resort and Spa; Teresa O'Toole, Sterling and Francine Clark Art Institute; Olaf Strassner; sydneycool.com.au; Kharbine Tapabor; Marina Tomassini; Billy Vong, Trunk Archive; Clémence Laplaige, Vrankenpommery (Alain Senderens); Jamie Vuignier, The Kobal Collection at Art Resource; David Zagdoun.